INDIGENOUS AESTHETICS

INDIGENOUS AESTHETICS

NATIVE ART

MEDIA

AND IDENTITY

by Steven Leuthold

 UNIVERSITY OF TEXAS PRESS, AUSTIN

Requests for permission to reproduce material from this work should be sent to Permissions, University of Texas Press, P.O. Box 7819, Austin, TX 78713-7819.

⊗The paper used in this publication meets the minimum requirements of American National Standard for Information Sciences—Permanence of Paper for Printed Library Materials, ANSI Z39.48-1984.

LIBRARY OF CONGRESS
CATALOGING-IN-PUBLICATION DATA

Leuthold, Steven, 1957–
Indigenous aesthetics : native art, media, and identity /
by Steven Leuthold.
p. cm.
Includes bibliographical references and index.
ISBN 0-292-74702-0 (cl : alk. paper).
ISBN 0-292-74703-9 (pbk. : alk. paper)
1. Indian aesthetics. 2. Indian art. 3. Aesthetics.
4. Documentary films. 5. Indians—Ethnic identity.
6. Visual anthropology. I. Title.
E59.A32L48 1998
701'.17'08997—dc21 97-37343

CONTENTS

LIST OF ILLUSTRATIONS

PREFACE

THE WRITINGS in this book span issues in philosophy, media theory, and the social sciences to formulate concepts regarding indigenous aesthetics. The book responds to aesthetic experience as a vital part of native cultures, and differs from traditional philosophical works in aesthetics, which tend to be more abstract in nature. In part, my writing reflects my own interests in art, independent media, and aesthetic theory, but the impulse behind the book is greater than this combination of personal interests suggests. I respond to the jostling, blurring, and blending of media and cultures that characterize the present. Indigenous aesthetics is not a nostalgic term that encapsulates a kind of postmodern primitivism, though primitivism continues to be a powerful force in intercultural relations. Rather, the term refers to the complexities and contradictions found in the art and media of indigenous peoples today and the ways that their aesthetic experiences inform, enrich, and challenge members of non-native cultures.

The book had its genesis in a research tradition within visual anthropology, begun by Sol Worth and John Adair, that investigates how new visual media are incorporated into the lives of native peoples. In the twentieth century, as in earlier eras, native peoples have proven remarkably resilient, in part, because they have been able to adapt the tools and traditions of non-native cultures to their own purposes and needs. Many visual technologies, from easel painting to videography and computer graphics, have found their way into the lives of indigenous people today. What impact has the adaptation of new media had upon their sense of themselves as a distinct people: what is the role of art and media in contemporary natives' collective identification? And how are aesthetic concepts and traditions represented within native cultures?

This book is a step toward analyzing concepts about aesthetic experience that have developed independently of the Western tradition. Even though intercultural processes play a major part in the lives of many indigenous peoples today, after my experience of and reflection upon

indigenous "art," I still sense the uniqueness of this expression. As a result, the meanings of concepts such as "art" and "aesthetic" may be extended, challenged, and even subverted through the study of indigenous ideas and expressions. In addition to the "aesthetic," a recurrent topic in the book is the contemporary meaning of the term "indigenous." I explore both the more traditional sense of the concept—native to a place—and recent political understandings of indigenous as bases of contemporary native expression. By considering these varied aspects of indigenous aesthetics, we discover how native art and media have conveyed profound meaning, both for non-indigenous people and within their communities of origin.

ACKNOWLEDGMENTS

MANY INDIVIDUALS and organizations have contributed to this book. It is difficult to adequately acknowledge the emotional, intellectual, and administrative support that goes into a project of this nature, but I would like to express appreciation to those individuals and organizations who have assisted me along the way.

In the early stages of the research process the Annenberg School for Communication at the University of Pennsylvania provided support through a doctoral research fellowship. Larry Gross, Kathleen Hall Jamieson, and Paul Messaris, all faculty of the Annenberg School, were instrumental in helping form the media issues that I address. Salish Kootenai College on the Flathead Indian Reservation willingly shared the resources of its media center, library, and offices. I thank Roy Bigcrane, Frank Tyro, and Corwin Clairmont for the time and energy that they shared with me during the field research portion of this project.

Several groups and individuals at Syracuse University have provided opportunities for me to present and refine my ideas. The Visual Communications Interest Group, formed by Kevin Barnhurst, provided a forum for discussing issues and ideas in visual anthropology and documentary theory as well as the material from this book. The Arts and Aesthetics Interest Group, formed by Philip Peterson, addressed several issues in comparative aesthetics and film theory that contributed to my thinking on these topics. I had the wonderful opportunity to offer seminars in comparative aesthetics during the spring of 1995 and spring of 1996. I extend my appreciation to the students who questioned and commented upon a broad range of ideas relevant to indigenous aesthetics and to Professors Philip Peterson and Richard Pilgrim for their involvement.

Particularly important in a writing project of this nature are those individuals willing to read and comment upon the entire manuscript. I extend my gratitude to Kevin Barnhurst, Derek Bousé, and Robert Craig for their comments. Other individuals who have read parts of the manuscript and

offered much appreciated constructive assistance include Judith Huggins Balfe, Roy Bigcrane, Duane Champagne, Elizabeth Cook-Lynn, Susan Ivers, Victor Masayesva, Jr., Thompson Smith, and William Willard. The editorial staff and advisory board of the University of Texas Press have been unwavering in their support and assistance. I would like to thank Theresa May, in particular, for her early and continuing enthusiasm for my ideas and unfailing effort in helping to turn a manuscript into a book.

In a somewhat different form Chapter 3 was previously published by the *Journal of Arts Management, Law and Society*, Chapter 6 in *Wicazo Sa Review: A Journal of Native American Studies*, and Chapter 7 in *On the Margins of Art Worlds* from Westview Press. I express gratitude to all of these publishers for their interest in the material, encouragement, and helpful comments. Over the past several years I have had the good fortune to present ideas found in this book to colleagues at several scholarly conferences. I thank those conference and panel organizers, fellow participants, and respondents at the following conferences who cared enough about the ideas herein to discuss them publicly: the International Communications Association Conference in Chicago, May 1996; the 17th, 18th, and 21st Annual Conferences on Social Theory, Politics and the Arts at varied locations; the College Art Association Conference in Seattle, February 1993; and the Speech Communication Association Annual Conference in Atlanta, November 1991.

My family has been very supportive of my writing activity and graciously tolerant of the hours that I have tied up the computer and videocassette recorder during the research and writing of this book. My wife, Mary Lake Leuthold, has helped see the book to its conclusion through many discussions over the years, and my sister, Lisa Koble, provided contacts to the community in Pablo, Montana, that helped make this research possible.

Many other persons—staff, faculty, and students—at the institutions that I have mentioned have been more than willing to help me at every turn of this research. I extend a heartfelt thanks to them for their professional competence, patience, and support for this project. Without the valuable assistance and kind suggestions of all who have been involved, completing this book in its present form would not have been possible.

Finally, but not least, I would like to thank those native organizations and individuals who are the subject of the book and who have opened

themselves to my ideas and questions. Without their creativity and heart-
felt stories, there would be no motivation for writing a book of this nature.
My greatest debt is to those native artists, writers, and media people who
have persevered and triumphed in the face of often daunting obstacles. I
dedicate this book to their independent spirit and vision.

INTRODUCTION

A Native filmmaker has . . . the accountability built into him. The white

man doesn't have that. That's the single big distinction. Accountability as

an individual, as a clan, as a tribal, as a family member. That's where we're

at as Indian filmmakers. We want to start participating [in] and develop-

ing an Indian aesthetic. And there is such a thing as an Indian aesthetic,

and it begins in the sacred.

—Victor Masayesva, Jr., Hopi videographer, 1991

WHAT IS the relevance of the concept "aesthetic" for in-
digenous artists and intellectuals? Aesthetic expression and
assumptions about the aesthetic help keep native commu-
nities together. As a means of expressing identities, the aes-
thetic emerges as an important aspect of self-representation
to the larger non-native public. The collective function of the
aesthetic is so well recognized by "outsiders" that non-native courts may
look at aesthetic traditions as "evidence" of the historical continuity of na-
tive peoples. More importantly, an awareness of and willingness to partici-
pate in indigenous aesthetic expression increasingly signify belonging and
accountability *within* native communities. In native communities the aes-
thetic is acknowledged as central to the expression of worldviews based in
religion, myths, and relations to nature. Despite this centrality of the aes-
thetic to native communities, there has been little analysis of indigenous
aesthetics in the general literature on aesthetics.

This book expands the discussion of aesthetic concepts beyond the Western theorists and examples commonly considered in the current discipline of aesthetics. A Western emphasis is common in both introductory and advanced college courses on the subject and in most of the professional writing about aesthetics. For Euro-American scholars there are linguistic, cultural, and philosophical barriers to studying the intellectual traditions of cultures other than one's own. These barriers are less present if a researcher chooses to focus on the aesthetic expression of *one* non-Western culture and develops the language and methodological skills necessary to that end. But, by taking as my topic indigenous aesthetics in general, I am hoping to avoid what might be labeled the "isolated example" approach, in which isolated examples of indigenous art and ideas are introduced into a largely Western analytical framework. In this approach, one builds observational detail, but the conclusions often lack generalizability to other aesthetic traditions, leaving scholars to question whether statements derived from the experience of a single group are philosophically fundamental in nature.

But problems also arise when one formulates principles applicable to many cultures. By taking "indigenous aesthetics" as my topic, I address issues applicable to several cultures because "indigenous" refers to something common about the experience of many peoples. Indigenous, then, may be a fundamental concept in aesthetics that has been overlooked due to the historical ethnocentrism of Western philosophy, but it is a concept that reflects the difficulty of making cross-cultural generalizations.

By indigenous aesthetics, I am referring to thoughts about aesthetic experience that developed independently of the Western tradition in various parts of the world: ideas about art held by indigenous peoples. However, since most indigenous peoples have had a history of contact with explorers, researchers, missionaries, immigrants, and conquerors, the study of present-day indigenous aesthetics is primarily intercultural in nature. This area of study might sometimes be called ethno-aesthetics or even the aesthetics of primitive art. I believe these are misleading names: "ethno-aesthetics," by being most often applied to ethnic groups other than whites, implies that ethnicity is a matter of primary importance for non-European peoples but not for Europe-derived peoples themselves. If the term were to be used consistently, the whole tradition of Western aesthetic thought, from Plato to postmodernism, would consititute a Europe-based ethno-aesthetic, but I have not seen the term used this way in

practice. "The aesthetics of primitive art" implies that there is no indige-
nous tradition of thought about art, only a Western theory of art that seeks
to account for art in primitive cultures. This appellation also seems to fa-
vor a view of indigenous peoples as "primitive" in the sense of primi-
tivism, i.e., as somehow removed from contemporary social processes,
when they are, in fact, involved in these processes.

The term "indigenous" presents definitional problems in a contem-
porary context. Originally, the term referred to traditions, implements,
natural specimens, and so forth that are native to a particular region or
regions. In this sense, the mask is an indigenous art form (or ritual ob-
ject) in much of Africa and the Americas. But since the 1970s, the term "in-
digenous" has acquired a political meaning; it reflects a growing awareness
of the role of ethnicity in national cultures and acts as an organizational
focal point for anticolonialism. Thus, many of the peoples of Europe are
indigenous to their current homelands, but are not often referred to in the
context of indigenous activism. Currently, "indigenous" refers to people
who are minorities in their own homeland, who have suffered oppression
in the context of colonial conquest, and who view their political situa-
tion in the context of neocolonialism. Much of this book considers the
role of aesthetics in relation to the stated goals of contemporary indige-
nous peoples: self-determination, cultural continuity, cultural distinc-
tiveness from the larger "dominant" culture, and so on. However, by ad-
dressing the concept of indigenous in its current political usage, I do not
mean to jettison the earlier meaning of the term—native to a place—be-
cause there is a larger "aesthetics of place" inherent in the term "indige-
nous." As political as "indigenous aesthetic expression" may be in the con-
text of neocolonialism, the term has a more general meaning: aesthetic
practices that express place attachment. "Indigenous aesthetics" has re-
flexive value for any people seeking to understand art as an expression of
place, whether they are members of an indigenous "minority" or not. For
non-native readers this book may be reflexive in two senses: in relation to
their own culture's role in the process of conquest and colonization, and
in the sense of their own expression of attachment to place through aes-
thetic expression, an attachment that often seems submerged in contem-
porary artistic expression.

The self-reflexivity of this topic is a major part of comparative aesthet-
ics. Non-natives study other cultures' ideas about art, in part, because this
study reflects upon non-natives' own experience. Studying others leads

to an acknowledgment that non-natives themselves have perspectives, frameworks for viewing, that are based upon collective experience. Some writers have suggested that non-natives are motivated to view or buy the art of other cultures by a sense of loss or dissatisfaction with the way art functions in the West, where art seems separate from life.[1] In the same way that art is separate from life, we may be alienated from ourselves. Detachment and alienation result from a culture that seems mechanical, ugly, dehumanized—in a word, soulless. Have non-natives lost a sense of grace and elegance that others have retained, lost ways to deal with the most essential aspects of our existence: birth, death, spirit, or life force?[2] If alienation and loss of belief are characteristic of modernity, what does the integrated nature of indigenous art and culture offer? Through our comparative viewing and analysis, indigenous aesthetic expression raises deep questions about the role of aesthetic expression in Western cultures.

For comparative analysis we need analytical frameworks that guide our study. The first several chapters of this book attempt to develop frameworks for discussing indigenous aesthetics. Some of the frameworks that I refer to include colonialism and internal colonization, nation-building, "art" itself, and collective identification. Later, I apply these frameworks to specific indigenous expressions in the context of today's intercultural, media-saturated world. In today's environment, after many indigenous cultures have been in contact with the West for decades or centuries, is there still a basis for considering "indigenous" to encompass experiences distinct from European cultures and expressive forms? Or do the same theoretical frameworks that have been developed to understand art in the West apply equally well to indigenous expression? One way to get at the heart of this problem of the distinctiveness of expressive forms is to look at contemporary media expressions by indigenous peoples, because these are inherently intercultural—influenced by the West—in their technology, form, and often in their intended audience. If distinct indigenous aesthetic expressions can be discovered in indigenous film and video, this would seem to point to the durability and importance of native aesthetic expression in general.

Identities differ; we need analytical frameworks within aesthetic theory that acknowledge culturally based differences. In the first chapter of the book I propose a systems view of aesthetics that considers the link between aesthetic expression and collective identity. The notion that theories of art will vary based upon cultural factors such as identification seems obvious,

but this simple premise has yet to gain general currency in the discipline of aesthetics because of the traditional emphasis in philosophy on universal questions. Which theoretical frameworks help us understand the link between aesthetic expression and collective identities in native cultures?

Over the last two decades many native communities have focused on the ways that "culture" is at the heart of the creation of national, tribal, and group identity. But *how* does "culture" create a sense of shared identity? Aspects of culture that have been especially important in collective identification are aesthetic expressions in all forms: dance, music, song, the visual arts, literature, drama, and storytelling. Some of these expressive forms may be considered traditional, others contemporary, but all contribute to forming native identities. Because *each* of these expressive forms can be said to express and consititute native identity, this book takes as its scope indigenous aesthetic expression in general, rather than any particular form.

I explore the link between aesthetic expression and collective identity by analyzing the documentation of these expressive forms in film and video, most often by natives themselves, rather than through analyzing examples of each form of expression. By considering how native artists, writers, and videomakers frame their own aesthetic practices, the book can focus appropriately on the social meaning of aesthetic expression as natives themselves see it. The "framing mechanisms" of films and videos about native culture are the subject of my analysis as much as any particular form of expression. Film and video documentaries by natives provide a necessary level of generalization for a discussion of the linkage between aesthetics and collective identification. In addition to the relationship between aesthetic expression and collective identity, this book discusses several related issues that affect the meaning of aesthetic expressions: the role of intercultural contact and conflict, generational relations, native and white relations to the land, and native religions as they impinge upon the aesthetic expression of native identities.

Before considering the importance of indigenous aesthetic expression, it is important to consider the meaning of the term "aesthetic" as I use it. The meanings of this term are quite varied and notoriously difficult to pin down within the history of Western thought, where the term originated. What can be the value of applying a debated concept to historically non-Western cultures if its usage is contested in the cultures of origin? In the first chapter, I advocate a "systems" approach to aesthetics which consid-

ers how aesthetic behavior is a set of social practices in the same way that political, economic, or judicial systems are sets of social practices. Thus, I feel that "the aesthetic" is an important concept to apply cross-culturally because it refers to real personal and social behaviors that occur in every culture. Not simply a logical construct or link in a philosophical system, the term "aesthetic" refers to real aspects of lived experience that have a social dimension. Linking ethics, religion, or politics and aesthetics reveals how value systems are embedded in our physical and emotional relationships to the world in which we live. Aesthetic experience is bodily, sensory; it is not just abstract and theoretical. Our value systems are rooted in our experience of the world. In the context of indigenous aesthetics, a conceptual explanation of a belief or value system may not be the only source of discovering aesthetic ideas; rather beliefs and values are lived and embedded in social relationships.

In this social context aesthetic systems have important links to other social systems but are not reducible to them. Aesthetics cannot be understood *only* in political, economic, or religious terms; there are aspects of our aesthetic experience that must be explained in the terms of aesthetic theory rather than political or economic theory. But the relationship of aesthetics to these other social systems is important.[3] I then discuss the basis for linking aesthetic expression with a people's collective identity and how this has become a common feature of aesthetic expression in today's intercultural political environment.

A view that frames aesthetic experience as integrated with other social systems can be contrasted with an autonomist view of art. There are major limitations of an autonomist view of art for understanding indigenous aesthetic theory and experience, not the least of which is that the connection between art and collective identity is hard to discern in an autonomist view. An autonomist view derives from assumptions about art, the artist, and philosophical theories of mind and knowledge that developed in Western culture during the Enlightenment and Romantic periods. In an autonomist view art has several attributes: Artworks are "unique," nonutilitarian, ego-identified (with the artist's intention), self-validating in a psychological sense, innovative, "without rules," and for sale or exhibition as a commodity or an independent object that extends beyond a community. These attributes of art are tied to other experiences and problems in the West such as the nature of materialism versus spirituality, the development of capitalism, the value placed on individual freedom, and so on.

Many of these attributes of art run counter to the attributes associated with art in indigenous cultures. A foremost distinction is that many indigenous cultures did not identify their traditional expressive works as "art"; natives often believe there are social rules or guidelines for expression that must be followed and guarded; expressive objects and events are community-oriented; art is both useful and beautiful (its functioning is a part of beauty); the artist is not above or separate from society (not "different" or eccentric); and there is no pressure toward innovation for its own sake. Just as an autonomist view of art in the West is tied to broader experiences and assumptions than can be encompassed within aesthetics alone, the same is true for the integrated experience of art in non-Western cultures.

When we take a systems orientation toward aesthetics, we consider the broader connection between expression and experience. How does expression reflect our experience of the world at the broadest level? Marcel Griaule wrote of Dogon masking societies: "The society of masks is the entire world. And when it moves onto the public square, it dances the way of the world, it dances the system of the world."[4] This broad view of the relationship between aesthetics and experience requires a transition from an object-oriented to a systems-oriented understanding of aesthetics, not traditionally encompassed by the concept "art." How is art integrated into or a part of a total system of belief and actions? To understand Dogon masks we need to view a total system of interrelationships. Interpreting a single mask as standing for or representing a spirit is much too limited: a systems approach addresses problems of organization and relationships. In the case of masks, how do different mythic expressions relate to each other? A difficult assumption for many Euro-Americans to question is that the artist's intention is the basis of aesthetic experience, a central element of autonomist views of art. A systems approach shifts the focus from the private intention of an artist to an environment of information and experience: the entire environment as ready to become a work of art.

A parallel with systems aesthetics is the linguistic theory of semiotics. Semiotics discovers the pattern of relationships that holds a linguistic system together, the algorithm of a language. Similarly, each aesthetic experience is a part of the creation of a system of meaning such that each part informs the other and the whole. But there is a difference between a systems view of aesthetics and a strictly semiotic view. In a systems view, aesthetic expression is performative; by doing something, aesthetic ex-

pression reestablishes equilibriums so that the order established in the culture may continue to exist. Thus, our concern in analyzing indigenous aesthetics is with action and agency as well as the organization of knowledge and meaning systems. In such a performative, pragmatic conception, the multiple meanings attached to aesthetic expressions are not necessarily contradictory. The idea that a single expression can have multiple meanings is an important ingredient of a systems approach to aesthetics. Acknowledging these multiple correspondences is one way to counter the notion of the "autonomous" artwork.

The discussion of the social, collective nature of aesthetic expression in Chapter 1 sets the stage in Chapters 2 and 3 for considering how *indigenous* aesthetics functions in an intercultural context. Aesthetic systems are focal points for intercultural communication on a global scale; members of varied cultures negotiate differing value structures through aesthetic expression. As a non-native I feel that it is important to acknowledge some of the ways that non-natives may understand "representation" in indigenous arts early in this book. The self-reflexivity of this book is a major part of comparative aesthetics, my interdisciplinary umbrella. I study other cultural ideas about art, in part, because this study reflects upon my own experience. The same can be said of native artists viewing and studying art from the European tradition. Studying "others," whoever this may be based upon our own background, leads to an acknowledgment that we each have perspectives—frameworks for viewing—that are based upon our experience as members of collectivities. The second chapter, then, focuses on the cross-cultural importance of indigenous aesthetic expression. I discuss organizing frameworks such as colonialism and internal colonization, nation-building and pan-tribal identification as ways of understanding the "representational" role of indigenous aesthetics. This chapter acknowledges that part of the comparative framework needed for understanding indigenous aesthetics is found in neocolonialist and postcolonialist discourse. However, a discussion of indigenous aesthetics from this framework alone may be too limited: limited temporally to problems of relatively contemporary art—art created during and since the colonial era—and limited analytically to art's political context and rhetorical goals, perhaps at the expense of religious or spiritual understandings of aesthetic expression.

Chapter 3 continues this broad, general discussion of indigenous aesthetics by focusing on the applicability of the term "art" to indigenous aes-

thetic expression. Aesthetic systems might encompass aspects of daily life, from habits of greeting to food preparation, the communal organization of space, and religious rituals that are much broader than the term "art" usually is thought to encompass. Like the term "aesthetics," "art" seems to be a term imposed on native expression. This chapter considers the implications of either using or withholding the term "art" from indigenous aesthetic expression. Why is it problematic to use or not use the term "art"? The chapter locates the consideration of native "art" by Westerners in the historical dynamic of modernist theorizing. While I critique the universalizing tendencies inherent in the ethnocentric use of the term "art," I stop short of advocating the abandonment of "art" altogether. Rather, I advocate a broader understanding of the concept, one that acknowledges ties among art, ethics, and spirituality and counters the materialism, ethnocentrism, and specialized uses of the term often found in recent Western theory.

This chapter points to the inherent problems of defining art crossculturally. Traditionally aesthetics has concerned itself with the fundamental nature and value of art. Interestingly enough, this fundamental, core meaning of art has yet to be discovered, or at least agreed upon. The existence of competing points of view in Western theory itself would seem to point toward culturally relative definitions of art. We could do away with a common definition of art, but the problem does not disappear that easily, because we have to somehow define what it is that Westerners look at and recognize as art in other cultures. Thus, our first problem—defining art itself—throws us immediately into a dilemma with respect to indigenous aesthetics. Westerners have to acknowledge having a definition of art that they use for comparative purposes, while at the same time questioning whether any definition of art is applicable across cultures. Chapter 3 puts forward a solution to this dilemma based upon broadening the notion of art to include concepts formerly associated with art in the West, but now often undervalued.

In the middle chapters of this book I apply some of the concepts discussed in the earlier chapters by examining Native American aesthetic expression within indigenous film and video documentaries. Since the 1970s, native documentarians and artists from throughout North and South America have produced a varied body of films and videos about their contemporary lives, cultures, and histories. An indigenous documentary is one made by members of an indigenous community or in close

interaction with the community: a film or video produced or coproduced by members of the group it is about. Indigenous documentary can be distinguished from films made by outsiders such as non-native filmmakers, scholars, journalists, and so on.

Previously, film and video were exclusive media, available only to wealthy individuals, institutions, or corporations. But as video technology increases in financial and technical accessibility for individuals and communities, people are reaping this technology's communication potential. Increasingly it is native media documentarians who tell the stories that constitute the collective memory of their people. Native communities attempt to document, preserve, or even revitalize *local* aesthetic practices through media. Indigenous films and videos communicate within the group and increase group affiliation. Showing the programs outside of the local area communicates cultural practices seen as important by community members. Documentaries preserve knowledge for future generations and communicate the group's identity to the wider non-native public.

With its emphasis on local aspects of film and video production, this section of the book differs significantly from those books that have focused on media in the context of mass distribution. Eric Michaels, in his study of the emergence of indigenous media at an aboriginal village in central Australia, makes this distinction very clear: "The bias of mass broadcasting is concentration and unification; the bias of Aboriginal culture is diversity and autonomy. Electronic media are everywhere; Aboriginal culture is local and land-based" (Michaels 1987, 13). Here, Michaels refers to the autonomy of one culture from another, not to the autonomy of the medium itself; this usage of the term is distinct from my earlier discussion of autonomist art. Though mass-mediated television contributes to cultural homogenization, I explore a potential countertendency, that media expressions may foster cultural and political autonomy. The potential for cultural standardization is apparent in media that transcend spatial and temporal boundaries, but the alternate possibility, that film, video, and television can be used for purposes of cultural self-determination, has been less frequently explored. In the past, scholars argued that the mechanical reproduction of images—the mass production and distribution of imagery—undermines the uniqueness and authenticity of art and commodifies aesthetic experience. This section of the book examines the possibility that film and video, when created and viewed in local contexts, increase both the accessibility and the social relevance of aesthetic practices.

Though the dangers of decontextualization and commodification exist, the localized aspects of indigenous media production and reception may counter some of the negative effects of mass reproduction. There is an inherent tension in the use of media technologies to express local aesthetic traditions to broad audiences that parallels the complexity of "indigenous" as both a local concept and an expression of an international, anticolonialist political movement. It is because of this dual power of media both to transcend and embody the local that I have chosen it as my analytical focus.

In addition to their usefulness for local or internal communication, aesthetic practices shown in the films and videos express the values of a group to a wider non-native public. Media technologies increasingly transmit the knowledge used in cross-cultural aesthetic appreciation. They cannot substitute for direct experience, but they expose audiences to a wider range of aesthetic practices than direct experience. In some cases, they may even incorporate demonstrations of technique and, therefore, directly affect artistic production. Many people's sole knowledge of the aesthetic traditions of non-Western cultures derives from film and video. Sequences embedded in travel films and ethnographic films shown on television expose people to forms of aesthetic expression other than their own. Exotic, frequently stereotyped images in more widely distributed fiction films also shape public perceptions of other cultures. But documentaries probably expose more people to non-Western cultural practices than direct experience, and they represent other cultures in a qualitatively different way than the written word or still photograph. Thus, this book explores how aesthetic theory might be relevant for, and informed by, "non-art" forms such as media documentaries.

In addition to the aesthetic and documentary aspects of recent films and videos, indigenous media are at the forefront of the struggle for cultural self-determination. Native-produced films and videos originated in the 1970s from the civil rights movement in the United States and, internationally, from the First World movement of indigenous peoples. Similar uses of film and video have emerged in Australia, New Zealand, South America, and Canada. Thus, aesthetic expression and indigenous peoples' collective goals intersect in native media, which makes these media expressions a prime site for investigating the thesis of this book, the tie between aesthetic expression and collective identities. Chapter 4 discusses this connection among art, media, and identity in Native American cul-

tures. I focus on American Indians because Native American media have been seldom discussed in print while Australian, Canadian, and South American indigenous media have received at least some scholarly attention. In addition, this book reflects my field research experience at a Native American media center in western Montana. I am more familiar with indigenous issues and media expression in the United States but will point to relationships with indigenous media and aesthetic issues in other regions.

In the next chapter I link the themes and processes of earlier visual and literary forms of expression to contemporary native documentary. Identifying expressive antecedents helps us understand how contemporary native media are a product of cultural and aesthetic continuities within native cultures rather than solely a reflection of Western media traditions. This is an important issue because a counterposition could be that indigenous expression has been undermined with the adoption of European languages and new media technologies by native peoples. Establishing a historical continuity of expressive forms and themes is important for the discussion of indigenous aesthetics. Though we normally associate the documentary genre with Western filmmaking, there are visual, literary, and oral antecedents for media documentaries within Indian cultures.

Continuing this investigation into the aesthetics of native media themselves, in Chapter 6 I analyze stylistic properties of films and videos by two noted directors, George Burdeau and Victor Masayesva, Jr., to discover whether recent documentaries reveal a "native way of seeing." Do today's native documentaries constitute a unique aesthetic expression in their own right, or are they more easily understood as traditional documentaries? I develop the position that the close tie between the videographer and his or her community, and the development of particular themes, override any specific formal or narrative characteristics in creating Indian perspectives within documentary. In a medium that is intercultural in its origin and formal development, there is not enough formal consistency in visual style or narrative structures to clearly define a single indigenous documentary aesthetic based on formal considerations alone. But substantive issues such as native views of "the sacred" and of the land, as well as social conditions of production, distribution, and reception, have led to the development of a recognizable native aesthetic in film and video.

The final chapters of the book shift our focus from the aesthetic properties of indigenous documentary to a consideration of the subject matter

of visual and performance arts films and videos. This analysis is important
because it points to the assumptions about art and identity that are important to natives themselves. Chapter 7 focuses upon documentaries about the visual arts and issues of aesthetic tradition and innovation. Several issues—assumptions about the relationship between art and life in native cultures; aesthetic tradition and innovation in relation to "Indianness"; and social aspects of artistic production, including marketplace forces—serve as touchstones for my discussion of the visual arts videos.

Chapter 8 addresses the central role of the performance arts in Native American collective identification as expressed in film and video documentaries. In Native American visual arts differences exist between contemporary and traditional art forms and between the ritual and commodity functions of art; these divisions are less apparent in performance contexts. My analysis of performance arts and rituals often focuses on the participatory and contextual aspects of a performance event. In this chapter I ask how performative elements overlap to create an aesthetic whole and whether performance practices prescribe ways of acting in a way that tells us something about Native American cultures. Several factors guide the discussion of performance arts documentaries: performance space and media, attitudes toward skills, types of participation, and social constraints on performance.

The final chapter addresses the relationship between indigenous art and media and their cultural context, with particular regard to Native American religions and attitudes about "the land." Intercultural issues again emerge as important in this contextual discussion of native art and media. The origins of art may lie in humans' perceptions of their relationship with nature and the spiritual. In representing nature, through both the portrayal of collective symbols and the creation of a visual poetry, Indian artists and writers, as well as film- and videomakers, have found their clearest, most unified voice. It is appropriate to end the book with an analysis of the relationship among aesthetic expression, nature, and religion, because a profound "sense of place," which grows out of the linkage between the spiritual and the natural, is at the center of indigenous aesthetics. The study of indigenous aesthetics opens us up to the possibility of a general aesthetics of place for non-indigenous people. This final chapter points to the role that indigenous aesthetics plays in aiding our understanding of place attachment in all aesthetic experience.

AESTHETICS AND
THE EXPRESSION OF IDENTITY

DEFINITION OF AESTHETIC SYSTEMS

I N THIS chapter I discuss the theoretical basis for linking aesthetic systems with group identification in contexts of cultural contact, conflict, and change. Two related topic areas are discussed: (1) the ways in which aesthetic experiences shape collective identification and (2) the role of aesthetic systems in group identification during processes of social change and intergroup conflict.

An initial task is that of defining the concept "aesthetic system." Other scholars have pointed out the dangers of adopting a universal definition of what aesthetics or art is (Merriam 1964; Maquet 1979; Anderson 1990). For instance, universal definitions of art may imply that artists from different cultures make art for the same reasons; that differences in major social factors such as population, technological development, or internal social diversity do not bear upon our appreciation of art; or even that the psychological motivations for making art are similar cross-culturally. Each of these factors—artists' intentions, social factors, and psychological experiences—can vary cross-culturally, which seems to imply that one's understanding of art would need to vary as well. A relativist understanding of aesthetics follows from a focus on the conceptualization of art by members of a particular culture, an ethno-aesthetic. In this view, the role of aesthetics in collective identification varies depending upon a culture's own understanding of art, or ethno-aesthetic.

In the ethno-aesthetic of Western thought, scholars researching aesthetic expression and response have focused upon perceivable, formal qualities of human and natural activities or products. An eclipse or waterfall may evoke an aesthetic response for some people, just as a painting or musical composition does for others. However, since Hegel, scholars

have focused more upon human-made art than the generalized aesthetic
response that can be evoked by the natural world in addition to art. Like
many theorists in the Western tradition, one researcher in aesthetic an-
thropology follows Kant's theory of aesthetics, which holds that aesthetic
activities or objects are subject to valuation, capable of being disinterest-
edly appreciated, and capable of affecting the perceiver (Forrest 1988, 21).
The effect upon the perceiver is often tied to the emotional response that
the aesthetic experience involves, but the effect may also be cognitive (Fi-
scher 1961; Sperber 1985). Much Western theory since the late eighteenth
century, then, associates aesthetics with valuative, normative aspects of
human experience, especially as applied to patterned and organized prod-
ucts or activities. Beyond this overly general definition Western theories of
art begin to diverge; some theories such as formalism focus upon the pat-
terning or organizing principles of art, while others stress the valuative
dimension, frequently in the context of expression or emotion. Other
theories, instrumentalist or didactic in nature, focus on the effect of art
upon the perceiver. Special qualities—genius, creativity, innovative-
ness—may also be attributed to the artist in formulating an aesthetic the-
ory. Thus, any theory of aesthetics tends to be an "attribute theory," in
which the proponent of the concept argues the relevance of a set of related
traits for our appreciation of art. These kinds of arguments can, and do,
vary quite a bit over time. For instance, in the nineteenth century the
academic European painting of nudes, often in classical contexts, was a
highly respected painting tradition. Today, these same nudes might be
interpreted as prurient, degrading, eroticized, or exploitive by some view-
ers. In the nineteenth century, the newly discovered temple carvings of
India's classical period were seen as prurient, degrading, eroticized, primi-
tive, even pornographic. Today, these sculptures are praised for their spiri-
tual qualities and emotional honesty because their representations are of
eroticized couples rather than objectified women. Even in the West, there
is no fixed "once and for all" definition or valuation of art. Many of the
Romantic theories that supported the judgment of art in the nineteenth
century have been invalidated a century later. Thus, recent traditions in
Western theory have focused on the importance that institutional, or so-
cial, processes play in validating aspects of aesthetic experience.

Given the importance of social, valuative, and normative dimensions in
aesthetics, it is closely linked to ethics in our understanding. Edmund

Leach goes even further in this linkage: "Logically, aesthetics and ethics are identical. If we are to understand the ethical rules of a society, it is aesthetics we must study" (in Kingsbury 1988, 10). Here, Leach collapses the distinction between ethics and aesthetics, a position that downplays the qualities of experience accounted for in each system of thought. But his statement linking ethics and aesthetics reveals how value systems are embedded in our physical and affective relationship to the world.

This link between aesthetics and ethics points to the relational character of aesthetic activities. Aesthetic activity relates to other cultural systems: economic, religious, political, and so on.[1] Thus, aesthetic expression comprises a social code or "social fact" similar to the way that politics and religion exist as social codes. The term "social fact" is an acknowledgment, following from Durkheim, who established the eminently social nature of religion in his pioneering work, that aesthetic expressions express collective realities. An aesthetic systems approach departs from traditional aesthetics in its recognition that art is not hermetically sealed from non-art. Instead of the emphasis on noninstrumental form found in traditional Western aesthetics, a systems approach emphasizes the social functions of aesthetic activities and the relation of these activities to other cultural systems. These relations change constantly. For instance, our understanding of how aesthetic experience relates to political factors has shifted in recent years. This shift has repercussions for both political and aesthetic activity, as seen in the increasing politicization of aesthetics and the aestheticization of politics. Some artists, like Jenny Holzer, have deemphasized aesthetic aspects of their work in order to heighten the ideological and political content. Conversely, advertising images of Republican campaigns in the 1980s partially substituted aesthetic for political appeals to voters.

A systems approach addresses the relationship between aesthetics and other cultural realms without reducing one realm to the other. In this sense, an artwork can be valued for its expressiveness, complexity, creativity, or formal structure—qualities that make up aesthetic experience—without artificially separating the experience of art from other valuative dimensions of experience: the moral, economic, political, interpersonal, or spiritual. A systems view emphasizes the collective aspects of aesthetic experience, not just the formal properties of art. One link among aesthetics, politics, and religion is the role of aesthetics in group identification.

All cultures have some process of identification. Group identification may be seen as an extension of the development of individual identity, but for the sake of expediency I will begin with a definition of group identification. The source of group identity is in an individual's primordial attachments or affinities; those "givens" of blood ties, race, language, region, and customs with which a child is born or into which a child is socialized. These customs are as integral to the child's legacy as biological aspects. The definition of group identity by biological criteria alone grows out of colonialism (Forbes 1990, 37). State policies often encourage ethnicization, creating broad biologically based categories such as "Indian" at the expense of local customs and autonomy.

Many cultures, including some Native American clans, may trace identity back to animal or plant affiliations. In contemporary Iroquois culture, clans such as the turtle, wolf, eel, and snake continue to serve as a source of identification. Other sources of identity include a person's alliances, which are bonded together by mythic traditions, ceremonies, marriage partners, and so forth. Family and clan affiliations have traditionally defined Native Americans' collective identity. Writers, artists, videomakers, and others who claim to speak for Indians but who have no known family or clan lineage may be suspected as adopting an Indian identity for their own gain (Bigcrane 1991). Tribal identities developed later than basic clan and family identities for many Indian groups. Collective identity, then, is multilayered; no single level can adequately describe or encompass identity. Group identification may derive from the geographical, biological, psychological, cultural, and intercultural elements of a group of individuals' shared experiences.

Why is aesthetics an important aspect of group identity? Since the Second World War, the world has seen the destabilization of larger social coherences. Specifically, the colonial powers have relinquished at least outright political control over their former colonies. We are currently witnessing the weakening of power systems in the former Soviet Union. The decline of spheres of national influence leads people to seek security in more basic group affiliations. Colonial powers leave legacies of their value systems—and their styles of life—in their wake. To the extent that "style of life" incorporates aesthetic in addition to ethical and governmental

systems, it becomes a factor for groups to respond to and possibly contest through their own aesthetic practices. Thus, the struggle for group identification often involves a struggle over signification expressed through style/aesthetic practices. Examples of resistant styles in music, art, dress, and so on are seen in youth cultures and African American cultural expressions such as Rastafarianism, soul music (Maultsby 1983), free jazz (Francesconi 1986), and rap.

If the management of group identity depends on the control of signification, then it follows that collective identity is achieved symbolically. Not surprisingly, symbols play a key role in aesthetic experience; symbols in aesthetic systems are mediating or connecting devices. Symbols bridge collective memory and social acts such as rite, ritual, and performance. Because what is stored in collective memory by means of art, customs, and myths may vary for different cultures, aesthetic signification has the potential to bridge gaps between differing cultures. The aesthetic expression of collective values influences other groups' understanding of what is important for a culture. In this sense, aesthetic signification acts as a site for the negotiation or mediation of differing value systems. Aesthetic practices mediate between memories and acts within a culture, and between the value systems of differing cultures.

Varying social contexts and individual experiences allow for multiple interpretations of a certain symbol or aesthetic activity. The meaning of any aesthetic experience fluctuates depending on context, so the understanding of aesthetic activity is an interpretive as well as a classificatory activity. Interest in how aesthetic practices lead to collective identification does not proceed from the physical fact of the aesthetic object but from individual or collective experiences of the physical fact. Thus, styles of aesthetic expression are not fixed analytical categories; rather they result from a series of experiences and decisions that relate to the larger contexts of culture and society.

Aesthetic experiences that are charged with suggestive emotional power for an entire group of individuals are similar to the collective representations of religion (Durkheim 1915) and politics (Jung 1959, 61). Collective representations derive their force from a central, organizing idea or system of belief. Because twentieth-century aesthetic theory often focuses on individual experience, the idea that our aesthetic experience derives from a "central organizing idea" seems untenable until one considers the unity

of styles. By definition, styles consist of shared formal motifs, patterns, or traits; this is what enables us to recognize and classify them. Style, then, serves as the basis for considering artistic expressions as collective representations. From politics, Jung describes anything that has an -ism attached to it as a collective representation. (The proliferation of -isms in art is notable: Realism, Impressionism, Expressionism, Fauvism, etc.)

The latter [politics] is only a modern variant of the denominational religions. A man may be convinced in all good faith that he has no religious ideas, but no one can fall so far away from humanity that he no longer has any dominating *representations collectives*. His very materialism, atheism, communism, socialism, liberalism, intellectualism, existentialism, or what not, testifies against his innocence. Somewhere or other, overtly or covertly, he is possessed by a superordinate idea. (Jung 1959, 62)

In some contexts, aesthetic expressions, like religious and political expressions, can evoke shared emotions and collective allegiances.[2] For this reason, art may serve as a potential substitute for religion as people turn away from institutional religions. This substitution involves the search not only for an alternative source of spiritual fulfillment, but for points of communal connection that were once provided by religious institutions. By considering aesthetic expression in this context, I am acknowledging the traditional close tie between art and religion; they serve similar functions. But the hope that some may feel for the aesthetic as a source of spiritual, communal experience has not always materialized. In fact, the loss of contemporary art's collective function acts as a backdrop to this book. Lucy Lippard writes that the affinity many contemporary artists feel for "prehistoric" and archaic art is a symptom of a desire to reintegrate art into social life: "These artists are rebelling against reductive purism and an art-for-art's sake emphasis on form or image alone with a gradual upsurge of mythical and ritual content related to nature and to the origins of social life" (Lippard 1983, 5). The origin of the collective function of art is in religion. Even in modern times, it is impossible to cleanly separate aesthetic experience from religious processes. In secular art, which is divorced from an institutional religious context, spiritual motives may be imputed to the artist—by the artist or the audience—and the audience may associate spirituality with aesthetic experience. Perhaps it is Western cultures' lack of shared beliefs and values that contributes to their fascination with "prehistoric" images and monuments. Considering aesthetic expression as a

form of collective representation, then, redirects us to the collective content of aesthetic experience and acknowledges the general significance of art for society.

Collective representations emerge as a key link between the psychology of the individual and the group. One psychological source of the persuasive, dominating power of collective representations is the parental image. Theorists have shown linkages between ethnic and national group identification and early childhood relationships to parents.[3] Commonly held values which are shaped by class, religion, occupations, ideas, and aesthetic experience are the ways in which "members of the group are drawn together.... The values to which we refer usually involve ego ideals and negative ego ideals, aspirations, and images of historical figures and events, which constitute shared mental representations.... These widely held sets of mental representation are then available for evocation by skillful leaders through the manipulation of allusions, symbols, rituals, and so on" (Group for the Advancement of Psychiatry 1987, 8). This report, written many years after Durkheim introduced the idea of collective representations and Jung elaborated it, confirms that the process of shared mental representation is basic to the psychology of ethnic and national identification.

In many ways, group identification through aesthetic experience resembles religious and political processes. Collective representations in religious systems help create a concept of the "holy" through categorization in much the same way parents use their power to teach us right from wrong, clean from unclean, and so on. Mary Douglas (1972) showed how religions create the sense of the holy through such categories as pure/impure and sacred/profane. These moral categories reduce ambiguity and create social order. The personal function of aesthetic systems is that of maintaining order in the psyche, and the social function of aesthetic systems is the maintenance of order through systems of classification. In the process of collective identification, categories of order define to a great degree who we are. The meanings of aesthetic, religious, or political symbols, as opposed to the arbitrary signs of ordinary language, emerge from prior understanding: the sense that categories of opposition have a given character embedded deeply in unconscious thought processes and bodily experiences. Both individual and social forms organize themselves on the basis of this substratum (Bourdieu 1984).

Symbols of order require symbols of transgression—which frame indi-

vidual action or the action of subversive groups in any categorical system—in order to exist. In religious terms, the category "sacred" requires the category "profane" to maintain its sanctity. In aesthetics, the relation between tradition and innovation may serve an analogous function in some societies. Innovation in art, often understood as avant-garde, requires both the idea of the traditional and an audience attached to traditional forms of expression to be effectively "shocking." In any system of categorization, such as those found in religion, art, or politics, a question arises: who has the power to define and control the categories and their transgressions? Who explicitly attempts to control aesthetic experiences in order to increase group identification? Frequently, the attempt to control cultural identification through aesthetic practices is politically or religiously motivated. The role of aesthetics in group identification relates to processes of social control and relations of power.

Hauck (1986) provides an example of the conscious association between aesthetic practices and social or political goals in an indigenous community. "For purposes of rallying support for economic and legal issues impacting Aleutian communities, Aleut leaders want to reconstruct selected high impact cultural traits that can readily connote 'Aleutness' to Aleuts and the general public" (Hauck 1986, abstract). Music and dance are the focal points of this attempt at aesthetic revival; they are points of "aesthetic locus."[4] Thus, while the earlier locus of Aleut aesthetic activities may have been contextualized by religious ritual, recent activities have been contextualized by political and economic purposes. It is the "affiliation quality" of these performance arts that Aleut leaders wish to promote (Hauck 1986, abstract). In regaining control of their symbolic behavior, the Aleuts are attempting to reforge a cultural bond and to send a political signal of unity to the non-indigenous culture.

In West Africa, contemporary performers of Ghanaian highlife songs draw on a performance tradition that integrates several art forms—music, song, dance, enactment, and a participating audience—to comment on society (Agovi 1989, 194). Much of the political flavor of these forms originated in the reaction to colonialism: "The period of anticolonial struggle in Ghana, for example, was dominated by a fierce cultural pride and intense nationalism. The people and their creative artists profoundly shared these aspirations of the nationalists in song, dance, and drama" (Agovi 1989, 195). The same anti-imperialistic struggle continues to motivate contemporary performers such as the late Nigerian saxophonist Fela Anikulapo-Kuti,

who was jailed for his political views. In struggling against "Western cultural imperialism," he wanted "Africans to reclaim an African identity by re-discovering their traditional religions (he [has] frequently reviled both Christianity and Islam), traditional methods of healing, and indigenous lifestyles" (Grass 1986, 143).

Not only political activists are aware of the affiliation quality of aesthetic experience. National governments may consciously attempt to establish a national culture that transcends those of individual groups through promoting national song, literature, and so on (Chopyak 1987; Henry 1989). The very multiracial or multicultural character of a society often increases the sense of urgency in establishing a common culture for the purposes of national unity. Thus, group identification may lead to social conflict in nations where several subcultures compete for influence. How are aesthetic expressions part of the negotiation between these conflicting subcultures?

INTERGROUP CONTACT

The problem of cultural contact and change or, perhaps in a more accurate reflection of the colonial past, cultural domination, conflict, and acculturation, leads us to question how aesthetic systems are used to negotiate the conflicting goals of various cultures and subcultures. Can aesthetic systems function as communication between two cultures? If so, is there a typical pattern that occurs when two cultures first meet, then over time negotiate their relationship through aesthetic practices? What effect do these intercultural aspects of aesthetic systems have on processes of group identification? What is typically guarded and what is subject to external influences?

We can start by considering how the dominant/nondominant tension affects identity formation for members of conflicting groups. Dominant North American culture has incorporated negative attitudes toward the aged, the disabled, homosexuals, Indians, blacks and other ethnic minorities, and other nationalities. This process has been one of systematic alienation or what the communication theorist Larry Gross calls "shaming." "By this I mean that the resources of the elite culture were utilized to convey to the members of the ethnic minorities a deep sense of cultural inferiority and inadequacy. The primary weapon in this system was, of course, the educational system and its targets were the children of non-Anglo-Saxon minorities" (Gross 1975, 43). The knowledge necessary for aesthetic

appreciation is one result of the educational process. In the process of shaming, the aesthetic practices of non-Western cultures have been systematically downplayed, marginalized, or ignored until recent years. There are several characteristics concerning the relation of these subcultures to the dominant culture which these groups share. For instance, in all cases the feelings engendered by the negative attitudes lead to negative *treatment* of subculture members. Frequently, the negative beliefs themselves are contrary to fact, but the danger is that these beliefs will become a self-fulfilling prophecy. Some Indians may internalize white stereotypes of the "drunken Indian" or "lazy Indian." Alcoholism and unemployment are the result of cultural dislocation and economic deprivation, but the process of shaming shifts the blame for these behaviors to the victims of dislocation and deprivation.

Beliefs and attitudes become ingrained in the way things are: a subtle ideology which becomes internalized over a period of generations. For this reason, stereotypes are very difficult to change. But, when awareness of the dominant culture's negative attitudes is heightened, members of subcultures may attempt to assert their own cultural identity. Initially, a typical pattern of acceptance of the dominant portrayal of the other is internalized so that it seems to be the "natural" image of the dominated group. For instance, as late as the fifties and sixties, American Indians were portrayed as savages in popular culture. This portrayal of Indians as filthy, heathen, and brutally violent provided an opposing category of impurity for the dominant culture's self-perceived cleanliness, Godliness, and civility.

"Normal" portrayals of the cultural other are then challenged through the presentation of an alternative portrait. The struggle for control of identification occurs through processes of representation, processes which include not only what is portrayed, but also how the subject is portrayed. Aesthetic practices are important in this discussion of the reconstruction and transformation of cultural identity because of their persuasive appeal for identification with a new frame of reference. The power of this persuasive appeal can only come about through the juxtaposition of styles. Because style is socially derived like all symbol systems, it "animates symbolic response through a comparative process" (Francesconi 1986, 37). As the listener or viewer recognizes familiar and unfamiliar stylistic components through a comparative process, he or she invests music, art, and other aesthetic forms with social and personal meaning. This tension between familiar and unfamiliar stylistic elements is resolved when audience

members supply a "new symbolic association for the unfamiliar stylistic elements" (Francesconi 1986, 38). Aesthetic practices which attempt to change and shape these associations are performing a rhetorical function by shifting the listener's frame of reference. Through the comparative experience of style one discovers the dialectical context of aesthetics, expressed here through the terms "familiar" and "unfamiliar."

Stylistic elements of aesthetic form influence subcultural communication systems. But radical subcultural signs are eventually converted into mass-produced objects through a process of labeling and redefinition by dominant groups. As the former radical symbols are converted into products, the media participate in the establishment of new sets of symbolic conventions. For example, appropriations of native aesthetic expressions are seen in regional tourist literature which features native dances or crafts as part of the allure of a particular region such as the Southwest, Plains, or Northwest Coast. The artificial presentation of a subculture happens in social practices such as tourism. One example of this special kind of ethnic relationship is found at the art colony of Taos, New Mexico (Rodriguez 1989). The portrayal of Taos by trained artists from the East emphasized natural beauty and a romanticized conception of Indians which was more commercially viable than a depiction of actual social conditions might have been. During the process of co-optation subcultural aesthetic processes are idealized and decontextualized. Rodriguez calls this process mystification, "defined broadly as a cultural process which perpetuates the social order by suffusing it with a shared sense of awesome, transcendent meaning" (Rodriguez 1989, 94).

The stylistic characteristics or breakthroughs which define a subculture are eventually integrated or mainstreamed into the dominant national culture and lose their persuasive power, whether through media, tourism, or other processes of social interaction. However, even in the process of transformation, cultures or subcultures may maintain stylistic consistency which makes sense to their own members. Appropriation does not necessarily hollow an aesthetic practice of meaning for the local community, though it may have this effect for some members. Instead of considering aesthetic practices solely from the perspective of formal development, the ideological implications of dominance and nondominance need to be analyzed. These questions of cultural power and authority have as much import for the relations between cultures as they do within cultures.

Aesthetics and ideology intersect in the representation of the other. In

contexts of intergroup relations a group's identifying characteristics, which promote affiliation within that group, may be used to label another group as other. The ethnologist Peter du Preez writes that this ideological tendency to reduce other groups to particular, stylized roles is a core element of political identification.

> Political ideologies often attempt to animate their agents as personae with finite and mechanical relations to one another. There is, from an ideological point of view, a well understood and predictable relation between collective identity-pairs such as Aryan/Jew; Catholic/Protestant (in Northern Ireland); white/black (in nationalist politics); Basque/Spaniard; or worker/capitalist. . . . Political issues crystallize in such oppositions and ideologies supply us with accounts of them, where an account takes the form of an idealized scenario. . . . Pamphlets, histories, novels, films, paintings and statues embody the vision. (du Preez 1980, 5)

A similar identity pair in the United States is that of white/Indian. This notion of otherness might not be problematic if it was not frequently accompanied by reductionist and, therefore, stereotyping tendencies in accounts based upon a mechanical, dualistic understanding of intergroup relations. This mechanical representation of other groups often emerges through aesthetic and media practices.

Representations of a culture by outsiders tend to be iconic and reductionistic. Both of these characteristics lend themselves to stereotyping. By iconic, I mean the images that will be chosen are those laden with emotional and value connotations beyond their physical appearance (as distinguished from the semiotic meaning attached to the term by Charles Sanders Peirce, the noted nineteenth- and early-twentieth-century philosopher credited with the development of semiotics and the founding of American pragmatism). They communicate beliefs and values related to the larger culture's attitudes about the subculture. By reductionistic, I mean those images that represent the essential or core elements of the outsider's perception of the subculture. These are images that tend to fix a certain meaning about the subculture in the minds of the audience. It is in this sense that the images' associations may be intertwined with a stereotypical representation of the culture. For example, toys, books, advertisements, and TV programs directed at children continue to reinforce existing stereotypes of American Indians (Hirschfelder 1982).

Within contexts of social conflict, this reduction of the other to stereotypical formulations may be strategic and very damaging. We tend to

denature or dehumanize collective symbols identified with the other. This process is familiar in war, where the enemy is either represented symbolically as an animal or simply as a strategic foe who is mostly dehumanized. The problem of the other is solved by objectifying it and thereby dehumanizing it. The other, with its relationship to our own inferior personality functions, is often simply too emotionally touchy to deal with directly. Instead, the image of the other is fixed so that it becomes more manageable. Through a process of projection, "fixing the image" of the other allows us to negotiate difficult parts of our own selves; "fixing the image of 'them' entails, in addition to the conscious agenda, negotiating with parts of 'us'"(Group for the Advancement of Psychiatry 1987, 126).

Some people may resist the discussion of aesthetics in a rhetorical context. Rhetoric is linked to persuasion and, therefore, propaganda for them, while art occupies a more elevated position. In his volume *Music as Propaganda* Arnold Perris (1985, 4) writes: "To link the beloved art of music with the devices of deception and with the presentation of controlled information that intentionally misleads is distasteful. Can this linkage be true?" In discussing music as propaganda, Perris uses a general definition of propaganda as the "spreading of ideas, information or rumor for the purpose of helping or injuring an institution, a cause or a person" (Perris 1985, 5).[5] In this definition, propaganda is understood as persuasive communication rather than merely as intentional "deception." Research traditions that consider persuasion, propaganda, or group identification in the arts need not reduce the study of aesthetic practices to their ideological functions. Not all group identification through aesthetic practices takes place in reductionistic ideological contexts. By reductionistic contexts, I am referring to those communication environments that reduce intergroup relations to dualistic "us/them" formulations. Aesthetic practices, even those that are persuasive, can contribute to a more integrated sense of identity because we recognize identity through a person's or group's overall style or continuity. Identification through aesthetic practices potentially leads to personal and group fragmentation or synthesis. Recognizing the synthesis of diverse elements involved in the actual construction of any person's or group's identity combats the dehumanizing reduction of identity often found in intergroup relations. To the extent that a group's members buy into an us/them distinction, they are open to manipulation by forces which perpetuate this framework.

Thus, aesthetic practices have both divisive and synthetic potentiality in intergroup relationships. The us and them polarization so common in intergroup contact tends to be self-perpetuating and to impede change: hostility and retaliation result from the rigid dualism of some ideologies. Though the historical reasons for opposition between groups cannot be ignored—they must be acknowledged and negotiated—fixed perceptions of the other never lead to cooperation between groups. We can hope that political and religious leaders will help groups overcome division, distrust, and fear, but history demonstrates that leaders often perpetuate divisions in order to solidify group loyalty. Understanding another culture's aesthetic practices and the context of these practices guards against the simple reductionism common in polarized group relations.

REPRESENTATION AND RECEPTION

A S I LOOK around my own home, I see artworks and reproductions representative of a number of indigenous cultures: Native American blankets, mass-produced goods that have "Navajo" patterns, prints and carvings by contemporary Native American artists, African carvings, a reproduction after an old Japanese print, and so on. The reception of indigenous arts and imitations of them is relevant for me personally; it is part of my everyday experience. Artists from Gauguin, Nolde, Newman, and Picasso to contemporary artists such as Lothar Baumgarten have found inspiration in indigenous cultures and causes. Many Westerners have purchased indigenous souvenirs and artworks when traveling, seen documentaries about art in non-Western cultures, decorated their houses and varied their wardrobes with so-called "ethnic" prints, or created art based upon a fascination with the "other." This chapter identifies some of the broader issues affecting the reception of indigenous art. I focus on overarching organizational frameworks, including nation, tribe, the Fourth World or First World, and even the microorganization "self," as in self-representation. Dynamic interorganizational relationships affect the reception of indigenous representation: colonialism and internal colonization, nation-building, and pan-tribal identification.

Gerald McMaster, writing in the foreword to *Indigena*, a catalog for an exhibit devoted to native perspectives in contemporary Canadian aboriginal art, states: "Thus, it is the intention of *Indigena* to present the widest range possible of art forms utilized today by Aboriginal peoples to show a broad *representation* of cultural ideas" (McMaster and Martin 1992, 16, my emphasis). The act of representation implies a community of receivers, and representation in this sense is a rhetorical act: an attempt to influence action or persuade viewers in some way. Non-natives are part of the community of receivers that contemporary native artists address in order to persuade, challenge, or move. Non-natives are part of the audience for this art, because the issues that native artists address are global in scope.

McMaster writes: "Many artists transcend local, Aboriginal-specific is- sues to address global concerns of human and ecological devastation" (McMaster and Martin 1992, 19). What are the assumptions that both natives and non-natives may bring to native art that both restrict and enable our understanding of this self-representation?

DEFINITION OF COMMUNITY AND SELF

To clearly understand indigenous art as representation, we must define, in some way, the community that the art represents. For varied reasons, modern native communities are less clearly definable in terms of *local* tribal, geographical, and spiritual affiliations than in the past. These reasons include the forced displacement of natives from traditional homelands, the urban migration of indigenous peoples for economic purposes, the participation of native peoples in foreign wars, the globalizing and nationalizing effects of electronic and print media, the forced and elected education of natives outside of the native community, and the influx of non-natives and their activities (spiritual, recreational, political, and so on) into areas that were once inhabited only by indigenous peoples. Thus, art that is representative in the political sense of the term may express the ideas of a global First World political movement as well as more locally defined communities. The First World is a global alignment of indigenous "nations" within those nation-states that resulted from the colonial period.

This emergence of a new alignment is both similar to and distinct from the emergence of the Third World alignment of developing nations in the 1950s, which has been discussed in such theoretical discourses as cinema studies under the rubric of Third Cinema.[1] Over the past seventy years Third World nations have sought increased political, economic, and cultural independence from their colonizers.[2] Indigenous aesthetics has been and continues as an important component of Third World representation.

For instance, in Mexico, the revolution resulted in the formation of a party, the PRI, that became the national government by the end of the 1920s. This relative stability allowed Mexicans to view themselves as a nation with a past, present, and future. Part of the shared sentiment of the time, and a key ingredient of Third and First World art today, was a hostility to imperialism—in Mexico's case, hostility toward the United States and Spain. In response to these developments, an explicitly public art

developed that was intended to define the nation's identity. In 1929 Diego Rivera painted the mural *The History of Mexico*, commissioned by the national government, at the National Palace in Mexico City. The mural is not a straight journalistic record of events; rather it records *reclaimed* history through readily identifiable symbols. The portrayal of the pre-Columbian world is in glowing, emotional, even nostalgic terms. Quetzalcoatl, the mythical white god-king who created culture, civilization, and learning, sits serenely among his subjects, a god of supreme confidence, knowledge, and authority. Rivera suspends criticism of this world of indigenous mythology and life. He resists judging the ancient Indian world by the standards of European Christianity, or showing the internal causes of this world's demise: its superstition, intertribal warfare, and economic competition. In Rivera's view, Mexico's problems result from the violation of Mexico from the outside or by local tyrants, and he idealizes the indigenous cultures of Mexico.

Early in the history of Third World politics and aesthetics Rivera makes use of the trope *indigenismo,* an idea that later motivated Chicano and Native American activists from the 1960s to the present. His use of this trope points to its power for creating collective identity and its inherent problem: relying upon an idealized, mythical past that may have never existed and may, in some cases, prevent native communities from addressing present realities. It is in this sense of referring to a mythic past that the trope of "indigenous" functions figuratively. Thus, one framework that non-natives bring to indigenous art is questioning whether indigenous representation is based in history, rhetoric, or some combination of the two. And thinking about indigenous representations of the past leads us to question the tropes non-natives use to represent the past.

Another framework that non-natives bring to indigenous artistic representation is postcolonialism. Frequently, art such as that found in the *Indigena* exhibit is understood according to a postcolonial framework that acknowledges the art transcends political boundaries inscribed during the colonialist period. The postcolonialist critique in art is geared, in part, toward breaking down national boundaries that divide people of common cultural heritage in an arbitrary manner. An important metaphor in this regard has been the border as a site of intervention; whole exhibits, installations, and anthologies have made it their goal to disrupt national borders inscribed during the colonialist period.[3]

How does this politically progressive view—that processes of native

self-representation take place in the context of postcolonial cultural pro-
duction—affect the capacity of non-natives to understand native self-
representation? The general postmodern critique of nationalism as a basis
of political organization directly confronts the importance attached to
sovereignty as a political goal by many contemporary natives. At the same
time that postmodernist theory employs a postcolonial critique of the
ideas of nation and borders, native communities are increasingly defining
themselves as sovereign nations or according to more limited notions of
sovereignty. Thus, even "progressive" views, such as those found in cul-
tural studies, may incorporate frameworks that limit our understanding of
native self-representation.

In the context of postcolonialist theory, an obvious distinction between
Fourth World and Third World movements is that Fourth World move-
ments are assertions of rights within and across the borders of existing
nation-states, whereas Third World countries are viewed internationally
as separate nations. First World movements may exist in Third World
nations, as is the case with the Chiapas uprising in Mexico. The ready as-
sumption that we have entered an era of postcolonialism—an assump-
tion that rises from the newly independent status of Third World nations
and the movement of people across national boundaries—seems more
dubious when ongoing processes of "internal colonization" are taken into
account (Churchill 1992). Internal colonization refers to the ideological
mechanisms, as well as political and economic structures, that keep in-
digenous peoples marginalized and powerless within national borders.
(We can even question the assumption that Third World nations exist in
an era of postcolonialism on the basis of economic ties between multi-
national corporations and Third World states.) *The question of indigenous
self-representation can only arise in the context of neocolonialism.* In a non-
colonial, or postcolonial, system artistic expressions of native cultures are
simply the expression of a local culture rather than indigenous political
representations. The idea of Third or First World always has to do with
the relationship of these to industrialized, colonizing cultures. Thus, the
concept of internal colonization challenges the assumption that we have
entered an era of postcolonialism, where power relations between former
colonizers and the colonized have equalized. Rather, inequities of power
persist but may be more difficult to recognize because unequal relation-
ships are not always formed along national boundaries.

Indigenous self-representation implies selfhood distinct from the in-

fluence of foreign nations; it also implies the authority to represent one's self to those nations. Indigenous self-representation primarily involves a shift in authority, implying that inherent in cross-cultural representations are the dynamics of power. Far from being an abstraction, useful only to social scientists, historians, and philosophers, changes in political dynamics, such as relationships of power, affect us at a personal level. Indigenous self-representation advances a concept of the self based in agency (as distinct from subjectivity or soul): The "macro" processes of cross-cultural representation require a political concept of self as "agent." The idea of indigenous self-representation relates in a fundamental way to identity formation and expression. It repositions the framework of reception for non-natives from considering indigenous peoples as apolitical selves, typically understood as "souls" connected in a polytheistic manner with nature, to understanding indigenous peoples as active political agents.

This transformation in the understanding of self, caused by the shift in authority for representation, is not without problems. In the Western context, the idea of person or self often becomes problematic "when used in contexts where questions of identity, social, moral, or legal rights, are at stake" (McCall 1990, 1). For example, the definitions of individual rights related to issues of abortion, the right to die, ethnicity and race (in the context of affirmative action), and gender all depend on an assumed understanding of person or selfhood that varies depending upon the position taken in the particular debate. The notion of indigenous art as self-representation leads us to question which idea of selfhood or community identity is being represented. Has this identity changed significantly from earlier collective representations? And how are the multiple identities expressed within native communities related to each other?

The very idea of "self-representation" as a personal and political concept challenges traditional notions of the self, where the self is thought of in terms of "subjectivity" or in the religious context of "soul." Western culture tends to separate the self into private and public dimensions, and this separation shows up in assumptions about art. Thinking about art as a form of representation that has political consequences goes counter to most peoples' assumptions about art. A recent survey found that the public favors depoliticized art or art that celebrates rather than criticizes public ideals, and these survey results served as inspiration for the blue, idealized composite landscapes created by the Russian artists Vitaly Komar and Alexander Melamid.[4] Most people reject or dislike what they perceive as

overtly political art. Therefore, it would be hard to say whether art intended as representation really represents the values of anybody but the artist who made it or the "art world." However, the "People's Choice" paintings of Komar and Melamid are themselves a kind of self-representation through popular taste. Thinking of art as indigenous self-representation calls into question Western assumptions about the ways that art represents collective identities. Do non-natives really accept this "representational" role for their own art, and, if so, under what conditions? One problem in understanding the role of art as representation is discovering the link between art, created by individuals, and its ability to represent organized groups such as "nation" or "tribe." Terms such as "self," "representation," "nation," and "tribe" are terms with evolving meanings that indicate changes in cross-cultural relations. In this process of evolution, the organizational concepts "nation" and "tribe" are growing more problematic as a basis for self-representation.

THE CHANGING ROLE OF NATION AND TRIBE IN INDIGENOUS REPRESENTATION

Should viewers understand native visual representation in the context of movements toward sovereign nationhood or as global expressions that transcend the limits of national boundaries? It seems that native communities desire greater political, cultural, and religious independence from nation-states, but are economically tied to the nations that "contain" them and, for the most part, implicitly realize this. In this sense, many Indian "nations" are advocating a limited model of sovereignty, similar to the most common contemporary model of nationhood worldwide, which combines political independence with economic interdependence. A harder distinction can also be drawn that limits the notion of sovereignty to instances of absolute political independence. This position rejects the idea of "limited sovereignty" as impossible by definition (Mulgan 1989). In this case, native "nations" would not be considered sovereign, because their interests and powers are contained to some degree by the interests and powers of the colonizer nations. But even for nations which consider themselves politically sovereign and are recognized as such internationally, there are several mitigating factors—environmental, economic, social, military—that make these nations interdependent. For both industrialized and First World nations, sovereignty exists on a con-

tinuum; the actuality of sovereignty does not match the ideal of absolute independence (and may never have). How, then, if at all, are organizational concepts such as nation and tribe helpful or problematic for understanding native aesthetic representation?

Before analyzing problems with the idea of nationhood, it is helpful to acknowledge nation-building as a legitimate social process that may be a viable goal for native artists and spokespeople. Among the legitimate aspects of the struggle for sovereignty is the basic motive of the struggle: liberation from oppression. The move toward sovereignty reflects real, not imagined, changes in the economic and political lives of oppressed indigenous peoples. Native nationalism grows out of the destabilization of particular colonial empires in North and South America, Africa, and Asia. Based upon recent history, where the move toward independence has occurred at different rates in different areas of the world, it could be argued that nationalism is a truer reflection of social life than global identities such as pan-Africanism or pan-Indianism, a point made by Frantz Fanon with respect to Third World nations' art more than forty years ago.

In a positive view of nation-building as a basis of artistic representation, art and culture grow organically from the experience of nationhood. The symbols of nation are not artificially created or imposed upon people in a propagandistic manner; they grow from the new social formation and express the spirit of liberation. The understanding of history changes with increased sovereignty. Nationhood leads to a reassessment of the past that rehumanizes the colonized and rejects the degrading portrait of indigenous peoples offered by their former colonizers. The new awareness of nationalism provides a sense of anchorage when identities are confused, an advantage that is not to be seen as a crutch for "weak" or "disadvantaged" indigenous peoples, but as satisfying a basic human need for affiliation. Collective identity is a significant part of the experience of all people: We are social animals by nature and desire community identity.

There are further advantages to the national experience. The status of nationhood allows indigenous peoples to function as community members at the international level. The nation buffers, counters, and undermines exploitation by neocolonialist powers in the areas of politics, culture, and economics. In some cases, achieving sovereign status may help bring political and economic authority to indigenous peoples. And the concept of nation is not tied to the interests of a single political party or "strongman" within a nation.[5] Nationhood may reflect an advance on

those tribal forms of social organization that are based upon the power of individual tribal chiefs. (Of course, not all tribes are organized in this manner.)

Nationhood is often expressed through the use of clearly ethnic (local or tribal) visual identity markers in art.[6] A resurgence of ethnic identity is usually evident in the art of emergent nations. This stage of ethnic resurgence sometimes involves invented traditions, the strategic employment of ethnic styles, as well as content tied to the spiritual world, nature, or formative myths that bonded the group together in the past. Additionally, ethnic resurgence may involve a conscious attempt to dispel ethnic stereotypes about the group. But the disadvantage of using ethnic identity markers is that they may lead to popular or derivative images that make ethnicity a marketable product. "Indianness" or "Africanicity" become less an organic expression of social relationships than a self-conscious idea abstracted for easy packaging and sale to an Indian and non-Indian public, each uncertain of its own identity.

Closely related to an art of ethnic resurgence is indigenous art that preserves tradition. This is the functional equivalent in indigenous art of a classical revival in Western art. For example, along the Northwest Coast carvers sought to identify traditional Kwakiutl and Haida aesthetics and techniques and reinvigorate an artistic tradition. The primary value of traditional art is that the art must establish continuity in the community; in this light, "not selling out" is important to traditionalists, because selling out would invite corrupting influences into the community. Souvenirs and other highly commercial forms, easily eviscerated of deep meaning for their producers, would be unlikely to sustain the cultural continuity that is the goal of the artists. The experience of nearly having lost the knowledge of ancestral art forms is one motivation for working within traditional styles. These ways of working depend on passing on information at a local level more than formal education outside the community. But as with "ethnic resurgence," the industrial world's interest in primitive, native, folk, or outsider art helps support this traditional art work. Non-natives may find in traditional work a sense of history and continuity missing in their own art and culture and collect it, in part, for these reasons. If traditionalists sell outside the community, and most do, their art depends upon the support of non-natives to succeed. Thus, the use of clear identity markers and traditional styles that sometimes accompanies the formation of sovereign, independent identities relates to the needs of

non-natives as well as natives. And this need rests on nostalgia for and glorification of a past that may feel inaccessible to many non-native viewers, except through indigenous arts. A complaint sometimes found in native communities is, why can't we just be left alone? Why do non-natives not fully explore their own past as a source of spiritual, aesthetic, or historical enrichment?[7] That non-natives are unwilling or unable to "leave natives alone" shows the cross-cultural, interdependent nature of indigenous representation.

CLAIMS AGAINST NATIONHOOD AS A BASIS OF AESTHETIC REPRESENTATION

It is this very interdependence that forms the backbone of the argument against nation-building as a basis of indigenous artistic representation. There are several claims against the legitimacy of nationhood as a basis of aesthetic representation. A first claim is that the best contemporary art responds to an international cosmopolitanism—both aesthetic and social in nature—that cannot be contained by the interests of any single nation or tribe. Allegiance to nation or tribe serves to prevent the fullest development of indigenous art as *art* in the general sense of the term, rather than as Haida or Hopi or, generically, Indian art. Another argument against nationhood is that most people in the world, including artists, are a product of mixed identities, whether ethnic, religious, educational, or economic in origin, rather than clearly identified with a particular group. For instance, the art of Joanne Cardinal-Schubert, who was included in the *Indigena* show of contemporary Canadian aboriginal art, reflects the influence of both her German and Piegan (Blackfoot) grandmothers; in addition, she has traveled extensively in Canada, Europe, and Japan (McMaster and Martin 1992, 130). Thus, an argument against nation and tribe as sources of indigenous representation is that they are not fluid enough to reflect the lives, heritage, and goals of contemporary native artists.

Nelson Graburn notes that "postmodernist" indigenous artists tend to break away from tribal affiliation and even the need to be perceived as Indian artists in a general sense (1993, 190–194). Among the artists that he mentions in this context are Carl Beam, Joanne Cardinal-Schubert, and Jane Ash Poitras, artists who were included in the *Indigena* exhibit. Many of the most politically inclined native artists may present their identity first as artists, and only later as tribal members. These artists may see the needs

of the tribe or nation, at least as expressed through traditional art, as dampening innovation in art.[8] Work by postmodern native artists is more autobiographical than tribal. The expression of personal identity by these artists often reflects the mixing of many traditions, indicating that artists may not identify with the unity of either "nation" or "tribe" any longer. For instance, the *Indigena* catalog entry on Carl Beam states, "He combines cross-cultural symbols to convey a universal message about the environment and the relationship between man, nature and the passage of time" (in McMaster and Martin 1992, 119). Postmodern native artists tend to take global stands against war, violence, pollution, and prejudice rather than national or tribal stands. Indigenous art in a postmodern context plays a part in the restructuring of world systems, where affiliations that cross national boundaries outweigh those that depend upon national or tribal identity. The breakdown of national boundaries acts as a metaphor for the assault on other boundaries formed by gender, class, ethnicity, and morality that characterizes postmodernity.

Contemporary work by indigenous artists tends to be process art, conceptual in its orientation. The viewer is not fixed in relation to the artwork, but can enter it from many angles. By contrast, the politics of both nationalism and tribalism often depend upon symbols or readily recognizable (traditional) visual styles. Postmodernists may hold little regard for those artists "clinging to ethnic styles," ultimately selling ethnic identity for personal gain. Ethnic markers may act as an artificially limiting way of representing the self (Graburn 1993, 193). Contemporary indigenous artists may feel that "ethnic" art, while outwardly Indian or African in approach, actually reflects acculturation to Western philosophies and values, because it fulfills non-native assumptions about the way native art "should" look. This very process of acculturation becomes a concern of the art. For instance, "Poitras's *Indian Blackboard* series of collages deals with acculturation and assimilation of Aboriginal peoples through education" (McMaster and Martin 1992, 165). While Jane Ash Poitras's work may appear to rely on traditional ethnic styles and symbols at first, it becomes clear on closer examination that these "identity markers" have been juxtaposed in ironic ways with non-indigenous forms of representation such as newspaper articles and photographs, history texts, and "blackboard" iconography. Traditional visual styles and symbols are used strategically as part of a larger collage to comment upon the cross-cultural process of acculturation.

Another challenge to the idea of both nation and tribe as a basis of self-representation in art is economic. Capitalism, especially in the form of multinational corporations, often destroys local economies and therefore works against indigenous nation-building in practical terms. The internationalization of business and culture affects the production and reception of indigenous art: indigenous peoples provide inexpensive labor (especially as craft workers); the land of indigenous peoples becomes a source of expoitable raw materials (which dislocates communities); the adaptation of Western models of production undermines traditional work and social relationships; and multinationals create international patterns of consumption through advertising and entertainment. Present-day nationalism, a side effect of nation-building, rests on a spectacle of "diversity" driven by the economic motives of the West. Safe blockbuster shows of the indigenous art of Mexico, Turkey, Indonesia, and India feed the economics of display that benefits the corporate sponsors of the shows.[9] In the context of cultural blockbusters nationalism functions as little more than a pseudoimage constructed to support the needs of international trade. In the theater of "display" indigenous peoples play a "self-orientalizing" role in which the most exotic and readily identifiable aspects of their cultures are encapsulated into neat vignettes suitable for global marketing.

An analysis of these types of indigenous artistic representation reveals typical patterns in the economic relations between countries where the show is mounted and the countries where it is being displayed. The two countries are linked closely through international trade; the Third World country owes a mountain of debt to the industrialized country; it provides cheap labor and raw materials for the more industrialized nation and usually is in the process of privatizing its state industries (Wallis 1991, 87). The relationship between the consumer of the image and the country being displayed is ripe for exploitation. Culture functions as part of the promotional material designed to attract capital to the developing nation rather than as an organic expression of collective identity. A further downfall of the politics of display is that it emphasizes the accomplishments of the "civilizations" of others as a source of national self-representation in contrast to the expressions of indigenous, small-scale societies. (This favoring of complex civilizations over small-scale societies may be another way in which the representation of Third World and First World nations differs.) Through economic pressures, indigenous art and culture become

part of a global marketplace; the economic system is in place to transform the reception of indigenous art as visual representation into its reception as touristic or commercial product.

In response to these economic, political, and cultural pressures at a national level, some artists have helped create a kind of pan-Indian political consciousness that transcends the boundaries of any single nation or tribe. Global movements such as Africanism/Negritude or the native First World alignment unify the concerns of their own communities and resist the nationalist interests of colonizers. The indigenous movement took form in the 1970s with the first meeting of the World Council of Indigenous Peoples in British Columbia in 1975. Since this meeting, others have taken place in Australia, South America, the United States, and New Zealand that have established the movement as almost global in scale. I use the term "almost" because the movement has directed its efforts toward people who are minorities in their own native lands and who perceive themselves as oppressed. For instance, indigenous European and African people are not part of the movement, because they are not minorities in their native land.[10]

But seeing artistic representation as "almost global" risks masking the ways that internationalization can function to acculturate indigenous artists. Many native artists working in a contemporary mode have art school training and degrees, most often from non-native institutions, that function as a stamp of approval from cosmopolitan non-Indian art worlds. Beam holds degrees from the Universities of Victoria and Alberta, Poitras from the University of Alberta and Columbia University, and Cardinal-Schubert from the Alberta College of Art as well as a certificate from the Banff Centre for the Fine Arts. The survival of these artists depends upon the mainstream art world's recognition and patronage. Each of these artists has exhibited widely: the Vancouver Art Gallery, National Gallery of Canada, Canadian Museum of Civilization, and Heard Museum are some of the venues where their work has been seen. Non-native art worlds and institutions may be their primary audience rather than native communities; if this is the case, the status of art by Native Americans as a form of indigenous self-representation is questionable.

Colonialism has resulted in a range of acculturation: through training and patronage the most radical of indigenous artists may ironically be the most acculturated. There is always a danger that if the colonized inherit and use the language of the colonizer, it will undermine the representative

function of their artwork. Is the work of contemporary indigenous artists tied to a global cultural critique found in contemporary academe and art worlds more than to the lives of native communities? Traditionalists within native communities may see this "postmodern" artwork as an emulation of non-native artwork that does not represent their own lives and view the artists who create the work as belonging to a class of intellectuals not "of" the people they purport to represent. I feel that it is possible to adopt the language and expressive forms of the colonizer and transform these into indigenous expression. However, these expressions are necessarily "indigenous" in a different, more politicized sense than traditional precontact forms of expression, because they reflect the acculturation of artists through educational, political, and economic processes.

Even though there are political arguments that support the legitimacy of the concept of nation for Third World and First World peoples, aesthetic self-representation in a nationalist political sense, such as Rivera's murals, is suspect for several reasons. Indigenous self-representation follows from and continues the destabilization of established national powers such as Great Britain, Italy, France, the United States, Canada, and Russia. We can think of this destabilization of national power systems as a challenge to the idea of "nation" itself: the power of "nation" and, therefore, "sovereignty" as concepts seems more limited in light of recent history. If one takes this tack, this destabilization of "nation" leads to the conclusion that representation must take place at more local, personal levels. The first step in redefining self is the fracturing of the old sense of identity based on national spheres of influence. (Many Euro-Americans may, of course, resist the attack on the concept of nation. The rhetoric of nationality, especially as the basis of international competition, still colors intercultural relations, but the most powerful cultural and economic developments in the world today transcend national boundaries.)

Other political realities argue against non-natives viewing sovereignty and nationhood as bases of indigenous self-representation. The concept of sovereign nation or independent tribe sometimes seems to require an essential unity that masks internal divisions and conflicts. Increasingly, national or tribal unity seems to be imposed by the government for political or economic purposes, rather than emerging from peoples' sense of their collective identity; in short, it reflects the needs of governments rather than of people. In European cultures, nationalism as an outgrowth of the nation-state and nation-building has an historical association with the

right wing and often results in racism, militarism, colonialism, and xenophobia, so the social consequences of nationalism can be very negative. In native communities, the rhetoric of nationalism/sovereignty can lead to division over issues such as taxation, community policing, tribal membership policies, and gambling. When the political goal of nationhood is transformed into the rhetoric of nationalism the result can be harmful for any community.

Not all of these claims for and against the sovereign nation and/or tribe as a basis of indigenous self-representation are weighted equally. Sovereignty as a genuine desire for liberation from oppression may outweigh the points I described in my discussion of claims against nationalism as a basis of aesthetic representation. But there are real complexities that arise from non-natives viewing national or tribal identification as the core basis of indigenous aesthetic representation. One is that art's role in collective representation at a national level may lead to a double code for art: one internal and either "national" or "tribal" in scope, the other international or cross-cultural. Though an argument can be made that all art is double-coded in this sense, another argument can be offered that what makes art "art" is its expression of universal concerns—how humans in general feel, think, care, love, believe—in contrast to purely local concerns. Thus, an art that expresses the needs, experiences, and beliefs of a particular community but touches a common chord will likely be the most successful representation of native independence.

Thinking of indigenous art as representation raises several issues for both the producer and receiver of these representations, issues that are important because indigenous aesthetic expression is part of the everyday lives of many natives and non-natives alike. Through crafts, mass-produced goods, souvenirs, documentaries, photographs, articles, fine art, and performances indigenous peoples represent themselves to "others." Non-native artists have made works inspired by the expressive traditions and processes of indigenous peoples. The question of how non-natives receive indigenous aesthetic representation is highly self-reflexive. It raises important questions about self-representation by "others" and about the role of art in Western cultures.

An important initial task is to define the community that the indigenous expression represents. This First World community is similar to and distinct from the Third World and shares its hostility to imperialism. Both the Third and First World alignments in their formative stages

have relied upon the trope of "indigenous," an idealistic evocation of a precolonial existence that suspends criticism of the problems of precontact cultures. The power of the indigenous trope is its usefulness for creating collective identity. But an inherent problem is the nostalgic reliance upon a mythical past inherent in the trope, leading some viewers to question whether indigenous representation is based in history, a romanticized evocation of the past, or a combination of the two.

First World alignments differ from earlier indigenous communities because they are less local and more global in orientation. They also differ from the postcolonial status of Third World nations because First World communities remain subject to "internal colonization." Indigenous representation exists in the context of neocolonialism. Indigenous peoples may attach an importance to sovereignty as a goal that seems out of place in a global climate where "nation" as a concept is frequently under attack.

An alternative to nationhood that non-natives bring to indigenous self-representation is that of "tribe," but this is also an abstraction that has its limitations for self-representation. "Tribal" representations often rely on clearly ethnic visual identity markers that may lead to derivative, easily marketable images. In this light, traditionalists attempt to guard against market influences; nevertheless, non-natives collect much "traditional" work, and the cultural continuity hoped for by traditionalists is affected by systems of patronage.

Modernist and postmodernist indigenous artists may attempt to break away from tribal affiliations and the label of "Indian" artist. Some indigenous artists do not identify with the unity of nation or tribe any longer, and, therefore, they produce artwork that is more open and processual and less conventionally symbolic. One way non-natives may understand this nonaffiliated indigenous representation is through the concept of self-representation. The concept of self that emerges in self-representation is one of agency, in which native artists play active political roles, a concept that strongly contrasts with traditional non-native views of indigenous peoples as Noble Savages who somehow exist without political structures. In part, this new understanding of native selves rests on a shift in the authority for representation, which, in turn, rests upon underlying changes in power relationships between native and non-native peoples. However, transformation in the understanding of self is not without problems. The very idea of "self-representation" as *both* public and private challenges traditional notions of the self found in Western thought. And if the non-

native art world comprises the primary audience and source of training
for independent native artists, rather than native communities themselves, the status of art by Native Americans as a form of indigenous self-representation is questionable. Despite the dislocation that often accompanies modern and postmodern art, ethnic style seems to be part of a labeling process that contemporary indigenous artists hope to avoid.

Within contemporary indigenous aesthetics it is seen as a sign of success to not be "labeled" from without as an ethnic artist. The development of ethnic style is in part market driven; ethnic style serves the needs of capitalism by acting as officially recognizable marks of authenticity, easily assimilated into the economics of display. Much of non-Indian society needs the nostalgic references to the past as a way of insuring the value of goods as "native-produced." For the same economic reasons, some "co-opted" native producers may try to control and manipulate the ethnic style of goods. Avoiding the label "ethnic artist" therefore undermines the commercial relationships that sustain neocolonialism.

It is logical, then, that some contemporary artists attempt to work outside of this dynamic. How does that affect the ability of their art to act as indigenous representation? The loss of specific identity markers need not undermine their artworks' representative value. Simply put, the artworks of contemporary artists will function as indigenous representations if the artists themselves are part of indigenous communities; if their work is primarily defined by and for non-native communities, it will not act as indigenous representation. But this formulation may be too facile. Another problem is that whole communities will become so assimilated that their values and style of life are the same as those of the surrounding national culture. In this scenario, the "indigenous" will have disappeared from indigenous aesthetics, but, in my view, this has not occurred. Indigenous representation rests upon social ties and a profound sense of place more than any particular medium, style, or subject matter. Non-native views of such fundamental organizing frameworks as tribe, nation, representation, and selfhood will continue to be challenged through a sustained engagement with indigenous art.

While this chapter has addressed organizing frameworks in indigenous aesthetics such as "nation" and "tribe," an even more fundamental term needs to be addressed. The preceding discussion seems to assume that what members of contemporary indigenous cultures produce and document is "art," but is it? Using the term "art" to describe native expression

IS THERE "ART"
IN INDIGENOUS AESTHETICS?

AVING TAKEN a course in aesthetic anthropology as a student, I have often since wondered about the appropriateness of applying the concept "art" to the expression of many indigenous cultures. Within this subdiscipline, aesthetics refers to aspects of daily life, from habits of greeting to food preparation, the communal organization of space, and religious rituals that are much broader than the term "art" can encompass.[1] It would be very difficult to separate art from craft, religious ritual, material culture, or entertainment in these contexts; therefore, art as a distinct concept seems to be inapplicable to many non-Western cultures. Later, in researching Native American media, art, and aesthetics, I was often told anecdotally that there is no term for art in native languages, which would again seem to suggest that indigenous aesthetics refers to expression that is not "artistic" in nature. Is there "art" in indigenous aesthetics?

If nothing else, the absence of the *term* "art" in indigenous aesthetics helps explain the qualitatively different experience of the aesthetic in indigenous and Western cultures. Where contemporary art in the West invites us to theorize to understand its role and complexities, traditional indigenous arts involve embodied, and often religious, experience. A state of immediacy and immersion, an experience of oneness between the audience and the artwork, seems present in much indigenous expression. This relationship is much different than the formal instruction and detached reflection associated with twentieth-century Western art and theory. Aesthetic experience in indigenous and Western cultures is so different that scholars and students may conclude that many traditional indigenous cultures do not have art in a modern sense, because they do not have an established language for theorizing, criticizing, describing, or even naming art.[2] Thus, thinking of native expressive work as art may be a projection of a Western framework onto indigenous expression.[3]

45

A chapter that reflexively considers the Euro-American reception of indigenous "arts" can also evaluate the Western attempt at defining "art." Early on, indigenous thinkers noted the process of attempting to define art as a trait peculiar to Europeans that seemed to go against the nature of art itself. In "What Is Art?" the great poet-philosopher of early-twentieth-century India, Rabindranath Tagore, worried that "To know is to kill our object of research and to make it a museum specimen" (1961 [1916], 12). He added that Western ideas about how to interpret and criticize art have influenced scholars and artists in India, specifically Western assumptions about art's universality, its social usefulness, its role in philosophical speculation, or its expression of a particular culture or people (1961 [1916], 13). For Tagore, this is judging art by that which is not inherent to it; he felt that if these social and theoretical responses to art became primary, then the "excellence of the river is going to be judged by the point of view of a canal" (1961 [1916], 13). He even questioned the value of trying to establish a definition for art because the "definition of a thing which has a life growth is really limiting one's own vision in order to be able to see clearly. And clearness is not necessarily the only, or the most important, aspect of a truth" (1961 [1916], 13). Despite these critiques of Western attempts at defining and theorizing about art, Tagore presented his own ideas about art based upon the classical Indian theory of *rasa*, which holds that "The principal creative forces, which transmute things into our living structure, are emotional forces" (1961 [1916], 17). We can see, then, that there are non-Western traditions that attempt to account for aesthetic experience, but even members of these cultures with traditions of talking about art associate the attempt to *define* art primarily with the West. Is the problem of finding "art" in indigenous aesthetics simply that Westerners have been the only ones to attempt to define art, and from this perspective, even if others have not defined art, do they not nevertheless have it? In this chapter I hope to demonstrate that the problem of finding art in indigenous aesthetics arises not from the absence of "art" in indigenous cultures, but from the narrowness of contemporary Western definitions of art. If one impoverishes the idea of art, of course it will be difficult to find art outside of one's own culture.

In their focus on the principality—and implied universality—of emotion in art, Tagore's ideas were remarkably similar to the thought of his

contemporaries in the West such as Clive Bell, Henri Bergson, and Wassily Kandinsky, who had shifted the focus of aesthetics to feeling rather than representation (*mimesis*) or taste by the early twentieth century. Where Tagore advocates an inner principle based upon *rasa*, Kandinsky makes use of the idea of inner emotion in *Concerning the Spiritual in Art* (1972 [1912]). Kandinsky's theory is similar to Tagore's in its metaphysical orientation and focus on "feeling" as the source of what is meaningful in art.[4] The difference, however, between Tagore and the Western thinkers was that Tagore based his aesthetics upon an ancient religious tradition, Hinduism,[5] while his contemporaries in the West were trying to discover an emotional necessity for art distinct from any religious tradition. The universalism of Tagore's ideas about art derived from religious belief (and ethics), whereas the universalism of early-twentieth-century Western aesthetics eventually led to principles of the unity of art that were not based in religion, but in science and theory.[6] As artists and theorists became more exacting in their attempts at definition, they tied these impersonal principles of art to the formal properties of art and the nature of media rather than to metaphysical principles. Though critics note modernism's tendency to universal definitions, the basis of this tendency fluctuated over the course of the twentieth century (from a search for metaphysical principles to a search for "scientific," then formal, principles). Moreover, any attempt at talking about art in the broad sense, including Tagore's, usually has a universalist quality to it because the definition is of an activity (aesthetic expression) that is found in all cultures. Should, then, the universalizing tendencies of modernist art theory be accepted? Recent scholars, especially those in anthropological aesthetics, have resisted overarching theories of art because there are cases in which our own assumptions block our understanding of other cultures' ideas about art. We seem, then, to be on the horns of a dilemma: aesthetics lends itself to broad statements that have cross-cultural import, whether in the West or elsewhere, but the assumptions that help form those statements may prevent us from seeing exceptions to the statements.

The possible counterresponses to "universalizing" definitions are: (1) not to attempt to define art at all, (2) to define art variably for each culture or period (even, as my students often argue, for each individual), or (3) to compare ideas about art found in different cultures or periods and be aware of commonalties that may emerge. (1) is unsatisfactory because we have all had aesthetic experiences of some kind; (2) is a variable, rela-

tivist definition of art that seems more in line with the pluralism of "post-modernist" aesthetics, but it is unsatisfactory because it cannot account for the collective nature of aesthetic experience, especially the fact that we can respond in some manner to the art of geographically and temporally distant cultures. Therefore, (3) seems to make the most sense because it acknowledges cultural differences in attitudes about art, but also allows for commonalties that may emerge.

The danger of modernism, then, was not in its search for universals but in its failure as a method to understand indigenous non-Western ideas about art. By beginning with an idea about art that privileged either emotion, spirituality, formal principles, or organic unity before conducting a cross-cultural investigation, the danger was that pre-formed notions would create the mold into which all "art" would be cast. Modernist art theory never really sought out indigenous ideas about art as much as it appropriated non-Western artworks; therefore it could not accurately translate those ideas by discovering corresponding ideas within Western culture. Rather, it projected descriptive and evaluative terms onto "primitive" art.[7] The failure of modernism's method leads to the critique that the viewing of historical indigenous objects as "art" by Westerners does not reflect the perception of the indigenous people who made the art. I set "art" off in quotation marks at this point because I am referring to the aspects of the received notion of "art" that seem most inadequate in describing indigenous art. In other words, the idea of art has a social history in the West, as elsewhere. For contemporary Westerners art has several attributes: it remains relatively autonomous (not tied to physical, religious, political, legal, or other social goals), special, unique, nonutilitarian, ego-identified, self-validating, innovative, "without rules," and so on. In contemporary Western culture we associate art with its commodity status and exhibition value (its value as established through sale or exhibition); art is usually made by an "artist" (someone with special training and/or talent or psychological properties who has been recognized as an artist); art is relatively permanent (it and the values that it expresses last over time); and art is not dependent on collectively held religious beliefs for meaning. There have been radical reactions against each of these assumptions in the last few decades, but they remain largely in place. For instance, conceptual art—supposedly a noncommodified, impermanent form of expression— is now for sale and made permanent through its documentation, and is regularly exhibited within the museum-gallery system. Most importantly,

a popular assumption about much contemporary art in the West is that it is not tied to shared belief systems, consisting instead of private languages, actions, or ceremonies that have their basis in the personal, psychological experience of the individual artist. Recent theory, of course, argues for the institutional character of art in all cultures, but one of the West's institutionalized beliefs is in the "freedom" or "individuality" of the artist.

These attributes that I have briefly outlined run counter to most indigenous aesthetic systems. That is why "art," if we define it according to the above attributes, is an inappropriate term for describing indigenous expression. Natives often believe there are social rules for art that they should follow and guard, including rules of content, context, form, and personnel; that art should be community-oriented; that art is an expression of the sacred; and that art is useful, beautiful, and functional (for many native cultures beauty is a result of functionality; art is beautiful because it "works" at some fundamental level). The artist is not above or separate from society (not different, eccentric, or professional); there is little social pressure toward innovation for its own sake; and art is understood in the context of religious, communal, and personal narratives, and through its utilitarian functions (Rose 1992, 412). As with the attributes of Western art listed in the preceding paragraph, we can challenge the appropriateness of these attributes of art in indigenous aesthetics, especially as indigenous peoples become more assimilated into Western social and economic systems. But this brief sketch does outline common assumptions about the different views of art in indigenous and Western cultures.

There are several possible responses to the strong contrast between indigenous and Western understandings of "art" that I have broadly outlined. One is to say that, because indigenous cultures do not have a term for art and do not usually perceive art according to the attributes that are common in the contemporary West, they do not have art. Rather, they have expressive traditions related to ritual, ceremonial, and other functional contexts. We might call these ritual objects or actions, rather than art. A second choice is to say that some native cultures have art but only in a weak sense; that is, because we can recognize aesthetic properties in some of their ritual or daily objects, they function as art for "us," if not for "them," and can, therefore, be considered art in a weaker sense. A third choice is to broaden Western ideas about art so that we include aspects of indigenous aesthetics in our understanding of art. The first and second choices are easier because they maintain current understandings of art in

the West; that is, they are reflexive only in that they clarify for ourselves our own understanding of art but do not really challenge that understanding. The third choice is more truly reflexive, because it forces us to rethink our own understanding of art. In effect, Gene Blocker, in *The Aesthetics of Primitive Art,* hedges against this choice when he states that "redefining our concepts in line with what we know to be the attitudes and beliefs of the people we are describing . . . can only add to the existing confusion. Since these words of ours (e.g., 'art') already have well-established meanings, using them in new ways will only create new confusions" (Blocker 1994, 131).

A counterposition is to see art as constantly redefined. Its meaning may not be as well-established as Blocker states. If we follow the argument of Morris Weitz, the function of aesthetic theory is not to create a relatively fixed idea of art, but to present various, and often competing, understandings of art that point out the most salient features of particular forms of expression (Weitz 1984 [1956]). But this third choice—broadening our notion and experience of art—is dangerous if it is only carried out in a partial manner. For instance, when we recognize indigenous art as "art" for aesthetic reasons but co-opt that "art" for social and economic reasons, negative consequences occur. While the third choice sounds hopeful, indigenous and Western assumptions about "art" often conflict in practical terms. Only a small shift in our assumptions, such as simply recognizing their expression as "art," can be very problematic for indigenous peoples.

We know that "art" is a problematic term because when the idea is first introduced to native cultures, it leads to the dying out or changing in function and form of ritual and ceremonial art. In Eskimo mask making this occurred around 1900 when whites inundated the area of western Alaska during the Gold Rush era. After contact with the West, Eskimos stopped carving masks for ceremonial purposes (with eyeholes for the spirit to enter and animate the mask) and began carving them without eyeholes for tourist decor, souvenirs, or curio items, a trade that had already been established with carved ivory. Early missionaries pressured the Eskimos to stop carving the masks for their religious ceremonies because they felt that these ceremonies were in conflict with Christianity (*Eyes of the Spirit* 1984). Thus, traders, collectors, and carvers rapidly transformed a traditional ceremonial art into a commercial art based upon the needs of the

Western economy and Christian beliefs which combined to hollow the masks of their original meanings.

Similarly, the Navajo do not intend sandpainting, in its traditional ceremonial form, to be for sale or exhibit. Definitely not autonomous, it depends on a specific ritual or performative context for its meaning. A shaman or holy man performs the ritual, not an artist. It has a purpose or function that is performative (participants believe the ceremony to affect the health of the person for whom it is performed); is impermanent (the painting is destroyed immediately after its ritual use); is dependent on collectively held beliefs for meaning; and compels religious belief in a sacred dimension. However, now sandpaintings are made for sale to tourists and collectors, a shift in context that undermines each of the preceding qualities.

MODERNISM AND UNIVERSALISM

The universalist assumptions of modernism—that universal formal principles of art account for the attraction of, say, African sculpture or Northwest Coast Indian masks for non-native viewers—exist in contradiction to the actual economic conditions of production and reception that marked the time of the development of these universalist assumptions. At the same time that early modernist theories of art were formed, the transformation of indigenous art by economic, religious, and political forces was well under way. Canadian native artist Loretta Todd writes that "Modernism has its origins in a culture based on exclusion and hierarchy," consistent with the intensifying colonialist expansion of European nations in the early twentieth century (Todd 1992, 73). Early modernism occurred immediately following the United States's conquering of Indian lands and parts of Mexico and the Caribbean. The Germans, English, French, Dutch, Spanish, and Italians were all continuing their struggle for power and resources on a global scale. Social Darwinism is one example of a theory, popular at the turn of the century, that attempted to account for power and its use. Progress was assumed to result from an aggressive interplay of natural forces; it was seen as a kind of practical necessity at the time that nations conquer less powerful peoples. The idea of a struggle for survival played into the competitive fervor of the time, a period when assumptions of cultural evolution and survival of the fittest held sway. Thus, universal-

ist assumptions about art were formed and acted upon in the context of competitiveness and power, two elements of intercultural relations that continue to affect cross-cultural responses to art.

As the Native American poet and anthropologist Wendy Rose has argued, supposedly universal theories of art are Euro-American derived, and a great deal of this Eurocentrism lives in universities (Rose 1992, 407). High theory becomes a normative expression of the intellect: the theoretical "big picture." In this context the intellectual lives of other cultures are seen as "appendages" or as areas of esoteric specialization, but not as a source of "universal" ideas (Rose 1992, 407). For instance, it is still very rare to see an article about non-Western theories of art in *The Journal of Aesthetics and Art Criticism*. Recent anthologies of aesthetics and art criticism largely fail to include entries by writers outside Europe and America or articles about topics related to non-Western art and aesthetics. Thus, universality is produced through conformity to sets of academic "standards"—of academic quality, method, form, subject matter, theoretical orientation—and affiliations that are, of course, Euro-American in origin. In contrast to the "big picture" offered within the Western humanities and sciences, other cultures are inherently defined as partial: incomplete because their intellectual traditions supposedly do not or cannot conform to these "standards." In framing the ideas of other cultures as partial, Euro-American academic thought becomes a way of framing, controlling, occupying, and consuming other cultures (Rose 1992, 407) in a manner similar to the colonialist economic and political relationships that have guided intercultural contact over the last several centuries.

In his book, Gene Blocker attempts to defuse this position—that "insisting upon using *our* concepts in describing alien cultures amounts to a form of intellectual imperialism"—when he writes:

> The fact that the concept must be *our* concept implies no imperialistic superiority whatever, but springs simply and only from the fact that *we* are speakers. If *they* are speaking about *us*, exactly the same principle applies. It is the purely logical and conceptual point that when speaker A attributes some description to an alien group B, it is A's concept which determines the meaning of that description, *whoever* A is. (Blocker 1994, 135)

Blocker is correct in a logical and semiotic sense, but this statement risks rationalizing or even denying the historical social relationships that have formed and continue to form our response to indigenous arts. In a later

passage, Blocker notes that any cross-cultural description involves an implied comparison between *our* culture and *theirs* that often includes an evaluative dimension. Blocker proceeds to try to account for "bias" in the description of other cultures of both the "positive" and "negative" variety, but Rose is concerned with a more fundamental issue: the way that institutional frameworks in the West create a politics of the production of knowledge in which Western thought acts as the normative center.

An example of a universalizing tendency that I myself have relied upon in the discussion of style in Western art is the dialectic of Dionysian/Apollonian or Romantic/Classical.[8] Briefly, the source of the Dionysian is the ritual and celebration of early cultures that were close to nature and its rhythms. The revelry associated with spring; the rhythmic force of primitive hymns; the rapture and suffering associated with a mystical awareness of nature are expressions of the Dionysian. Art expresses this spirit visually through layered, interconnected, twisting, gestural, and labyrinthine forms. By contrast, the Apollonian is expressed through balanced, measured, proportionate forms that express the knowledge of self and the abstract, discoverable principles that guide nature valued highly in a classical worldview. Though this is a powerful comparative framework, the Dionysian and Apollonian may not constitute universal and fundamental dimensions of aesthetic experience as Nietzsche suggested more than a hundred years ago.[9] The evidence for a dialectic of the Apollonian and Dionysian in Western art seems clear. We can identify specific styles in art with each impulse, and these styles seem to vary in a pendulum-like manner throughout Western history, at least until the nineteenth century.

What is less clear is how well this model applies to the art of other, non-Western cultures. Ruth Benedict's classic application of the contrasting attitudes to Native American cultures can be criticized for imposing a European framework on indigenous cultures (Benedict 1989 [1934]). More recently, an American art historian, Jackson Rushing, discussed Barnett Newman's response to Northwest Coast Indian art in the context of the Apollonian/Dionysian duality (Rushing 1988). Rushing refers to Jung and Nietzsche as incorporating a paradigm of duality—directed (Apollonian) and fantasy (Dionysian) thinking—that forms the basis of Newman's attraction to the primitive art of the Northwest. But Rushing's article does not critique the use of a Nietzschean model by Newman; it attempts only to demonstrate the source of his response to the "primitive." A great deal more research will need to be done to discover whether such dialectical

relationships as the Apollonian/Dionysian exist in non-Western art and aesthetics or are unique to the West. What is clear is how tempting it is to view the art and ideas of other cultures through this lens, simply because it is available and familiar.

Aesthetic universalism in the West is found in the formalist and stylistic assumptions of early modernism and in broader theories of artistic development such as the Apollonian/Dionysian contrast that allow us to consider indigenous arts as "art." How does this projected universalism affect the ability of art to "stand for" *local,* indigenous beliefs and attitudes? At a basic level, it would seem that the universal inevitably contradicts the local. Traditionally, indigenous art expresses a strong "sense of place." For instance, Navajo art is a part of ceremonies designed to create balance in nature. The relationship between the Navajo and the gods that they believe balance nature is governed by complex regulations. Any transgression against the natural/spiritual world must be appeased or rectified through a prescribed ceremony. Many other elements of Navajo life are ritualized in a way that reflects a profound sense of place and balance: the planting of corn is ritualized, a farmer walks through his field in a prescribed manner. Paintings of Navajo life and the weavings produced by Navajo women reveal ties between weavings and the animals and land that produced the wool. Like farming and the ceremonies associated with it, weaving is one expression of the close integration of the Navajo with the land, because the source and processing of materials are intensely local. By contrast, the materials of Western art are manufactured or, in cases such as found object art, byproducts of a manufacturing process. An American artist may use paints manufactured in England; a camera manufactured in Korea; or steel from a mill across the country. The processes of art media are much less local in contemporary Western art practice. If we base our understanding of indigenous aesthetics on the media of art, the introduction of Western materials, such as manufactured dyes into Navajo weaving, weakens the localized nature of indigenous expression. However, the expression of "sense of place" can occur through non-indigenous media, as in the use of photographic and video technologies by recent native artists. Thus, the "sense of place" in indigenous art arises from the belief system that creates a sense of responsibility for land and community and is not dependent on the particular medium of expression. Cross-cultural developments in art media need not necessarily contradict the local. However, Western fashions in *ideas* about art may undermine the aesthetic

function of indigenous arts more than the introduction of any particular
new medium.

INTELLECTUAL FASHIONS AND "ART"

Western philosophy of art contains subconcepts that allow us to recognize the affinity of art in other cultures with art in the West. But changes in the intellectual fashions of Western culture may make it difficult to view "their" expression as art. While Blocker argues that we can never replace our concept of art with an indigenous understanding, he states, "What we can and should recognize, however, are subconcepts within our own concepts, along with the possibility that the group we are investigating may have a greater affinity for a different subconcept than the subconcept which defines our current interests" (1994, 133). I agree with this statement, but feel that the "conceptual" orientation of the language in which it is stated risks overlooking the psychological tension implied by the last clause. If we think of subconcepts in the terms of cognitive psychology as psychological constructs that may come into conflict, and, therefore, create psychological tension, it becomes clear that understanding the art of another culture is not simply a matter of matching it with our own relevant subconcept of art. It may mean forcing ourselves to rethink primary values that were once attached to art in Western cultures but which have now been rejected or ignored, thereby creating cognitive dissonance as incompatible constructs are weighed against each other.

Since the Enlightenment, Western thought has embraced a materialistic, mechanistic attitude toward nature and life that has often been experienced within Western cultures as antireligious.[10] Materialism (as contrasted with theological or metaphysical explanations) emphasizes the empirical observation of matter and physical forces in the world. Scholars have attempted to explain events, actions, and even thought in materialistic terms. The debate about metaphysical and materialistic explanations of reality in the West actually predates the Enlightenment to Plato's debate with Heraclitus. However, it was in the Enlightenment, a period of expansion in scientific explanation, that materialist, mechanical forms of explanation gained significant ground over metaphysical and theological forms of explanation. More recently, the emphasis on social and economic relations as an explanatory framework (how physical reality is organized and controlled socially) has gained ground through Marxism, an explana-

tion that extends materialism from the physical to the social and economic. Proof that many academic theories are materialist is found in our dependence on measurement as a form of evidence to support theories; there has to be some "thing" in order to measure it. Often, science and art seem to require fundamentally different attitudes: in science, you must suspend belief; in art, sometimes you must suspend your disbelief. In contrast to materialism are the religious explanations that provide the basis of art in non-Western cultures.

Many indigenous cultures did not identify their traditional works as "art"; rather they were understood in the context of religion or community and personal narratives that emphasized a spiritual explanation of life. The idea of the "sacred" that exists in, say, Navajo sandpainting or Eskimo masks, may be so different from a Western worldview that our ideas about "art," discussed earlier, only confuse us when understanding these expressive forms. Westerners may not be able to understand the sacred, often mystical view of the world expressed in indigenous art and ritual when we have been taught to view the world through a materialistic, mechanistic, rationalistic lens. One result of this worldview is that thinkers in the West have sought to draw ever finer distinctions between different aspects of experience. Especially since Kant, aesthetics has been afforded its own place in philosophical systems, distinct from logic, ethics, metaphysics, and so forth. While this has helped us define and understand issues unique to art, it has also tended to downplay the importance of the connections between art and religion, ethics, or social life in general, connections that are paramount in most indigenous aesthetic systems.

It is tempting to think about the relationship between art and the sacred in indigenous aesthetic representation as "New Age," as part of a desperate search for meaning motivated by the sense of unease brought on by the complexities and rapid cultural change of modern life. Some recent native artists even reject the "nature-spiritual" dimension of indigenous aesthetics, seeing it as a product of non-natives' fervent search for meaning more than an integral part of indigenous cultures.[11] However, speaking comparatively, I would hypothesize that the primary and original function of art in every culture is religious in some sense of the term. Rather than being New Age, the connection between religion and art is ancient. Religion is the source of ideas about the *efficacy* of art and art's *collective* meaning or function in most, if not all, indigenous cultures. Most aesthetic theory in the West, and I include Kant as well as Plato, Plotinus, Tolstoy, Aquinas,

Augustine, and others, has been spiritual or religious in character. Even in this century, many Western artists from Kandinsky and Mondrian to Newman and Rothko have talked about their art in spiritual, though non-religious, terms.[12] Art itself in the West was primarily religious until the mid-to-late nineteenth century. Thus, we have a subconcept, sacred art, that helps us grasp the meaning and function of art in many non-Western cultures. But, for cultural reasons in the West, this is a concept that is largely out of favor. Few artists would describe their work as sacred, though some might allow for an ill-defined "spirituality" as an ingredient of their art.

A recent search of the subject terms "art" and "religion" at my university library turned up many entries, but most of them referred to art outside of the West. Has religion become a term that scholars apply to the beliefs and expression of others and spirituality a term that they apply to the West (albeit infrequently)? Religion seems to permeate the discussion of the art of others but apparently has no place in the discussion of contemporary Western art. The divorce between religion and art is more complete than the divorce between art and beauty in the twentieth century. A relationship between spirituality and art is not part of the art curriculum, except in historical terms. In lecture halls, historical paintings of Christ, the Madonna, and Saints inadvertently serve as something for students to react against, rather than to make part of their lives. More frequently, art and politics or art and society are the focus of discussion today. Thus, religion, when it is referred to in art education and scholarship, is seen primarily as a social phenomenon (in a Durkheimian manner) rather than as a spiritual phenomenon. One contemporary artist, Francesco Clemente, sometimes mentioned in the context of art and religion, draws his themes from the banks of the Benares in Varanasi, a city he has lived in from time to time, not from any religious tradition alive in the West. And Clemente is an exception, in that critics see a link between his art and any religious tradition at all.

However, in global and historical terms it is the developed, industrialized West that is an exception by not viewing art as an expression of the sacred. The comparative study of art as it has been conceptualized and experienced throughout much of world history requires us to come to terms with indigenous concepts related to Western ideas of spirit, soul, sacred, ritual, morality, Nature (in the spiritual use of the term) that motivate much non-Western and historically Western art.

An example of how a mechanistic, materialistic, rationalistic worldview makes it difficult to understand indigenous aesthetics is art's role in transformation. Frequently, indigenous arts involve performance or participation designed to produce a transformative experience for either the artist or the viewer. This transformation may be from a human to an "animal," or from a conscious to a trance state. While the scientist or historian may be able to provide a material or rational explanation for some aspects of the transformative experience, this risks overlooking the value that the experience serves for the participants themselves. (Even if you do not agree with the possibility of transformation, it is worthwhile to consider the widespread belief in supernatural transformation in many cultures, including Christianity. What human needs does this belief serve; what is lost when it is missing, if anything?) Is it possible that art's transformative power in these contexts ties it to spiritual realities not accounted for by scientific explanation? How do these different belief systems "work"— through means such as transformative art—in ways that have profound meaning for members of indigenous cultures, but which we cannot grasp through Western theories of art? Again, Western cultures contain a concept, transformation, that allows us to understand this function within the art of other cultures, but current social attitudes downplay this concept in Western cultures, making it hard to accept in others.

"ETHNIC" ARTS

Another Western attitude about art that undermines our understanding of indigenous expression as art is the tendency to see "ethnic arts" as an appendage to "mainstream" (read Euro-American) developments in art. How does the marginalization of indigenous expression as "ethnic art" affect the ability of non-natives to accept that expression as art? Does the term "ethnic" imply a value judgment or is it merely descriptive? An earlier meaning for ethnic was heathen or pagan, and this sense of marginalization carries over into views of ethnic art. Why do whites not often refer to themselves or their expressive culture as ethnic, even in educational settings? It is apparent from this selective usage of the term that "ethnic" functions for purposes of labeling and exclusion. If it was used for the purpose of inclusion, whites would refer to their own styles as ethnic. The use of "ethnic" for the purpose of labeling is even more obvious in the area of applied aesthetics. If you go to buy an ethnic pattern in a fabric store, the

pattern would be the one that is intentionally exotic. What's more, the pattern would probably be produced by a white designer according to his or her perception of what constitutes this ethnic design tradition. Thus, to the degree that indigenous art is seen as ethnic, it is viewed as outside of the mainstream of Euro-American stylistic developments, but produced and marketed in a system that maintains Euro-American values. And ethnic design is easily controlled in a commodity marketplace according to pre-formed concepts about how it should appear. It is impossible for indigenous aesthetics to explain indigenous "art" in this context of reception, because its meaning is controlled from without.

Related to ethnic art in its limiting nature is "ethnic style." Again, the problem here is not that ethnic styles exist, but that their reception is controlled according to specific Euro-American understandings of style that emphasize influence as a basis for explaining style change. This model of influence leaves little room for a situation where the aim is not to modify a style but to maintain it as it is. In other words, Western views of style privilege change as a positive or at least "natural" value and downplay consistency as an element of style; the influence model of style foregrounds contact and change over the stylistic status quo (Pasztory 1989). In daily practice Westerners tend to blend, and possibly collapse, stylistic differences, whereas indigenous cultures have often worked hard to maintain them. In this sense, modernism, with its high valuation of change and formal innovation, undermines the conventionality and consistency of much indigenous expression. Another possible drawback of the European concept of influence as a basis of style change is that it results from an evolutionary paradigm, where art is treated in terms similar to those of natural history. However, it remains to be seen whether an evolutionary paradigm is an appropriate model for the discussion of culture, including art. (Current social theory seems to be reversing the evolutionary thought that marked the formative period of the social sciences in the late nineteenth century.)

Esther Pasztory (1989) notes that ethnic styles emerge for specific purposes and in particular social conditions. Ethnic styles emerged for the creation of difference in conditions of cultural interaction but also competition and hostility. Ethnic styles vary in the way and the degree to which they symbolize difference; they can be invented, or they can result unselfconsciously from centuries of aesthetic expression. Thus, no source of influence or trajectory of style development is inherently more "natural"

than another. The marking of ethnic identity through aesthetic expression is often a strategy (conscious or unconscious) for practical survival. Instead of applying a Europe-derived model of style and style change universally, we need comparative analysis of the practice and theory of style.

BEAUTY AND THE GOOD

Another association with art that was prevalent in Western aesthetics historically but little discussed today is that of beauty. The topic of beauty has grown so out of favor with artists and theorists alike that its negation, a kind of antibeauty, has been much more influential in the twentieth century.[13] This development has its own logic within Western art history; it results from an attempt to destabilize the class relations that traditional standards of taste were assumed to uphold. However, it would be a mistake to apply this rejection of beauty and taste cross-culturally, because beauty serves a much different function in other cultures than it did in early-twentieth-century Europe and America. *Hozho*, the core concept of Navajo art, refers to the restoration of "conditions of beauty." Navajo art functions as a guide for living—one must walk in beauty, radiate beauty—that is much more far-reaching than the equation of taste and social status that motivated many twentieth-century artists to eschew beauty in their art. In addition, in Navajo thought beauty is in the nature of things, as well as in people, so that it is a key expression of balance in the relationship between humans and the world that they live in. Beauty in art reflects and even reinstates balance in nature and vice versa. Though classical and neoclassical philosophers made similar connections between art and nature in the context of beauty,[14] more recent texts note that Western aesthetics has divorced the discussion of beauty in nature and art. When artists draw a connection between nature and art, it tends to be in the context of entropy, decay, or geological and environmental processes, as in the work and writings of Robert Smithson.

In Navajo thought beauty is found in activities, not in products: not in things, but in the relationships among things. Beauty is balance. For example, the importance of sandpainting lies in the process of creation; the finished product has no worth. Though some Western artists, influenced more by the process orientation of Asian art than by Native American philosophy, have emphasized process over product (Pollock, Motherwell), fundamental differences in attitudes are revealed through the painting's

fate after leaving the hand of the artist. The primary relationship of West-
ern culture to art is that of collecting—which follows from the desire to
own and display artworks permanently—rather than the immersion of
oneself in a creative process akin to natural creation. Thus, ideas from in-
digenous art have influenced Western artists and collectors at the level of
rhetoric, but the frame of reference remains fundamentally different.
Beauty, and the process of living in beauty, are experiences for which we
have concepts, but current attitudes about art prevent us from fully ap-
preciating these aspects of indigenous aesthetics.

A final consideration is how the divorce between aesthetics and funda-
mental ethical concepts such as "the Good" in Western thought affects
one's ability to understand indigenous art. The Good, of course, is closely
tied to the beautiful in classical aesthetics, an association that also shows
up in indigenous aesthetics (Onyewuenyi 1984).[15] Tagore expresses a link-
age between aesthetics and ethics in Indian thought: "The Good, I repeat,
is beautiful not merely because of the good it does to us. There is some-
thing more to it. What is good is in consonance with creation as a whole
and therefore also with the world of men" (1961 [1916], 5). Similarly, an
African philosopher, Innocent Onyewuenyi, states that the connection be-
tween the Good and the beautiful, a connection that he acknowledges was
expressed by Western philosophers from Socrates to Kant and Hegel to
Croce, is a fundamental aspect of indigenous African aesthetics.[16] Again,
for a variety of historical reasons, Western aesthetics has divorced itself
from a general discussion of the connection between art and ethics, pre-
ferring instead to address extreme cases of the conflict between art and
morality when they arise. As a result of this disinclination to consider art
in the context of ethics, it will be difficult for Westerners to respond to in-
digenous aesthetic expression as art when the aesthetic and ethical are so
closely linked in many indigenous cultures.

We can see, then, that there are several factors in Western culture and
attributes of art in Western aesthetic theory that make it difficult for
contemporary Western theorists, artists, and audiences to accept art in
the context of indigenous aesthetics. Culturally, Eurocentrism resides in
universities and other institutions, which leads Westerners to view non-
Western art as peripheral and partial. Economic and social differences cre-
ate cultural conflict in practical terms; for example, the dying out of tradi-
tional art forms follows from colonialist and neocolonialist economic and
social relationships, as does the emergence of newer gallery and tourist-

oriented forms such as the "airport art" of Africa or the American South-west. In this light ethnic arts function as an appendage to mainstream de-velopments; they are controlled through economic and social relation-ships to the mainstream art world. A primary relationship of Western culture to art is that of collecting, a practice that may or may not be found in non-Western cultures. When collecting is introduced into cultures (ei-ther in the form of producing for non-native collectors or for local collec-tors) where this was not a common activity, it changes the meaning of art for that culture. It is these kinds of social practices surrounding art that help form its meaning and value for us, more so than abstract definitions of art.

Even so, several theoretical constructs also prevent Western scholars and audiences from viewing non-Western aesthetic expression as art. A universalizing tendency in the definitions found in Western art theory excludes any concept that doesn't fit the definition, leading some indige-nous theorists to question the Western inclination for definition. Or non-Western art may be merely subsumed under the currently accepted defini-tion, regardless of the ideas of the artists who made the work. If this seems too extreme a statement, a quick glance at introductory design texts will show that they primarily discuss non-Western art in the context of for-malism, a holdover from the early modernist interest in the primitive and the Bauhaus model of art education that continue to prevail in American art schools. As extensions of formalist theory, the concept of style and models of style change remain powerful theoretical constructs in art his-tory that form our analysis of non-Western art. An alternative approach is to seek out indigenous attitudes about style and style change. The danger of aesthetic universalism is that it may undermine the ability of art to stand for *local* beliefs and attitudes; is a sense of place lost in the search for overarching commonalties? Thus, we need to seek out particular expres-sions in order to discover the universal in art, a process of seeking truth that Tagore notes differs from the methods of the sciences: "The scientist seeks an impersonal principle of unification which can be applied to all things. . . . But the artist finds out the unique, the individual, which yet is in the heart of the universal" (1961 [1916], 23).

Even the term "indigenous aesthetics" may entail a stance of essential-ism, consistent with unwarranted universalizing definitions of art. This is the accusation of one native artist, Loretta Todd: "It could . . . be said that the term 'Native' is a discourse, inscribed with meaning from without—

meaning that runs the gamut from the Noble Savage to the radical warrior to the quiet maiden to the wanton half-breed. . . . the discussion about Native theories of representation, about our 'art' of 'diverse aesthetic values' continues to be reinterpreted according to dominant values, whether mainstream or on the peripheries" (1992, 77). There is, of course, always a risk of essentialism when members of one culture attempt to represent or respond to expressions of other cultures. This is why stereotyping exists and will continue to exist. But I feel that one way to guard against essentialism is to examine and reevaluate one's own terms of viewing. As Todd indicates, "indigenous" as another category of aesthetics may represent "our" needs more than "theirs," so these needs must come under scrutiny. Another way to guard against essentialism is to try to understand the terms of other people's aesthetic life rather than imposing Western schemata. I have argued in this chapter that the properties that Westerners currently attribute to "art" are inadequate for understanding indigenous aesthetic expression, which is not to say that art does not exist in indigenous cultures; it may only mean that Western definitions of art have grown too inflexible or narrow to address art in a comparative manner.

This inflexibility results, in part, from the divorce of spirituality, beauty, and ethics from aesthetics. I singled out these qualities because they seem to be most prevalent in traditional indigenous aesthetic systems. A similar divorce is undoubtedly found in those segments of indigenous cultures heavily influenced by modernist art and theory. When this divorce is combined with a materialistic, mechanistic attitude, inherited from the Western faith in science and technology, it becomes difficult to see or accept the close connections between art and other domains of life so common in indigenous aesthetic systems. Or, if we do see them, we feel that they are being expressed in some other manner than art. However, there is a precedent for our understanding those connections in the history of Western philosophy, where issues of spirituality, beauty, and ethics were intricately intertwined with aesthetics. It is only in the context of this more inclusive framework that we will see the art in indigenous aesthetics.

NATIVE AMERICAN IDENTITIES
AND MEDIA

I N AN ESSAY written for the *Indigena* catalog the film-maker Loretta Todd warns readers about the essentialist nature of the term "native" itself: "the term 'Native' is a discourse, inscribed with meaning from without . . ." (Todd 1992, 77). Perhaps one way to guard against inscribing essential identities onto "others" is to emphasize that the formation of collective identity is a continuous process. Rather than thinking of groups as "having" an identity, a more accurate approach may be to think of groups as constantly forming or negotiating collective identity.

NATIVE AMERICAN IDENTITIES

The current variation in American Indian group identities and the development of these identities through cultural contact and change demonstrate the processual nature of group identity formation. Contemporary Indian identities result from (1) differences in the organization of Indian groups before their contact with Europeans, (2) various types of interaction with whites after contact and conquest, and (3) more recent developments such as pan-Indianism and urban migration. In addition, Indian collective identity can be understood both in political terms, and in cultural terms as a group's self-concept (Cornell 1988). Political refers to the structure of a group's self-organization. Self-concept refers to a group's sharing of meaning through identity symbols and collective participation (often in aesthetic experiences). Though the collective experience of Indian groups varies, current Indian identities result from a progression of diverse to more centralized tribal political structures and an inverse progression from consensual to fragmented group self-concepts.[1] While this thesis may contradict an alternative thesis first proposed by Murray Edelman (1964)—that politics is primarily a symbolic as opposed to an orga-

nizational activity—separating the two does help explain historical and
contemporary aspects of Indian group identification.

Precontact Indian societies generally lacked polities or distinct institutional structures in which secular authority was vested (Cornell 1988, 28). Politically, traditional Indian identity rested on the extended family, or clan (kinship system), or autonomous bands as the key element (Forbes 1990). More recently, clan rivalry has been accentuated within some tribes due to the reservation system, which restricts the independent movement of competing tribal factions. Some tribes, such as the Cheyenne, did have a tribal-level government or council that predated white contact, but most tribes depended on custom rather than a hierarchical structure of authority to govern communal life. Tribal-level political identity is, for the most part, a consequence of interaction with European-Americans.

However, precontact Indian identity went beyond political organization and was situated in the conceptual or symbolic dimensions of groupness. These collective identity systems also varied between tribes, but religious beliefs, history, shared language, and ties to the land were common elements of indigenous communal life. For example, to the Comanches, the notion of tribe had symbolic meaning but didn't function as a political unit. Though some tribes had less-developed self-concepts than others, conceptual or symbolic identification was generally more comprehensive than political identification.

Several aspects of intercultural contact led to increased political consolidation. Missionaries introduced institutional structures such as churches and schools into Indian communities. They encouraged the development of formal codes of law which included the definition and protection of private property. Intercultural contact also led to the need for negotiation and diplomacy, especially with regard to rights to land. The U.S. government demanded a structure of authority on the part of Indians which would ensure the results of land negotiations. Thus, tribal political roles developed with respect to United States government expectations but also proved advantageous to Indians because they helped preserve some Indian claims to territories.

Just as there were variations in precontact indigenous organizations and self-concepts, the process of cultural contact and change varied. Some tribes followed a pattern of incorporation, in which they absorbed aspects of non-native technology and culture but conformed these aspects to the

functional relations of the original cultural system. Little in the older culture was replaced by contact with the new cultural system, though some new aspects may have enhanced existing practices. The Navajo and Yaquis tribes are examples of this cultural incorporation.

The polar opposite of incorporation is assimilation, in which native cultural behaviors were replaced by aspects of the Euro-American cultural system, leading to the breakdown of the indigenous cultural systems. Members of most North American tribes have experienced assimilation, though the speed and amount of assimilation that occurred often depended upon the proximity of a tribe's native land to major Euro-American population centers. Less extreme experiences involved some form of cultural integration. In a compartmentalized form of integration some elements of the dominant society were adopted but were kept separate from traditional culture. Another form of cultural integration occurred when there was a fusion between the two cultural systems. This fusion differs from simple biculturalism, in which an Indian's way of acting shifts according to cultural context. Biculturalism involves dual participation in two cultural systems, not systems merging.

Indian groups progressed through different sequences of these types of cultural contact and change. In general, though, there seems to have been a progression from integration, especially involving material and technological aspects of Western culture, to assimilation. Further integration was inhibited through the use of force by the dominant culture. However, despite assumptions about the gradual disappearance of the native ways of life through absorption into the great national melting pot, many Indian cultures have defied assumptions of cultural disappearance through assimilation. Government policies, designed to assimilate Indians, instead have challenged natives to develop new understandings of their collective identity.

During the late nineteenth and into the twentieth century, the United States, Canadian, Australian, and New Zealand governments carried out policies of forced dismantling of indigenous cultures. Ironically, the reservation system, which also was established during this period in the United States, both reinforced and created new tribal identities. Though the identities of some native bands weakened, reservation boundaries gave physical reality to tribal boundaries that were once primarily culturally defined (Cornell 1988, 35). The tribe emerged as the primary unit of Indian legal and political identification with the Indian Reorganization Act (IRA) of

1934. This "new deal" for Indians reversed previous government policy and gave federal support to indigenous communities and tribal governments, and increased their political status (Cornell 1988, 35). Subsequently, the IRA has been interpreted as encouraging a form of paternalism which ethnocentrically lumped all indigenous peoples into the category of "Indian" and continued the basic model of political subservience that treats natives as "childlike subordinates" (Jarvenpa 1985, 30). In this interpretation "tribe" acts as an imposed category that creates confusion and tension even as it increases political power (Jarvenpa 1985, 34).

Behind the outward appearance of tribal unity very real divisions developed on reservations. These divisions occurred along clan and family lines that predated tribal political identities, and along conservative/full-blood vs. progressive/half-blood factions. The IRA, which encouraged a separation of religious from secular authority, led to a tendency for the Bureau of Indian Affairs to side with secular authority, dominated by mixed-blood factions, with a resulting lack of attention to traditionalist concerns (Cornell 1988, 38). Though tribes continued to consolidate their political power and natives identified with the tribes for administrative purposes, a breakdown of consensus occurred in Indian communities over the meaning of conceptual identities. Since the 1930s the feeling of "peoplehood" that predated Indian-white interaction has been eclipsed by the notion of the tribe as a political and legal construct.

Cornell examines the growth of tribal government, an issue centered around the reservation as the primary social context. Jarvenpa (1985) writes that the question of Indian identity must also take economic matters into account and points to the increasing urban migration of Indians as one important economic factor. Urban migration began in the immediate postwar period as returning Indian soldiers were encouraged to move to cities by the BIA's Employment Assistance Program. The current population of urban Indians may be over 50 percent of the total U.S. Indian population. Though many urban Indians experience the poverty and despair so common to reservation life, a Native American urban working class has gradually emerged. Urban Indians have formed numerous voluntary associations such as singing and dancing groups, sports associations, and Native American churches to promote affiliation and to serve as identity "badges" to the larger community (Jarvenpa 1985, 36). Economic well-being results from a clear symbolic identity; the identity "badges" help proclaim a right to economic resources. This notion of group rights

to resources contrasts with European assumptions that individual rights are the basis of social ties, but it reflects the increasingly pluralistic nature of American cultural, political, and economic life.

Pan-Indian movements have developed beyond the reservation level. Early examples of these movements were spawned by the reservation system, which crystallized a feeling of shared oppression in Native Americans. In the 1890s the Ghost Dance movement emerged as a pan-Indian movement; this was followed in the early twentieth century by the peyote movement. Both were facilitated in part by the boarding school system in place on the reservations (Jarvenpa 1985, 31). One result of pan-Indianism is that as general identification with Indianness has grown, local indigenous culture has declined, accompanied by increased secularization. Pan-Indianism may have led to a more general ethnic identification that eclipses a specific cultural identification, raising the question whether there is an apparent or implied conflict among local, tribal, and general Indian identification expressed in indigenous media. It seems that in recent years Indian identification has widened to include indigenous peoples of the world, the First World movement, but the degree to which this movement complements or departs from more local identification remains open to question.

Another point of potential conflict in contemporary Indian identification lies in the status of mixed-race, including "triracial," individuals. Forbes (1990) and Jarvenpa (1985) write that Indian identity has been manipulated through census-taking and other administrative practices based upon a rigid white/nonwhite bipolar classification system. People of mixed black, white, and native ancestry are automatically excluded or marginalized according to current ethnic classifications. Pathologies may even develop within individual families of mixed-race heritage when individual family members vary widely in appearance or coloration. Forbes feels that "self-identification" should be a basic right in order to counter the "feeling of being processed" (Forbes 1990, 48). While this plea for "self-identification" coincides with the liberal notion of individual rights, it is mitigated by the importance of groups in identity formation. In Forbes's model of "multiple identity" (1990, 41), which states that identity is multilayered, extending from individual to local and national identification and including global alliances, the idea of self-identification undoubtedly plays a role. But, perhaps the most important issue he raises is

the potential divisiveness of mixed-race stigmas, which has led to the
"shattering" of native communities and the splitting asunder of family and clan cohesiveness.

Several questions are raised from this brief examination of Native American collective identification. How do traditional clan relations and newly traditional tribal relations complement or conflict with growing pan-Indian, ethnic, and global indigenous identification? How can the traditionally collective orientation of Indian conceptual identity blend with the forms of political organization encouraged—or imposed—by the dominant society? Can they be blended at all, or is a new conceptual and political identity likely to emerge from the Fourth World alignment? How can the results of cultural shaming, for Indians in general and triracials or mixed-race black-Indians in particular, be overcome through changes in collective identity? Many of these questions arose out of the experience of the civil rights movement in the United States and the global indigenous rights movement that coalesced in the 1970s. At the same time, native activists and artists turned to photography and broadcast media for expressive, political, and affiliation purposes.

INDIGENOUS MEDIA

The first indigenous-directed films were funded by the United States government through the Department of Health, Education, and Welfare (HEW), but since the advent of more affordable video technology in the late seventies and early eighties, various groups have recognized the potential of video for intragroup communication and as a means of gaining cultural and political recognition in the wider society. Video and film productions are used to "rethink history," even to address "the ignorance of the dominant culture" about past history and contemporary culture (Weatherford 1990, 59). In the United States, Native Americans have been actively making videos based on an initial focus of "helping to enhance the survival of their own communities," in their own production facilities and through coproduction arrangements with non-native videographers and filmmakers (Weatherford 1990, 59).

Similar developments in indigenous video production have occurred in Canada, South America, and Australia, and alternative video has grown as a communication tool for political movements throughout the world. For

the Sinn Fein group in Northern Ireland, "Videos have become one of the elements by which a predominantly working class organization can develop its political skills" (Roberts 1990, 95). Members of Sinn Fein feel the use of "low-level technology has a progressive role to play in both establishing self-identity and disseminating information efficiently and providing the necessary conditions whereby members and supporters can raise political consciousness in pedagogic exchange" (Roberts 1990, 95). Video can be tied to Irish nationalist and, more generally, Celtic nationalist goals. Video's decreasing cost, ease of use, and resulting accessibility make it a convenient medium for establishing an ideological framework counterposed to that of the dominant culture. The increasing use of video technology by indigenous and ideologically divergent groups points to alternative scenarios for media production and use: "for example, a networked cooperative of autonomous community stations resisting hegemony and homogenization" (Michaels 1987, 17). This scenario runs counter to dominant-culture assumptions about the inevitable demise of native cultures in the face of Euro-American progress, assumptions which have been ingrained by centuries of imagery portraying Indians as enemies, then vanquished foes, and currently relegating Indians in the popular imagination to movies, curio shops, and museum exhibits. It also seems to fly in the face of the production and distribution systems that have led to the centralization of mainstream media. In spite of these counterassumptions, indigenous media have existed for twenty years now. Part of the reason for this endurance may be that indigenous media grow out of documentary traditions that have their origin *within* Native American cultures.

Native Americans argue that their own awareness of the power of visual imagery lies deep in the past. Pueblo petroglyphs of spiritual significance that date from eighteen thousand years ago reveal this deep belief in the power, even sacredness, of visual imagery (Silko 1990, 72). Natives' awareness of the intimacy of photographs reveals this knowledge of the special nature of images. From early in the twentieth century, many Indian people, including those in the most traditional and conservative households, have used photographs to evoke memories and narratives of the past (Silko 1990, 72).

The stereotypical idea that natives object to photographs for their own sake is misleading. Writing of early attempts by whites to photograph Indian religious ceremonies, Silko argues that the actual source of natives' distrust was—and remains—the photographer, not the tool:

At first, white men and their cameras were not barred from the sacred *Katsina* dances and *Kiva* rites. But soon the Hopis and other Pueblo people learned from experience that most white photographers attending sacred dances were cheap voyeurs who had no reverence for the spiritual. Worse, the Pueblo leaders feared the photographs would be used to prosecute the *Cusiques* and other *Kiva* members, because the U.S. government had outlawed the practice of the Pueblo religion in favor of Christianity exclusively. (Silko 1990, 72)

This same distrust extends to the present for some tribes such as the Hopi. Though religious leaders will allow outsiders to observe traditional ceremonies, they disallow photographic and written recording of the events. For instance, the attempt by Robert Redford to film a production of *The Dark Wind,* a Tony Hillerman novel set on the Hopi and Navajo reservations, led to a rift in the tribe between the tribal council and religious leaders.

Tribal council members, while committed to preserving traditional Hopi culture, approved the project in the belief that "stepping into the future is an economic necessity" (Woestendiek 1990, 14-A). The religious leaders, who view all Hopi land and ceremonies as sacred, took a harder line toward the outside intrusion into the inner Hopi world represented by the project.[2] Given previous Hollywood depictions of Native Americans (Bataille and Silet 1980; Friar 1972; O'Connor 1980), it seems inevitable that many natives will object to the way outsiders portray them and desire more control over the visual depiction of their cultures.

A central desire of indigenous peoples, then, is to regain community control over the depiction of tribal life, a desire implicit in the indigenous production of documentaries. Not only do most commercial films misrepresent native ways of life and reinforce dominant-culture stereotypes,[3] but many documentaries produced by outsiders provide few benefits to the community where they were filmed. In response, some film- and videomakers have coproduced their documentaries with native participants. This close tie between non-native and native producers preceded the rise of indigenous media and continues into the present.

Community members decide who, and often what, will be filmed. Filmmaking expertise is contributed by the non-native producers. Often they arrange for the community to benefit in other ways from the filming experience, through sharing any profits made by distribution of the productions, or by providing technical training for crew members of the community. (Weatherford 1990, 60)

The Alaska Native Heritage Project, begun in the 1970s by filmmakers Leonard Kamerling and Sarah Elder, exemplifies coproduced films in which native perspectives are central. Coproduction is a form of collaborative ethnography based upon the shared decisions of the film team and the communities (Collier and Collier 1986, 156). Films by Kamerling and Elder, such as *From the First People* (1977) and *On Spring Ice* (1975), also depart from traditional ethnographic and fiction film because of their "lack of any overt message, a leisurely pacing that allows cultural processes to unfold at their own rate, and an episodic structure in which there is no clear beginning or end" (Collier and Collier 1986, 157). In contrast to the closed narrative structure of many ethnographic films, the open structure in the Alaska Native Heritage Project films allows students and others to work with the visual content without overriding conclusions to color their thoughts and discussions (Collier and Collier 1986, 157). Coproduced films often demonstrate a respect for native perspectives and values, leave economic and educational benefits to the community, and may even reveal native ways of representing the world.

Achieving an insider's or "emic" view of the world is, of course, the ultimate goal of cultural anthropology and also the motivation behind a 1966 experiment by Sol Worth and John Adair, when they placed 16 mm cameras in the hands of seven Navajo men and women in an effort to understand "the way people use visual modes of expression and communication to orient themselves, and to express their relationship with their environment" (Worth and Adair 1972, 12). The combined anthropological-aesthetic-visual interests of the authors led them to ask, "What processes in human beings allow them to communicate visually?" (Worth and Adair 1972, 15). Worth and Adair's approach was structuralist in orientation: they were seeking information about processes of visual coding—"the process by which meanings are put together from specific parts of a visual communication" (Worth and Adair 1972, 19).

Worth and Adair were also interested in the problem of innovation in communication: how a new mode of communication would be patterned by the culture into which it was introduced. The researchers' analysis of filmic conventions such as narrative style in these early films revealed that there were major differences between the Navajos' visual patterning of their world and non-Navajo filmic conventions. For example, the Navajos concentrated on images of walking in order to describe the surrounding landscape, to convey a sense of place intimately tied into narrative struc-

tures, and they avoided facial close-ups and close eye contact due to their valuation of privacy.

Collier and Collier write that the Adair-Worth project was a "revolutionary development of emic understanding," but that this experiment and the work of Kamerling and Elder and a few other researchers who strive to obtain "the inside view" are "rarely repeated and their methods have not been incorporated into other ethnographic film productions" (Collier and Collier 1986, 157). They speculate the reason for this could be that many filmmakers are not themselves anthropologists or that anthropologists themselves are too conservative to appreciate the possibilities of these methods, but they feel there may be a more human and ethnocentric explanation at base: "that only in theory are 'we' willing to let 'the native' have authoritative judgment!" (Collier and Collier 1986, 157). On a practical level, this statement reflects my concern for the problem of ethnocentrism in the study of comparative aesthetics. A belief that Western intellectual traditions contain the most general or theoretically valid framing mechanisms will work against the discovery of ethno-aesthetic codes in media such as film.

From this background of sporadic efforts by anthropologists to produce visual documents from an emic point of view, indigenous peoples themselves have begun documenting their cultures. Coproductions between natives and non-natives have continued. The Video in the Villages Project, directed by Vincent Carelli, has filmed more than ten tribes in South America, resulting in over two hundred hours of video. Like the earlier Alaska Native Heritage Project, this project has provided production assistance and editing instruction to tribal members. The Mekaron Opoi Djoi Project has actively worked with the Kayapo tribe to provide training and production equipment for the Indians' use. Unlike the relative objectivity that may come with an anthropologist's observer status, the natives' increased involvement reflects their concern for their very existence or at least for the existence of traditional cultural practices. "Stimulated by recent threats to their continued existence, some Kayapo now videotape the practice of valued traditions, as well as events which are seen as white Brazilian encroachments" (Weatherford 1990, 60). Community self-determination may be more of a motivating factor than detached scholarly analysis in most cases of indigenous video production.

In response to the introduction of television to the far north of Canada, Inuit leaders lobbied the Canadian Broadcasting Corporation for their

own broadcast capabilities. The Inuit Broadcasting Corporation (IBC) was established in 1980 and, along with five subsequent native communications projects, has actively stressed community control, topics of native interest, and an emphasis on indigenous language and culture. An interesting problem arising from these independent broadcasting efforts is the need to establish a significant difference from U.S. broadcasting conventions. *Qagit,* the IBC's current affairs newscast, resembles U.S. news broadcasts, raising questions about the "Inuitness" of some forms of indigenous video production (Madden 1989, abstract). Programs like *Qagit,* which adopt some conventions of the dominant society while still responding to native concerns, "may demonstrate how to retain one's cultural identity while dealing with people who do not share it" (Madden 1989, abstract). Native cultures' adoption of new communications technology reflects efforts at self-determination but also at intercultural communication—of educating the wider community about contemporary Indian life.

Outreach to new audiences and for new technologies is not without danger. The distribution of images out of their local context, and the loss of control entailed by wider distribution, may end up compromising the cultural conventions and practices that Native Americans wish to maintain. But members of native cultures also recognize the value in identifying and describing their art and culture to the rest of the world.

Some natives feel that this readiness to adopt technical innovations has deep historical roots in aboriginal cultural life, based on centuries of pre-European trade and intertribal communication. Inclusion, rather than exclusion, of technical and cultural innovations is a matter of survival in harsh natural environments.

The Pueblo impulse is to accept and incorporate what works, because human survival in the southwestern climate is so arduous and risky. . . . Europeans were shocked at the speed and ease with which Native Americans synthesized, then incorporated, what was alien and new. (Silko 1990, 73)

From this perspective, assumed conflicts between old and new technologies like basket- and videomaking are projections of a non-native point of view on native cultures. This projection may arise from a continued need of European-origin people to view indigenous peoples as "primitive" (therefore making the destruction of native cultures during the nineteenth and twentieth centuries somehow justified in the name of progress) and,

as a corollary, to stress "authentic" or "traditional" Indian aesthetic and communicative forms over contemporary ones (Silko 1990, 73).

Tradition was the touchstone for Indian aesthetic expression through the middle of the twentieth century, and the dialogue between tradition and innovation, with its implications for the aesthetic expression of Indianness, has been a point of debate in the contemporary Indian art world, at least since the early 1960s. Much of this debate has its roots in market forces.

Ideas of Indian art that developed early in the twentieth century continue to define the market and, therefore, the terms under which artists are expected to work. These concepts, however, are no longer responsive to the lives modern Indian artists have led in terms of education, travel and other experiences in the world outside their reservations. (Eaton 1989, 46)

The experience of contemporary Indian artists brings the assumptions of authenticity and tradition as the central defining criteria of Indianness in art into question. Most Indians respond to both their own identity as Indians and their place in the larger American society. Contemporary natives ask how to "bring together American and Indian ideas of art for a liveable and creative synthesis" (Eaton 1989, 49).

As a way of presenting the work of Indian artists, and an art form in its own right, video is a tool for synthesizing traditional aesthetic practices—and, therefore, sources of communal identity—and contemporary aspects of Indian experience. Native ways of seeing may be expressed in the new technology as well as in the old, and many Indians see no conflict in using technology as a form of aesthetic communication to integrate communal values. For example, "Victor Masayesva, Jr.'s two videos, *Itam Hakim, Hopiit* and *Ritual Clowns,* reveal that the subtle but pervasive power of communal consciousness, perfected over thousands of years at Hopi, is undiminished. In Victor Masayesva's hands, video is made to serve Hopi consciousness and to see with Hopi eyes" (Silko 1990, 73). The availability and accessibility of video make it an ideal technology for cultural preservation and innovation. Video allows the user to combine art, information, and community identification in the process of communication; it enables the user to readily combine aesthetic, educational, and rhetorical goals.

A reviewer of *The Ute Bear Dance Story,* produced by Ute Audio-Visual, explains how these goals can be combined by contemporary videomakers. Described as an "art and information project," the video addresses the

essence of tribal culture in a kinetic, fluid manner (White 1988, 7). The educational aspect of the video lies in its production—the video was made by Larry Cesspooch with a teen video workshop—and is explicit in the product; this original-language video production with English subtitles is part of the Ute Instruction Material Program, which attempts to bridge the gap between older tribal members and younger "culturally alienated, non-native tongue speakers" (White 1988, 7). Rhetorical goals are revealed in the structure of the video, where black and white historic stills function as visual tropes which signify historicity (White 1988, 7). The beauty of the Utah landscape, a flashback to a legendary bear dance, and the use of costuming for cultural affirmation are other visual and narrative elements that evoke collective identification. The aesthetic aspect of the video involves the direct experience of the youths who participated in the making of the video and the feeling of cultural appreciation and ownership evoked in the video's viewers. Aesthetic aspects are rooted in the evocation of deep feelings that create a sense of cultural engagement:

These kids, who literally see themselves in this, will know the magic of cinema in its pure, cleansed sense. Media is thus experienced not simply as entertainment (as commercial audiences have taken for granted) but empirically. Life becomes enriched, the world becomes theirs to interpret and depict however they feel or can imagine it—not as borrowed material or a privilege of the white man in Hollywood. Their own. (White 1988, 7)

White's review article points to the compatibility of several goals—educational, rhetorical, and aesthetic—within indigenous media productions.

Studying aesthetic communication through indigenous videos does not allow for the same kind of comparison that direct observation provides; it is not equivalent to direct experience. However, the opportunity for repeated viewing that film and video allow may be an advantage over direct observation in many cases. Because film and video incorporate a visual language of motion and the component of sound, they are ideally suited to recording performing arts; more than the still image or written word they provide a clear expression of the complex interrelationships between individuals in performative contexts. The moving image has the advantage of qualifying the character of human behavior.

With moving records . . . the nature and significance of social behavior becomes easier to define with responsible detail, for it is the language of motion that defines love and

hate, anger and delight, and other qualities of behavior. For this reason visual studies of behavior and communication tend to use film and video rather than the still camera. (Collier and Collier 1986, 140)

Through indigenous videos elements of the performance that members of the cultures themselves consider important are foregrounded. Indigenous videos will reveal which aspects of aesthetic experience are integral to a group's collective experience.

Another advantage of studying culture through films and videos is that they are expressive forms as well as records of performance. Looking at culture through the films and videos produced by that culture reveals the beliefs and rules that governed the filmmaking, the purposes of the filmmakers, and the film production process. Like other expressive forms, film and video depend upon common, shared significance. They are data *of* a culture (a phenomenon of culture in their own right) as well as data *about* a culture (Worth 1968).

EXPRESSIVE ANTECEDENTS OF
NATIVE AMERICAN DOCUMENTARY

HOUGH WE normally associate the documentary genre with Western filmmaking, there are visual, literary, and oral antecedents for media documentaries within Indian cultures. This is immediately apparent in art forms of the Plains Indians, which were often visual narratives. Have Plains Indians taken more readily to the documentary form because their indigenous art forms often served a documentary function? This question points to the broader issue of connections between earlier genres of indigenous expression and contemporary native media. Writing of the Kayapo Indians of South America, anthropologist Terence Turner noted that " . . . Kayapo dramatic self-representation in contemporary contexts of inter-ethnic confrontation continues traditional cultural forms of mimetic representation" (Turner 1992, 10). Indigenous media, then, are not just the result of Western media or cultural influences. Accordingly, this chapter is a step toward understanding the relationship of antecedent visual, literary, and oral native expressive forms to contemporary indigenous documentary.

Problems of interpretation arise when a construct like "traditional documentary," used to refer to the Western documentary tradition, is applied in non-Western contexts. Even if native-produced films and videos initially appear to be "traditional" in their documentary structure, this application of a construct does not take into account traditional Indian forms of cultural and historical documentation that serve as a source of contemporary media documentaries. Indians documented and expressed their own lives through winter counts on hides, pictographs and petroglyphs on cliff walls or boulders, quill- and beadwork, and ledger drawings. The evolution of some of these forms, such as ledger drawings, beadwork, and so on, resulted from cross-cultural contact and conflict; nevertheless these forms helped constitute indigenous visual "languages."

However, the more general appropriation of documentation through non-native film, video, and photography has been part of the process of colonization.

Artistic interpretation of cultural events and images was violently threatened by Euro-pean invaders who, unable to comprehend the intensely connotative forms used by tribal people, "saw it as their duty to take over the task of documentation" (Bataille [quoted in source]) of Native cultures. The result: Indian cultures interpreted by and for non-Indian audiences. . . . In documentary film, the results have ranged from sim-plistic to sensitive, but inevitably, even documentary films with their claims to objec-tivity have been ethnocentric, encoding tribal cultures in the language, images and val-ues of Euro-American culture. The subordination of aesthetic to scientific goals in filmmaking is just one example of the imposition of Anglo cultural norms by even the most sensitized ethnographic film-makers. (Sands and Sekaquaptewa Lewis 1990, 389)

A simple transfer of critical constructs such as "traditional documentary" from one cultural context to another may have an effect similar to the ap-propriation of documentation itself. We need a basis for understanding contemporary native expressions in their own terms. What, then, are the expressive antecedents that help us understand contemporary native me-dia in the context of native documentary traditions?

ANTECEDENT VISUAL EXPRESSIONS

The most characteristic Plains art forms were narrative, probably due to the influence of the oral narrative traditions so central to Plains social life: ". . . visual symbolism is directly related to the oral narrative tradition that provided the fundamental means of religious, social, and historical com-munication" (Maurer 1992, 37). Frequently, the symbolism was heroic or highly personal in nature. For instance, Plains buffalo robe painting was historical art that often recounted the battle experiences of an individual or tribe. Robe compositions featured pictorial vignettes arranged to sug-gest a visual narrative. In this concentration on both personal and tribal narratives buffalo robe paintings are the culmination of traditional Plains visual artistic development. Though changes occurred, narrative form re-mained consistent in the evolution of Plains visual art. "Although Plains figure drawing became more naturalistic and detailed during the middle years of the nineteenth century, this basic style of pictorial narrative re-

mained constant, a lasting visual convention that is still used in traditional forms of Plains Indian hide painting" (Maurer 1992, 40).

In the earliest known Plains paintings, tribal members recorded their visions experienced during vision quests, dreams, and hallucinations on personal objects. Early hide paintings (ca. 1700) were emblems painted on shields, other tools of war, and personal objects. Images were revealed to the artist through his vision quests and dreams. These artistic expressions reveal the centrality of individual experience in Plains social life, even though Native American art has too often been presented as the "anonymous product of a generic culture" (Maurer 1992, 40). However, Plains Indians' art increasingly reflected a sense of collective solidarity during the nineteenth century, which may have been due, in part, to rapid cultural change and the increase in conflict with non-Indians. One collectively oriented art form is the genre of winter counts, annual tribal histories which chronologically recorded activities of the Teton Sioux and Kiowa of the High Plains.

As the traditional culture of the Plains was curtailed and eventually forbidden, biographical art became a principal means of recalling and confirming cultural values and identity. Images were made by the men to document and celebrate the way things used to be, not so much as a nostalgic recollection of the past but as a crucial method of reaffirming the ancient and essential values of their society. The pictorial means of biographical art were also used to document the past in calendrical histories known as winter counts, in which one image recalling a particular event was used to signify an entire year in the history of the tribe. Most of these historical calendars were kept by the Lakota, who used them to document events going back over hundreds of years. (Maurer 1992, 41)

During the late nineteenth century, increased conflict with whites led to the deportation of seventy warriors from the Southern Plains to Fort Marion, in St. Augustine, Florida. The young men's jailer, Captain Richard H. Pratt, provided them with paper, pencils, and colors to create art; these drawings both documented the lives that the warriors had been forced to leave behind and appealed to non-Indians in the area as collectible artworks. Like buffalo robe paintings and winter counts, Plains Indians' ledger drawings (named after the ledger books provided by their Anglo captors) were a narrative art form; they recounted aspects of the lives and lands from which the Indians had been wrenched away. At Fort Marion, imagery and styles distinctive to individual painters emerged. As individ-

ual rather than tribal expressions, these paintings—often signed—coin-
cided with Western assumptions that artworks should be unique and cre-
ative: that they should reveal the hand of their maker. Ledger drawings
helped create a new commercial market for native art, even though this
may not have been the intention of the artists themselves.

Ledger drawings are an important antecedent for contemporary native
media production because, through them, Indian artists acknowledged
their status as between "two worlds." There is a deliberate ambiguity to the
drawings of some artists such as Wohaw (Kiowa), who addressed the wider
audience of whites in St. Augustine while at the same time documenting
his own personal experience as an Indian. Louise Lincoln explains this
ambiguity, found in Wohaw's image of Fort Marion prisoners dancing for
tourists (1875–1877) from the *Cheyenne Sketchbook:*

The ambiguity of the image is deliberate. It claims a parallelism and equality between
the two worlds that Pratt [the jailer] would surely have denied, yet does so in terms that
are calculated to evoke both respect and sympathy. His use of the pipe image and tra-
ditional dress roots the picture in a Kiowa context, while the solitary figure emphasizes
the difficult situation of an individual in Wohaw's position. . . . In its deliberate and
strategic ambiguity, the drawing allows varying interpretations of multiple messages.
(Lincoln 1992, 51)

Contemporary native media similarly address multiple audiences and al-
low for varying interpretations, both because of the cross-cultural nature
of the subject matter and the formal hybridity of indigenous documentary.

These earlier narrative forms—historical hide paintings, winter counts,
and ledger drawings—also relate to the goals of current native documen-
tarians who *narrate* historical subject matter. Historical documentaries by
and about members of Plains and Plateau tribes include *Circle of Song*
(1976), *Awakening* (1976), *Spirit of the Wind* (1976), *Legend of the Stick
Game* (1976), *Crow Dog's Paradise* (1976–1978), *Visions* (1984), *Lakota
Quillwork: Art and Legend* (1985), *Changing Visions* (1988), *The Spirit of
Crazy Horse* (1990), *The Place of Falling Waters* (1990), *Warrior Chiefs in a
New Age* (1991), and *In the White Man's Image* (1992). Often the directors
of these documentaries rely on historical stills and film footage or paint-
ings of historical events to convey content. In other cases actors reenact
traditional ceremonies and past events. Historical narrative is emerging as
a consistent trait of Plains and Plateau documentaries.

Traditional arts of the Southwestern tribes contrast with Plains visual

forms because they are often abstract arrangements of static visual forms. Of the native North American tribes, the Southwestern tribes are known to have had a rich pictorial tradition (as distinguished from Eastern and Western native sculptural traditions) that predates the arrival of Europeans. Excavations such as the one at Pottery Mound in New Mexico reveal that Anasazi artists actively painted a large number of frescoes in the period from approximately 1300 to 1475 (Hibben 1975, 10). This pictorial tradition is known through pottery and the murals found in underground ritual or prayer chambers (*kivas*) that remain central to Pueblo ceremonial life today and are closed to outsiders. The *kiva* murals were painted on plastered walls in flat, even tones. Designs were often separated from each other by contrasting lines. Modeling, shading, and texture are very limited in the examples that have been discovered at Pottery Mound and by the Awatovi expedition in northern Arizona. Unlike Plains art, Southwestern mural art eschews personal expression in favor of communal ritual subjects. The characteristics of balance, symmetry, and enclosure found in the murals have led scholars to characterize Southwestern Indian art as abstract in nature and ceremonial in function (Hibben 1975, 67–70). These traits carry over today in their influence on traditions such as Navajo sandpainting: "It is almost certain that the Navajo learned sandpainting and the rituals accompanying it from early contacts with Anasazi groups such as those at Pottery Mound" (Hibben 1975, 34). Stylistically, then, traditional Southwestern art is more abstract and contained and less active than Plains art. Its content tends toward mythic, symbolic, and abstract expressions of subject matter compared to the narrative traditions of the Plains.

Videos produced by members of Southwestern tribes and communities are often not "historical" in a traditional linear sense. These include *Red Road: Toward the Techno-Tribal* (1984), *Hopi Prayer for Peace* (1986), *Tiwa Tales* (1990), and Victor Masayesva's *Itam Hakim, Hopiit* (1984) and *Siskyavi* (1991), in addition to several films by both Indian and non-Indian outsiders that document Southwestern tribes: *Dan Namingha* (1984), *Hopi: Songs of the Fourth World* (1983), and *Seasons of a Navajo* (1984). *The Pueblo Peoples: First Contact* (1990) is the only linear historical narrative about the Southwest that I have viewed. Significantly, *First Contact*, which documents the cultural clash between Pueblo peoples and early Spanish explorers, was directed by George Burdeau (Blackfoot/Plains), who made several films about Plateau tribes for *The Real People Series* (1976). Docu-

mentaries of Southwestern tribes are often organized cyclically according to the seasons, myths, and cosmology, in contrast to the linear historical narrative common to Plains and Plateau productions. A good example of this mythic, cosmological organization is Victor Masayesva's *Itam Hakim, Hopiit* (1984).

Do the contrasts between Plains and Southwestern art and documentary hold up in other twentieth-century expressive forms? In the early twentieth century, other visual media such as painting and photography were integrated into Southwestern pictorial traditions. Unlike the introduction of Western art materials and techniques to the Plains Indians, which occurred under conditions of captivity, the artistic interaction between Anglos and Indians in the Southwest developed within the contexts of education and tourism. Between 1900 and 1910 Elizabeth Richards allowed students to paint at the Pueblo San Ildefonso Day School, where she taught. The 1910s saw continued artistic activity in the Pueblos, especially under the influence of Edgar L. Hewett, director of the School of American Research at the Museum of New Mexico. Like the earlier murals, work by Hewett-sponsored Pueblo artists, such as Crescencio Martinez and Awa Tsireh (Martinez's nephew), was highly decorative, impersonal, and stylized. The visual vocabulary was two-dimensional, flat, and static, reflecting the influence of geometric pottery and mural traditions. Painters of San Ildefonso became political and religious leaders in their community and sought to document the central values of the tribe, which were embedded in religious ceremonial participation. Hopi painters such as Fred Kabotie also focused on ceremonial and religious subject matter. In this sense, the motives of Pueblo painters are antecedent to those documentarians whose primary goal is the preservation of traditional ceremonial practices. Pueblo paintings are often ahistorical in the sense of recording a linear unfolding of events over time. Rather, they mark the place of ceremonial events in the cyclical life of the community.

Documenting and preserving ceremonial dances also motivated twentieth-century Plains artists. But their art continued to incorporate a personal, visionary component, influenced in part by the rise of peyotism during the 1920s. Plains art, especially that of the Kiowa, is colorful and filled with motion, in contrast to the Southwestern emphasis on discrete, relatively stationary forms. Both traditions came under the influence of Dorothy Dunn from 1932 to 1937, when she headed the Santa Fe Indian School Studio. At the studio, the traditional style, with its emphasis on

subject matter such as ceremonies, nature and animal symbolism, and traditional ways of life rendered in a flat, outlined graphic style, reigned supreme. Along with the historian J. J. Brody, Dunn, who wrote a 1960 survey of American Indian painting, has "contributed to Native American studies by recognizing the continuity of the Plains pictorial tradition and emphasizing its aesthetic and cultural values" (Maurer 1992, 31).

Though he studied at the studio with Dunn, the Sioux painter Oscar Howe was the first to strongly depart from the traditional style in the 1950s with his efforts at the abstract expression of movement. His artistic vocabulary radicalized the institutional, traditional painting of the studio schools, but Howe remained traditional in his artistic goals:

My reason for painting is to record visually and artistically the culture of the American Indian, particularly the Dakota Indian. My reason for painting is to carry on what is traditional and conventional in art. . . . Ceremonial paintings have an emotional value in addition to their purpose as artistic records. The formal execution of a documentary painting by an authorized artist shows that the artist takes part in community life and affairs as a contributing member in a community, working to fulfill the need for his services. If he satisfies or fulfills the community needs, he is accepted as one of the officials. . . . As long as the artist is living according to standards, he is "right" within the Indian society. Knowing that the source of inspiration for the artist stems from "sacred" dances, ceremonies, etc., the Indians accept the artist as a member of their society. (Howe in Highwater 1976, 153–155)

It is clear that the desire to *document* and preserve traditional culture motivated Native American artists from the beginning of their initial experimentation with Western art materials and continued despite the impact of Western art theory on early Indian modernist artists, such as Howe.

Though native artists occasionally experimented with modernism as early as the 1920s, it did not exert a strong influence in the native art world until the founding of the Institute of American Indian Art in Santa Fe in 1962. The conscious expression of Indianness by contemporary visual artists has become more complex than the earlier documentation of traditional symbols, ceremonies, and dances. And some artists have downplayed the importance of Indianness in their creative process, emphasizing that their identity and goals as artists are separate from their ethnicity (Wade 1981, 16–17). However, many contemporary Native American artists continue to express, and even to visually document, their Indian heritage in a way consistent with the goals, if not the methods, of earlier

generations of artists. With some recent exceptions, then, native visual artists set a precedent for indigenous film and video documentarians in their motivation to document native cultures. As in the case of Howe, this emphasis on documentation emerges from the artists' and filmmakers' understanding of themselves as fully integrated into the religious, political, and social life of their communities. As an integral part of culture, earlier visual genres were central to the public life of the tribe or community because they celebrated commonly held values embodied in ceremonial ritual and symbolism.

ANTECEDENT LITERARY EXPRESSIONS

Native directors' attempts to preserve, document, and heal their cultures also have an important precedent in Native American literature, which ranges from novels to plays, poetry, and storytelling. A representative novel, *The Surrounded*, by early novelist-anthropologist and member of the Salish-Kootenai tribe D'Arcy McNickle, demonstrates the affinity of themes and styles between literature and contemporary documentary. I chose *The Surrounded* for extended analysis because it is a relatively early example of native literature; the analysis demonstrates a connection between foundational themes in native literature and issues that continue to motivate documentarians today.[1]

First published in 1936 and reprinted in 1978 by the University of New Mexico Press, *The Surrounded* was praised when it appeared by noted historian Oliver La Farge for its credible portrayal of "the first Americans" (in Towner 1978, vii). The story's setting is the Flathead Indian Reservation, where McNickle was born in St. Ignatius in 1904. Scenes in the novel describe two youths tricked into going to the mission school and then avoiding the school the following year, reflecting McNickle's own experience. He was sent away to the federal Indian boarding school at Chemewa, Oregon, where he and his schoolmates were given corporal punishment if they lapsed into Indian tongues (Towner 1978, xi).

The boarding school experience has emerged as an important topic for contemporary videomakers. The wrenching scenes of *Healing the Hurts*, directed by Phil Lucas, reveal how violent a scar was left on the lives of attendees. According to Lucas's comments after a video screening, this scar has been unconsciously transmitted from generation to generation.

Other videos, such as Darrel Kipp and Joe Fisher's *Transitions* (1991) and

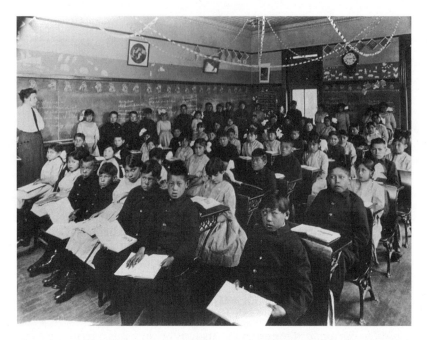

FIGURE 1 ▶ *In the White Man's Image* (schoolroom)
In an effort to transform American Indians from "savages" into "civilized peoples" Indian students were taught the "white" way to live in this government-sponsored, military-style school located in Genoa, Nebraska. The typical classroom consisted of students from many tribes who varied widely in age and ability. (Courtesy of The Genoa Museum, Genoa, NE, and Native American Public Telecommunications [NAPT])

NAPT's production *In the White Man's Image* (1992, see Fig. 1), examine the price of losing language, which was one consequence of the boarding school experience. Collective memory is threatened when the language is lost. In *Transitions*, Fisher and Kipp, both Blackfeet Indians, demonstrate that their tribe feels that the "Mother Tongue [was] gifted us by the maker," and that, as the result of government and religious intrusion, "our Mother grows weaker by the day." Schoolmasters tried to change Indians to the white man's way by using stool pigeons and stern discipline. Older children who had been at the school longer were encouraged to tell on the younger children when they spoke in their own language. Nonconformers were forced to kneel on broomsticks or, as McNickle describes, placed in solitary confinement and indoctrinated into a dread of the power of evil.

The legacy of boarding schools that emerges from both the novel and contemporary documentaries is one of "cultural shame," in which the loss of language is part of a "continuum of loss" (Fisher 1991).

The book is a moving account of Archilde Leon's process of confronting his culture, his parents, and the white culture's influence after his return to the reservation. Published in 1936 when McNickle was in his early thirties, his first book reveals McNickle's coming to terms with his prolonged separation from his culture following four years at the University of Montana, a year at Oxford University, and another year later at the University of Grenoble. Cultural as well as geographic distancing may be the price of outward success for the educated Native American.

Much of the novel's tension centers around Archilde's conflicting desires of "coming home" or leaving the reservation for good. This tension is embodied in his relationship with his father, Max Leon, a Spaniard who settled in the valley, married an Indian woman, and had several children before becoming estranged from them. Archilde, who has just returned to the reservation, is his father's last hope as an heir to the land and fortune he developed over the years.

Other points of conflict in the novel are the relationship between Archilde and his brother, a "bad" Indian, and between the native and white communities at large. The white characters in the novel are representatives of the major cultural institutions that confronted Indians after contact: the economic system, embodied by a former trader who is now a merchant; the Church, represented by an older and a younger priest; and the law, symbolized by an Old-West-style sheriff.

Despite the role of the Church in the forced education of Indians, McNickle's most sympathetic portrait of a non-Indian is of an elderly priest, Father Grepilloux, who was one of the first to come to the reservation and now has returned in his retirement years to write a history of the experience. This elderly priest is instrumental in Archilde's and Max's slow reconciliation and in Archilde's decision to stay on the reservation, at least for a while, in order to continue his study of the violin with one of the other priests.

McNickle's novel debunks some of the pervasive myths about Indians. He rejects the romantic portrait of Indians as noble "children of a lost paradise." He also avoids describing all Indians with a few overarching characteristics. One of the goals of the book is to account for an overall change in Indians after contact with the whites; and in it the emergence of

the "bad" Indian contrasts with earlier accounts of the "mild" Salish people.

Part of the change is found in the relationship of Indians to the Church. After hearing of the new religion from members of the Iroquois tribe, the Salish sent small groups from Montana to St. Louis to bring the "Black Robes" to the West in order to learn more about their religion. Eventually, the Black Robes arrived. The Salish were favorably inclined toward the Church, and many continued to faithfully practice during the period in which *The Surrounded* is set. However, in the novel, the strongest sign of disaffection from the Church is the rejection by Archilde's mother, "faithful Catherine," of Church rites and doctrine. Throughout the novel, Catherine's doubt in Church teachings increases.

McNickle's rejection of the Church through the character of Catherine foreshadows the return of some Indians to traditional religious practices, a theme of many documentaries. For some, traditional practices such as the sweat, demonstrated by Flathead spiritual leader Johnny Arlee in *Awakening* (1976) of *The Real People Series*, are examples of spiritual renewal validated by the elders of the community. *Awakening* tells of Arlee's quest for personal healing through his renewal of traditional practices such as ritual sweats and solitary contemplation in the mountains. The film also documents Arlee's heightened role as a community leader or, as he says, "a go-between between the young and old." From his own personal difficulties, he realized the pain caused to children from broken homes and formed numerous "drum groups" to help bring kids together. The groups strove to "make the drum sound like one," a task that demanded the united concentration of the performers. Young singers and performers learn cooperation as a basis for successful performance. This can be contrasted with Western music education contexts, which emphasize a clear group hierarchy based upon the competitive chair system (ranking order) within each instrumental section. In *Warrior Chiefs in a New Age* (1991), a video made fifteen years later, Dean Bearclaw (Crow) also emphasizes the role of the drum group in passing on generational values. Extended sequences of the video feature an outdoor performance of the "Cedar Child Drum Group" intercut with shots of children running, playing, and singing and voice-over narration explaining the importance of children as an intergenerational link. An implicit claim of a number of the videos is that a return to traditional spiritual practices is the strongest

antidote to the dissolution of community, evidenced by the widespread use of drugs and alcohol.

However, in Phil Lucas's docudrama of the Alkali Lakes community's dramatic turnaround from near total alcoholism to a rejection of alcohol (*The Honor of All* [1985]), it is one of the local priests who provides strong support for the Indians' efforts. The Church's role as a healing force in the community isn't necessarily rejected while the ongoing interest in traditional Native American religions is rekindled. In some communities, such as the Koyokan community of Athabaskan Indians documented in the five-part *Make Prayers to the Raven* series (1987), traditional and Christian religious practices may be balanced. The second episode of the series, *Bible and the Distant Time*, underscores the affinity between Athabaskan creation myths and Christian stories from the Old Testament. Indian beliefs in the pervasiveness of spirituality in the natural world are blended with compatible Christian beliefs as demonstrated in a sequence depicting a handful of native faithful singing the traditional spiritual "He's Got the Whole World in His Hands" in an outdoor setting. The Christian doctrine of sin is understood by local Indians in the context of "sins against nature." While many American Indians who experienced an initial conflict between the two belief systems have been able to blend them in their own understanding, they feel it is important to maintain the traditional "nature spirit" beliefs because a deep respect for the land is something they don't find in whites' actions or beliefs. These traditional beliefs are maintained through prayer, myths in the form of stories, and communal feasts or potlatches.

In *The Surrounded*, it is in the context of a traditional welcoming feast that Archilde is confronted by a past he had forgotten or never knew. At the dinner, elders relate traditional stories of the tribe. One of these is a coyote story. In many Indian cultures coyote is the trickster that creates new tools or difficult situations through his curious explorations and humorous exploits. One way back into the fold, then, is the retelling of the traditional tales. This role of oral narrative in collective identity is seen in several native-produced or coproduced videos including *Chalath Whadlik* (1989), which portrays the telling of raven stories by Northwest Coast Indians; *Tiwa Tales* (1990), which incorporates clay animation to tell traditional Pueblo stories; and the series *Word and Place: Native Literature from the American Southwest* (original release 1978), which documents traditional tales and songs of the Navajo and Hopi in their mother tongues.

The Chief, Modeste, is the last to tell his story at the feast. While the other stories are meant to amuse, the Chief's is directed to Archilde to let him know what it was like in the old times. Modeste's story is an oral history of the Flatheads, recounting the acquisition of guns by traditional enemies of the Flathead such as the Blackfeet and Crow and the gradual decimation of the tribe by the new weapons. So many deaths occurred that the violence was never revenged, despite continued conflicts after the Flathead themselves acquired weapons. Modeste's tale continues with the arrival of the Black Robes and the Flatheads' dashed hopes for a renewed power: "We thought they would bring back the power we had lost—but today we have less" (McNickle 1978 [1936], 74).

This tale of past conflict, oppression, and resignation seems to prefigure the historical orientation of many documentary videos. One of the strongest themes in Native American video is the reevaluation of the past. The elders, traditionally respected in Indian culture, necessarily take a central part in this retelling. Videos like *The Place of Falling Waters* (1990) (see Fig. 2) and Dean Bearclaw's *Warrior Chiefs in a New Age* (1991) give voice to elders in a way that histories written by outsiders have never done. Archilde's own reaction to Modeste's story reveals a motivation at the root of recent videomakers' attempts to retell history through the voices of their elders: "Perhaps the old people had nothing, and perhaps they were despised, but it did not seem deserved. He found himself thinking about them rather often, he kept wondering about their lives" (McNickle 1978 [1936], 113).

Several other themes that affect contemporary American Indians are presaged in McNickle's story. While the story of contact with the Church is one of a gradual loss of faith, episodes detailing Archilde's contact with the law are much more abrupt and violent. A key turning point in the novel is when a game warden discovers Archilde, his mother, and brother deep in the mountains. Archilde has just returned to camp after failing to shoot a deer after he had trained his rifle on it. Though he was excited about the hunt, he suddenly realized that killing for sport instead of for food was hollow: "The excitement was increased when a man kept himself from starving by his hunting skill. But lying in wait and killing, when no one's living depended on it, there was no excitement in that. Now he understood it" (McNickle 1978 [1936], 121).

Upon returning to camp he manufactured a feeble excuse for his mother, only to have his renegade brother, Louis, soon show up with a

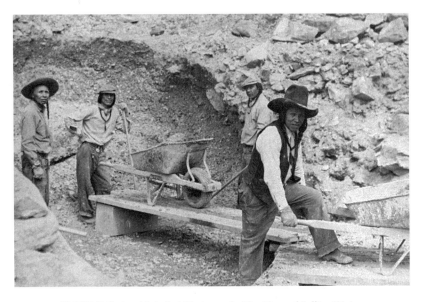

FIGURE 2 ► Historical Photograph, *The Place of Falling Waters*
Native historical documentarians often seek to establish a close connection between the past and present-day realities: Elders provide this direct link to the past. The goal of Roy Bigcrane and Thompson Smith for *The Place of Falling Waters* (1990) was to document past developments concerning the Kerr Dam on the Flathead Indian Reservation, especially revolving around white and Indian interaction, and the effect of these developments for the past, present, and future condition of local Indian culture. The videographers made frequent use of historical photographs, such as this one depicting native laborers working on the dam. (Courtesy of Salish Kootenai College [SKC] Media Center)

freshly killed young doe. As Louis aggressively challenges Archilde to show him his own kill, a game warden quietly rides into camp. He accuses Louis of an illegal kill—female deer are illegal quarry—and prepares to take him in. Louis protests that, as an Indian, he is "free from all game laws by special treaty" (McNickle 1978 [1936], 125). The situation escalates and the game warden murders Louis as he makes an ill-timed reach for his rifle, then climaxes when the mother, Catherine, revengefully kills the game warden as he inspects Louis's body.

In addition to being a tragic act that shapes Archilde's destiny in critical ways, this confrontation points to a number of issues in contemporary white/Indian relations: the questions of legal jurisdiction over tribal prop-

erty; of differences in the hunting and fishing rights of Indians and non-Indians; of the role of hunting in Indian culture and how it may have changed; and the overall issue of different attitudes about the land in Indian and white cultures. A recent video, *Lighting the Seventh Fire* (1994), directed by Sandy Johnson Osawa, documents a struggle for land and resource rights. The documentary focuses on the advocacy by Chippewa Indians of and opposition by many non-Indians to spearfishing rights on Lac du Flambeau in Wisconsin. This video relates the historical basis of the Chippewa claim to their fishing rights and the struggle within the courts to have those rights recognized. However, the court battle was only half the battle waged by the Chippewa. The deep-seated racism of the whites, especially the sport fishermen, in this region made the court's decision very difficult to implement. Native fishermen were the subject of shootings, rock throwing, pipe bombs, and intense verbal harassment of a racial nature. The intensely negative racist reaction to fishing rights for Native Americans only strengthened the resolve of the Chippewa leaders to assert their rights. Thus, legal and accompanying cultural differences related to hunting remain as major difficulties in the relationship between whites and natives sixty years after McNickle's novel.

But hunting often retains positive value in Native American communities. For some natives the hunt is a ritual that provides physical sustenance but also reveals a spiritual tie to the land. Videos like *The Passages of Gifts* (1987), Part 1 from the *Make Prayers to the Raven* series, demonstrate how even commercial trappers treat their game in a special ritual fashion designed to show respect to nature. An earlier film from *The Real People Series*, *Circle of Song* (1976), documents the intergenerational importance of hunting for Spokane Indians. Hunting, and the preparation for the hunt, which includes the singing of special songs, are ways that cultural values about the land are transferred from father to son. "Songs are given to us from Mother Earth, from the wind and the mountains, from the visions in the clouds, from the animals that walk the earth and the ones that fly in the air, from the old people, and from our hearts" (Sijohn 1976). This film underlines the importance of symbolic behavior for intergenerational continuity and ethnic identity, even when other aspects of life may closely resemble the lifestyles of the larger, mainstream culture.

My father lived through the era of the changing of the Indian, from the warriors to the farmers, to the peaceful Indian who dressed like a white man. Now I find myself living in that world: dressing like the white man, speaking like the white man. But I refuse to

give up my values that my father has given me and his father gave him. The values of
the Indian, the treasures of the Indian, the life of the Indian. I refuse to give those up.
I have told my children to refuse, [and] to tell their children to refuse. (Sijohn 1976)

By asserting that many of the changes affecting Indians have been merely changes in appearances and livelihood rather than changes in basic values, Cliff Sijohn, the central subject of the video, acknowledges the power of symbolic behaviors, such as ceremonial dance and song, to perpetuate those values. Several portions of the film refer to hunting, the primary means of sustenance during the precontact era. Sijohn explains that hunting remains "extremely important to my family. . . . Deer meat is a basic part of our diet. . . . Hunting to us is a way of life; it is not a sport, it is not for fun" (1976). He adds that there are songs for each of the animals in nature. The hunters' dependence on natural balance motivates native hunters to show respect for their environment, a respect that includes the attribution of special intelligence and purpose to animals. For instance, when Cliff and his sons' tracking brings them upon a tree full of bald eagles, he explains to the boys, "The deer brought us here for a specific purpose . . . this is where your education is—with the animals and the birds" (Sijohn 1976).

For some Indians, the processes of learning to hunt and learning to sing are integral to one another, and for male members of the tribe, they are an essential part of the transition to manhood. Animal symbolism abounds in native cultures, and much of this symbolism relates to the central place of hunting in aboriginal societies. Though the hunt itself may have been replaced as a form of *physical* survival, the symbolism associated with hunting continues to have a central place in *cultural* survival. The overriding theme of *Circle of Song* is that the Spokane Indians have songs for *everything*. However, this may change as children, less tied to the traditional ways of life that are the source of the songs, understand less and less of their meaning. Songs once understood by everyone are now rarely understood by children. Part of the reason for this decline of understanding is the loss of native languages. Traditional song can only survive in the fullest sense when native languages survive. Thus, song is more at risk of disappearance and less easy to revive than other expressive forms, such as dance and the visual arts, which depend less on the knowledge of language. For the same reasons, narrative song is less likely to cross tribal boundaries. Musical and rhythmic aspects of music may flourish in intertribal contexts, but language often highlights cultural differences.

In *The Surrounded*, Louis's murder seems to be the price he pays for ignoring the tradition and ceremony many Indians attach to nature. Louis represents the "bad" Indian that McNickle feels emerged soon after contact with whites. McNickle, for instance, describes a change which overcame Louis after being sent away to a Catholic boarding school. This was represented by a change in his interaction with his mother; he never met her gaze directly, demanded food and horses from her, then gambled the horses away, stabbed a man, and ended up in prison. He then stole horses, which he spirited off to the mountains in order to hide from the relentless pursuit of the sheriff.

Archilde's nephew Mike, one of the boys who is tricked into attending the mission school, also experiences a horrifying detention at a boarding school that markedly changes him. For the other students, his run-in with the priests is evidence that the mark of evil is upon him. And it is the fear—of the dark, of the woods, of hawks, of horses—associated with a first-hand experience of evil, that seems to have marked Mike. This experience of boarding school students like Mike is part of the general question of whether Indians are better off after learning about evil and sin at the schools; as the old Spaniard, Max Leon, doubts, "Were they saved or were they destroyed?" (McNickle 1978 [1936], 139).

Archilde tries to help Mike overcome his "sickness" and thus avoid the fate of Louis, who met an early death. He discusses Mike's plight with Modeste, the old chief who emerges as Archilde's mentor. Modeste suggests a cure for this sickness, which he believes is rooted in fear.

There will be a dance of the old times down on Buffalo Creek, below St. Xavier. I will go to this dance. As you know, I have been without eyes for a long time and you know how I go about. My grandchild walks in front, holding a thong, and I follow. Now, it will be a good thing if Mike comes to this dance, to hear of the old times and dance with us who lived in those days. If he wishes, and you let him, he shall take the place of my grandson and lead me by the string. (McNickle 1978 [1936], 199)

This attempt to reawaken Mike's cultural pride and self-esteem is very close to the motivation of contemporary video- and filmmakers. The intergenerational contact embedded in aesthetic practices and ceremonies is at the heart of many videos.

For instance, Victor Masayesva, in *Siskyavi* (1991), a video about Hopi pottery, contrasts the relationship between an old woman and her grand-

daughter with the technological understanding of pots emphasized in non-Indian contexts. He compares the girl's interaction with her grandmother as she gathers clay, prepares it, and makes pots with a field trip by several young Indians to a lab at the Smithsonian Institution in Washington, D.C. The two cultures' attitudes toward pottery are placed in stark relief. For the Hopi, pots symbolize a continuity of generation, tribe, and the human and natural world; for the Euro-Americans Hopi pots are scientific evidence to be examined in excruciating detail to produce clearer archaeological understanding. Other videomakers make even more direct reference to the healing, restorative power of aesthetic practices which can reunite communities. These videos are discussed in detail in the following chapters.

In *The Surrounded* McNickle describes the community role of aesthetic practices and how these practices are perceived differently by outsiders. His description of the dances points to reasons why community singing and dance are the focus of current cultural revivals.

In the old days the Salish people held a great dance in midsummer, just as the sun reached its highest point. They would come together from all parts of the country; all branches of the nation would be there; their tents would be scattered over miles of prairie land. . . . This dance was the expression of their exultation at being alive, it sang of their pride, their conquests, their joys. . . . Such a dance could not be tolerated in later years. Its barbarous demands on strength offended those who came to manage the affairs of the Indians in their own homes. There was nothing wrong with the dance in itself but it ought to be kept within reasonable limits. If the Indians wished to express their joy for, say, ten hours a day and then rest, like a factory or office worker, that would be all right. (McNickle 1978 [1936], 203)

Events that lasted several days threatened the economic system, in which Indians were an available pool of manual labor, that whites hoped to impose on the reservation. By limiting the length of dances, whites attempted to assimilate Indians into a new temporal system structured around the demands of work. But "culture" is not easily contained by the temporal structure of the work world; this difference is another site of conflict between natives and non-natives (see Fig. 3).

McNickle devotes several passages of his novel to the feeling of riding horses. As an important symbolic animal in the Plains and Plateau cultural areas, the horse represents a feeling of unconquerable spirit. In Indian-

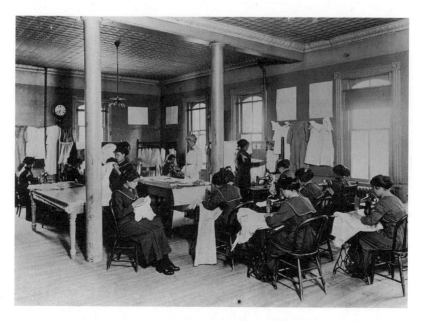

FIGURE 3 ▶ *In the White Man's Image* (vocational class)
One goal of boarding schools was to socialize Indians into the white world of work by training students to become laborers. At the school in Genoa, Nebraska, after the fifth year, men and women were separated into different classrooms and taught vocational skills. (Courtesy of The Genoa Museum, Genoa, NE, and NAPT)

produced films such as *Spirit of the Wind* (1976), horses are shown elaborately adorned for festival occasions. The rich detail of decor, beading, and blankets indicates that horses are central aesthetic objects in Plains cultures. As the carrier of the camp crier at contemporary powwows, horses carry songs to the people. Another social occasion in which horses figure prominently is the Indian rodeo. Rodeos are similar to hunting in that preparation for the rodeo is linked to the development of strength of character. Like hunting, participation in the rodeo functions as a transition to manhood and an intergenerational link; rodeoing is often handed down from father to son. Some rodeo events express the oneness of humans and animals, especially the horse, while others are designed around the competition between humans and animals.

In one passage, McNickle describes Archilde's impressions as he watches his nephew Mike dance.

For a moment he felt everything Mike felt—the rhythmic movement, the body's de-
light in a sinuous thrusting of legs and arms, the wild music of drums and dancing
bells, and best of all, the majesty of the dancers. It really seemed, for a moment, as if
they were unconquerable and as if they might move the world were they to set their
strength to it. They made one think of a wild stallion running free—no one could ap-
proach him, no one would ever break his spirit. (McNickle 1978 [1936], 218)

In this passage McNickle metaphorically combines the physical and spiri-
tual absorption in dance with the freedom symbolized by the horse in or-
der to express Indian pride. This metaphoric reference to the stallion, and
films like *Spirit of the Wind*, demonstrate that aesthetic experience as a
source of collective identification isn't limited to activities, such as dance,
that Westerners easily recognize as artistic. The examples of the horse and
hunting show that animals, the natural world, and the social occasions that
revolve around them are also important aesthetic loci.

Another major theme arising out of Indian/white contact that is de-
veloped in *The Surrounded* is the economic consequences of contact.
McNickle addresses economic questions through the character George
Moser, a former Indian agent who is now a merchant. Moser had been
present when the reservation was thrown open to white settlement and,
though he was familiar with the rationalizations of how settlement was
supposed to help the Indians, realized the injustice of the process. As a
businessman, he extended credit in the hope of staying afloat; therefore,
everyone in the valley was in debt to him. Even in the earliest days of reser-
vation life, then, a cycle of dependency and resentment had taken hold, a
cycle whose grip on some Indian communities continues to this day.

This is evident in a video like *The Spirit of Crazy Horse* (1990), which
considers the difference between the "hang around the fort Indians" and
those who hope to effect a fundamental change of life through the renewal
of traditional cultural practices. The hope is held out that a renewal of aes-
thetic and ceremonial activities will bridge the gap between those
benefiting from the system—often half-bloods—and those outside the
system, represented in the video by full-bloods and chemically dependent
Indians. Communal participation in dances and feasts and the solidarity it
affords have economic as well as cultural consequences.

In his attention to economic, aesthetic, and religious issues McNickle
anticipates a number of major themes in contemporary Native American
expression. As a product of the boarding school system, he was aware of

the devastating loss of culture and language in a system fueled by cultural shame. He writes thoughtfully about the dynamics of organized religion in Salish culture. When the Black Robes first came to the Salish, the Indians hoped the new teachings would give strength to their community. Some Native Americans still follow Christian beliefs, but many, like Archilde's mother Catherine, reject Christianity as hypocritical and return to traditional religions or balance Christianity with traditional ways. In *The Surrounded*, Western religion is contrasted with the traditional ceremonies and feasts, where stories central to the maintenance of culture are passed on from elders to younger generations. McNickle also anticipates contemporary issues such as hunting rights and disputes over legal jurisdiction that are often explored in contemporary videos.

At the end of the novel McNickle writes about the healing role of dance and ceremony, the way these activities express cultural pride and provide a sense of continuity with the past. Running throughout the book is a concern for the economic consequences of white/Indian interaction, another issue that is still central to reservation life and explored by contemporary documentarians. This novel, then, written in a driving, realistic style, demonstrates the continuity of social and cultural issues for Native Americans throughout the twentieth century.

ORAL EXPRESSIVE ANTECEDENTS

One assumption of Native Americans (Beaver 1991) and non-native scholars (Michaels 1987) is that contemporary media technology has been more readily adopted by traditionally oral indigenous cultures than written forms of communication because it more easily supports oral narrative forms than other communication forms such as extensive written histories. The maintenance of oral communication practices in the face of the loss of native languages has been a central concern for Native Americans throughout the twentieth century. For instance, Archilde's renewed interest in his culture was spurred by the stories of elders at a traditional ceremonial feast in McNickle's 1936 novel. And the most recent video documentaries, like *Transitions*, continue to explore the centrality of language and speech to cultural survival. Speech communication forms, including storytelling, oral history, song, and prayer, are central to a traditionally oral culture. As with literature, a full accounting of these oral genres would require a book in its own right.

Part of the task of studying oral communication forms is experiencing them in their own setting.[2] Relying upon a secondary source, the videos, limits the application of a strictly ethnographic approach to understanding traditional and contemporary indigenous speech genres. It is also difficult to generalize about traditional speech genres because they haven't been preserved in a manner similar to the pictorial record. In many cases we have to infer the structure and content of past speech from contemporary forms. However, another framework, Aristotelian rhetoric, helps explain the traditional functions of the various speech forms that emerge in the videos. The well-known tripartite framework of deliberative, forensic, and epideictic rhetoric provides an analytical division of speech forms based upon their temporal and functional orientations. Deliberative rhetoric is oriented toward the future and exhortatory in function. Forensic rhetoric is oriented toward the past and concerned with accusation, defense, and the motives behind past actions. Epideictic rhetoric focuses upon the present; it is used to fix praise or blame and rehearse communal values. One danger is that the imposition of a Western explanatory framework upon other cultures' communication forms leads to ignorance of the special qualities of those cultures' practices. This application of the tripartite Aristotelian framework to Native American oral communication forms is an attempt to underline possible characteristics shared between traditional speech forms and indigenous media aesthetics, but it is not intended as a summary analysis of native speech genres.[3]

From the war council to the tribal council, one central function of Indian speech genres has been deliberative. Council members try to convince each other, and then the tribe at large, of the relative merit of future courses of action. Usually, the goal of deliberative speech is to achieve consensus about proposed actions or policies. Council speeches are persuasive, designed to sway the opinions of others through both reasoned and emotional appeals. The third episode of *The Place of Falling Waters* (1990), which documents internal tribal council disagreement over the use of revenues, reveals that consensus through negotiation and persuasion can be just as difficult to reach within a tribe or council as in the larger society. But general consensus on a course of action remains a goal of deliberative speech, even when it is unattainable in practical terms. Videos which are primarily exhortatory, such as *Red Road: Toward the Techno-Tribal* (1984), incorporate the persuasive tone of deliberative speech and direct the message to Indians and non-Indians alike. An earlier example of

Indian deliberative rhetoric directed toward a non-Indian audience is the body of nineteenth-century speeches by chiefs when Indian cultures were under extreme pressure to give up land and traditional ways of life. These speeches, documented in popular anthologies like *Touch the Earth* (McLuhan 1971), demonstrate the refinement of deliberative rhetoric in traditional Indian culture.

Other examples of deliberative rhetoric are those videos which incorporate traditional prophecies as a guide to future actions. A unique example of this is the *Hopi Prayer for Peace* (1986), which was shown to the United Nations General Assembly after Hopis had repeatedly tried to gain access to that body. This video presents ancient prophecies as a guide for future international relations, indeed, as a guide for global survival; subjects covered range from racial relations to environmental issues to spiritual philosophies. Other videos refer to the role of prophecy in guiding action. Phil Lucas referred to the way prophecies shape his understanding of his work.

And so, as we begin in this new time that's coming—well, I don't know where you are in terms of knowledge of your own tribal prophecies, histories, or anything else—but I do know that this is prophesied; I do know that we are in a very particular, specific time. And I do know that we've got our shot at it and what we're supposed to do in terms of the coming together of the people. And I do know that we're going to play a major role in the unification of the planet. . . . I know all of those things because they have been prophesied. This is just my understanding from what the elders have told me and what I've heard from the elders of many of the tribes. (Lucas 1991a)

Roy Bigcrane has also discussed his belief in the importance of prophecy. Many videomakers are motivated in part by a feeling of historical opportunity rooted in their understanding of tribal prophecies. They see this time as an opening—one that will not last forever—in which they can positively influence the future by presenting a worldview counterposed to that of postindustrial capitalism. Deliberative aspects of Native American media extend beyond the domain of political and social issues affecting Indians to include philosophical debates about humankind's collective future.

While forensic speech more narrowly refers to the attempt at ascertaining motives and presenting evidence in a court of law, perhaps this analytic category can be extended to those expressions which weigh historical evidence and explore past motives on a grander scale. We have seen a

fictional example of forensic speech in Modeste's oral history of the Flat-
heads, where he recounts fights with traditional enemies such as the
Blackfeet and Crow, the arrival of the Black Robes and their debasing of
native culture, and the Flatheads' dashed hopes for a renewed spiritual
power. This account is based in experience: that elders were and are reposi-
tories of past knowledge and experience. Videos that incorporate state-
ments by elders about the past, along with the historical evidence of old
film footage and photographic stills, carry on a tradition of oral history
that attempts to account for the past behaviors and motives of tribal mem-
bers and their enemies.

A third category of rhetoric, epideictic, refers to those types of speech
which exhibit or explain presently held common values. Thus, the cate-
gory encompasses forms of communal celebration, such as the powwow,
which validate those central values that define a culture's *ethos*. An ex-
ample of epideictic rhetoric at powwows is the songs which honor contri-
butions of warriors before the wider community. The epideictic nature of
powwows is further demonstrated by videos such as *A Tradition Lives: The
Powwow* (1984), *Powwow Fever* (1984), *I'd Rather Be Powwowing* (1983),
and *Keep Your Heart Strong* (1986). *Keep Your Heart Strong* (1986) locates
powwow celebrations in the context of a Native American worldview that
emphasizes integration, harmony, and balance. The prevalence of reli-
gious symbols, including circles, represented by the drum, eagle feathers,
and the designs incorporated in beadwork, demonstrates that the powwow
is more than just a festive dance. The dominant theme of powwows is that
they are times for "the coming together of the group" (*Keep Your Heart
Strong* 1986), which is a defining component of epideictic rhetoric. Forms
of speech found at the powwow, whether they are the informal passing of
stories between generations, or the formal honoring of veterans in honor
songs, rehearse these communal values.

Another example of epideictic rhetoric that has strongly influenced
contemporary videos by both natives and non-natives is found in religious
speech or prayer. In films and videos like *Awakening* (1976), *Crow Dog's
Paradise* (1976–1978), and *Apache Mountain Spirit* (1985) traditional
prayers are represented. This documentation of contemporary prayer af-
firms the living status of traditional religions and their role in group iden-
tification. Secular healing documentaries that may draw from both con-
temporary group psychology and traditional religion in order to heal the
group, whether this is a therapy group or a community, can also be seen

as a form of epideictic rhetoric. Though other oral communication forms with traditional roots emerge in indigenous media expressions, this small sample indicates the continuity between past and present indigenous communication practices.

HYBRID EXPRESSIVE GENRES

Indigenous video production is not definable by a single set of properties. Rather, indigenous media are characterized by heterogeneous claims and practices. This heterogeneity is apparent from Weatherford and Seubert's subject heading index for their bibliography of Native American films and videos (Weatherford and Seubert 1988):

Animations	Land/Land and Water Rights
Archeology/Pre-History	Leaders and Leadership
Art and Artists Contemporary	Legislation
Art and Artists Traditional	Missionaries
Ceremonies and Rituals	Missionaries/Christianity
Child Development and Learning	Music and Dance
Children, Productions For	Myths and Tales
Crafts and Techniques	Native American Film Productions
Culture Revival/Survival	Native American Media/Co-Productions
Culture Change	Native American Independent
Daily Life	Media Makers
Dance and Music	Native American Community Media
Ecology/Natural Resources	Natural Resources/Economic
Economic Development	Development
Education/School	Oral Traditions
Elders	Oral Traditions/Native Language
Elders and Reminiscences	Political Issues
Ethnographers/Archeologists	Political Organizations and Actions
Food	Portraits
Fictional Productions	Powwows and Fairs, Giveaways,
Games and Sports	and Potlatches
Health/Alcohol and Drug Abuse	Reenactments
Health/Traditional Medicine	Reservation Life
Health/Western Medicine	Sacred Ways
Indian and White Relations	Series Titles

From the diversity of subject matter and issues addressed, it is apparent that indigenous videomakers vary in their concerns and goals. If grouping according to subject matter were the sole criterion of a genre or subgenre, then there are obviously many here to be considered. On the other hand, most of these videos can be included in the broad category documentary.

New genres may emerge through the blurring of previously distinct forms. When genres are blurred they create hybrid forms. This hybridization is seen in the recent development of the docudrama, a form unsettling to some critics because docudramas often blur fact and fiction. Taking their cue from the dramatic realism of nineteenth-century literature, twentieth-century cinema, and the television realism of shows such as *Hill Street Blues*, as well as the conventions of nonfiction forms such as investigative journalism, docudramatists have blended drama and journalism into a new form. Though this form raises ethical questions about the reenactment of news, it continues to gain in popularity, as shown by the continued success of television shows which feature short vignettes of dramatic rescues and crimes and miniseries that dramatize real-life events.

The docudrama *Apache Mountain Spirit* (1985), commissioned by the White Mountain Apache tribe and produced by John and Jennie Crouch of Silvercloud Video, confirms the centrality of ceremonial dance to Indian identity (see Fig. 4). The plot of the drama centers around a young boy, Robert, who has returned to the home of his grandmother after running away from his boarding school. In a state of inner conflict, Robert falls under the influence of Leon, a local hood, as well as the positive influence of his own family. A morality tale about hard choices, the video departs from other similar productions through its incorporation of dream and vision imagery. Presented as a form of power, dreams and visions occur for a reason: "When the power comes, it is real," but the power

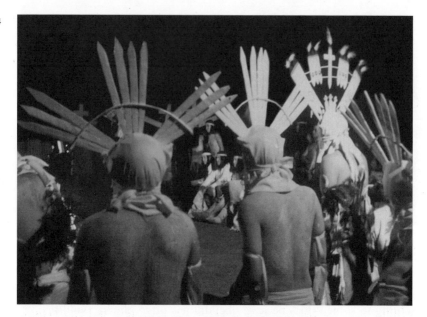

FIGURE 4 ▶ *Apache Mountain Spirit*

An Apache Crown Dance vigil outside of the cave where the central character of the video, Robert, had joined the Apache gods, the "Ga'an." This docudrama, commissioned by the White Mountain Apache tribe, creates a powerful fusion between traditional beliefs and contemporary realities and illustrates the creative potential of the docudrama genre. (Courtesy of John and Jennie Crouch, Silvercloud Video Productions Inc.)

has potential for danger; "it's like a rifle, it depends on who is usin' it" (the boy's uncle). In this context of real-life temptations and inner visions the boy is tested.

An extended sequence in the body of the video documents Robert's vision, set in the historic past. Almost surreal representations of the sacred Crown Dance are intercut with a symbolic hunt for a deer. The location of the deer appeared to the boy in a vision, even though older, more experienced hunters had lacked hunting success for some time. The boy predicts that One Feather will kill the deer but warns the hunters to wait for him before they butcher the animal, which they fail to do. At this point the narrative is skillfully cut to the present, where Robert gets caught up in an attempted burglary, backs out at the last minute, and is shot by Leon.

The climax of the video cuts back to a dreamlike vision of an Apache Crown Dance vigil outside of the cave where the boy had joined the Apache gods, the "Ga'an." In this sequence, dissolves, special effects that create sparkling halos around the dancing figures, and firelight illumination, along with the significant power of the hooded dance itself, effectively create an air of compelling mystery, agitation, and spirituality. Set in this context, the dance functions as a powerful form of prayer.

Native American directors have used docudrama for treating emotionally charged themes. Phil Lucas's storytelling has flourished with docudrama, beginning with his two-part *The Honor of All* video (1985). The videos reenact the struggle of the Alkali Lake (dubbed "alcohol lake" by local whites), British Columbia, band with alcohol and its effect upon the community, from its introduction by white traders in the 1940s to the successful effort of the community to go 95 percent dry in the late 1970s. In the period from 1960 to 1972 adult alcoholism in this community had neared 100 percent. Lucas focuses on the efforts of one family, with the help of a local priest and Alcoholics Anonymous philosophy, to release the grip of alcohol on the tribe. Lucas directs from the heart, notably through his casting of tribal members in the lead roles; they play their own former, alcoholic selves in a convincing, moving way. At the end of Part 1, Lucas shows a community gathering where lead characters in the video talk about the experience of acting out their former selves. The self-revealing group-therapy style of this epilogue ties the docudrama to the present, further underscoring the reality of the emotional trauma and healing documented in this drama.

This video about personal despair and community healing foreshadows some of Lucas's recent work, which incorporates actual group therapy sessions. In his video *Healing the Hurts* (1991), Lucas documents a workshop where people confront the deep-seated trauma resulting from experiences at boarding schools. In *Healing the Hurts* history is not an abstract, anesthetized, or distant past experience; instead, the past erupts into the present-day emotional lives of people. In his comments about the film, Lucas explains how the boarding school mentality passes from generation to generation, long after the actual experience. He begins by relating his own reactions to physical or verbal interpersonal violence. As a child he reacted violently to any kind of physical pain; as an adult he found himself flying into a sudden rage after simple mishaps. He tells of a recent in-

cident when he bumped his head and smashed his fist into a closet door in a blind rage for having hurt himself. His son, Jason, yelled from the living room, "Did you hurt yourself?" and he shouted back "Yes, goddamit, I hurt myself."

> So then it's dinner time and I mean it's quiet.
>
> Jason said, "Well, I was havin' a real good day 'til dad came home."
>
> She [Lucas's wife] said, "Well, what do you mean?"
>
> "Well, he got mad at me, I was just wonderin' what happened."
>
> At this point we were able to go back to that whole issue of why I got mad when they got hurt. And what I explained to them was that, when I was a very small child, all the kids I played with were larger than me, and they could always just beat the hell out of me. They would do terrible things to me and I would come home crying but instead of getting [this] from my parents, what I got was [he yells]: "You're so goddamn stupid. You haven't got the brains God gave a piss ant. You know we tell you over and over again those kids are going to hurt you. Why do you go play with them? Why are you so fucking stupid?" That's what I got and that's what we pass on from the boarding schools to our kids.
>
> And so, we have these feelings, these ways that have been taught institutionally. We have five generations of people who have no role model for parenting. No role model for how siblings interact with one another. No role models as to how the opposite sex interacts with one another. Five generations. But we have this wonderful ability to survive. We have this wonderful ability to [adapt] and forget the pain of these experiences.
>
> And this film is an attempt to move beyond the step of denial . . . to begin looking at how our attitudes have been affected . . . by the boarding school. (Lucas 1991b)

This style of documentary reveals destructive personal, social, and historical experiences. It's important to note that a number of Native American film- and videomakers have grappled with the common pain of Native Americans and attempted to face, head-on, their legacy of cultural genocide resulting from their confrontation with whites.

Indigenous documentary has visual, literary, and oral precedents in both Native American and Anglo-European communication practices that are essential to understanding its origins and development. This chapter suggests the relationship between Native American documentary and the expressive forms which preceded and shaped its development, but more detailed studies by specialists in these antecedent forms of expression will help draw out this relationship. As a larger body of indigenous films and videos develops, it may be possible to generalize about regional

styles; for instance, Plains media seem to be taking on some of the histori-cal narrative content and structure of earlier expressive forms. The thematic connection between contemporary media and earlier expressive forms is somewhat clearer: cultural preservation and loss, the challenge of economic survival, relationships of natives to Western political and religious institutions, the continuity between generations, and other themes bind recent media to earlier native expressions. Few native media expressions produced to date are self-consciously modernist or avant-garde. Though innovation takes place in indigenous media, it tends to be innovation within traditions of documentation, storytelling, and visual expression, not a radical departure from the past. In both stylistic and thematic concerns, indigenous media reflect many natives' valuation of historical continuity.

AN INDIGENOUS MEDIA AESTHETIC?

E HAVE seen that contemporary media expressions share an affinity with traditional native expression. But do Native American media documentaries constitute a unique aesthetic expression? Scholars expect that distinct identities will be expressed through native visual and narrative styles different from those found in documentaries by non-natives. To address this question, this chapter focuses on the work and stated goals of two noted native videographers, George Burdeau and Victor Masayesva, Jr. Native imagery of nature emerges as a central and controversial issue in native media aesthetics.

George Burdeau has been singled out by his peers for his early involvement in Native American documentary and his role as an educator and organizer in the indigenous media world. However, his work is less frequently discussed in the context of a unique indigenous aesthetic than Masayesva's (Silko 1990; Sands and Sekaquaptewa Lewis 1990; Silberman 1992). In fact, few directors other than Masayesva have been singled out for their uniquely indigenous way of seeing. Exceptions are found in discussions of works of novice native film- and videomakers (Worth and Adair 1972; Michaels 1987). However, the rise of indigenous media production in the late seventies involved the efforts of media-literate producers and directors. In this context, the recent focus on Masayesva raises the possibility that discussions about an indigenous aesthetic have involved a critical debate about the merits of one director's work. If this is the case, the question of a distinct indigenous media aesthetic may have lapsed into auteurism.[1] Therefore, this section considers the work of a more mainstream documentarian, Burdeau, before discussing Masayesva.

GEORGE BURDEAU

George Burdeau locates the origins of native media in the affirmative action policies of the mid-seventies and the efforts of a few native producers to get other natives involved in media.

Twenty years ago there was a thing called affirmative action that opened up a few doors for a few of us producers [and offered] the opportunity to make some films from our point of view. When I started in Washington state on a project there, it was a situation where I felt it was very important that we had more native people behind the camera and I insisted on it . . . and they agreed. "If you want to have native people behind the camera, we're more than happy to have them." But then I had the job of going out and finding them, and they weren't there. So what I ended up doing is actually going out to the reservations. . . . And, surprisingly, we were able to produce in that very first project thirteen half-hour documentaries. And it began a movement that's been going along for the last twenty-something years. Now, more and more native people have gotten experience. (Burdeau 1991b)

According to his own account, Burdeau was involved in native media from their beginning. Two factors, making films from an Indian point of view and using Indian talent, motivated Burdeau during this period. Burdeau's films from the early series that he directed in Washington state, *The Real People Series* (1976), include *Circle of Song* and *Awakening*. Both of these films are highly personal profiles of individuals, Cliff Sijohn and Johnny Arlee, who maintained and revived traditional aesthetic and religious practices in order to foster intergenerational continuity. While Arlee and Sijohn acknowledge the challenges presented by the breakup of families and other social problems on their reservations, the tone of the series is largely positive. This may reflect influences of the funding source (Office of Education, HEW, Emergency School Aid Act), intended audience (Native American children and families), and series advisory board (eighteen-member, 50 percent Native American) (Weatherford and Seubert 1981, 98). The series is personal in focus but regional in scope. Aspects of lives of Native Americans from the Spokane, Colville, Kalispel, Kootenai, Nez Perce, Coeur d'Alene, and Flathead tribes are documented.

Burdeau's overall approach is personal, though not overtly biographical. He singles out specific individuals for concentrated attention and visually reinforces this personal focus by filming their home environments. Thus, in *Mainstream* (1976) the camera enters a cabin in the Northwest woods where a Spokane native woman has moved from the city. The camera's eye explores the interior of the cabin, settling on close-ups of glass kerosene lanterns and well-scrubbed old cookware. In *Awakening* Arlee speaks to the camera from his kitchen table while his wife fries bread and his children sit around the table with him. One sequence depicting a family drum group practice in *Circle of Song* takes place in Sijohn's living

room. In *Spirit of the Wind* (1976), which documents the place of horses in Indian cultures, Burdeau trains his camera on a former Indian rodeo rider who now lives in an older downtown hotel in a Western town. The director interweaves shots of the old man in the hotel lobby with sepia-toned film footage of his rodeo heyday.

Burdeau's expressive interior shots complement his narrative focus on the personal lives of magnetic individuals and anticipate the striking interior interview settings of *The Pueblo Peoples: First Contact* (1990). This video opens with a shot of a dignified Zuni elder, dressed in white, sitting in front of a fireplace in a white room room bare of furniture or wall decor. In another sequence, interview subject Edmund Ladd, curator of ethnology at the Museum of Indian Arts and Culture, sits in a sparse interior composed of simple arches and lines. With little extra decor or strong color the interiors seen in *First Contact* are classical in their restraint. Several of the sequences show the host of the episode, Conroy Chino, in a gray-walled underground *kiva* (see Fig. 5). The hard-edged designs of the wall murals and the ladder leading upward out of the room blend with its geometric structure. These shots of sparse, clean, geometric interiors of residential and communal rooms express the highly ordered and contained nature of the Pueblo worldview. In *First Contact*, as in the earlier *Real People Series*, Burdeau's attentiveness to interior settings and details reveals aspects of his subjects' lives and thought beyond the spoken narrative.

Landscape is central to Burdeau's visual repertoire. From the mountain and prairie landscapes of *The Real People Series* to the sun-drenched desert scenes of *First Contact*, Burdeau develops the context for his narratives through landscape. For instance, the director zooms from a long shot of Montana's Mission Mountains to a close-up during a sequence that describes the mountains as a source of spiritual renewal in *Awakening*. This example points to the constant connection Burdeau draws between the land and human activity. In *Spirit of the Wind* low-angle shots of a steep bluff and flyover shots of the Omak River and Omak Stampede (a horse race) in central Washington heighten the sense of challenge faced by men and animals during this annual event.

Burdeau establishes this connection between humans and the land as a formal editing device in *First Contact*. After the opening image of the elderly Zuni man, Burdeau symbolically links the fire in the fireplace behind

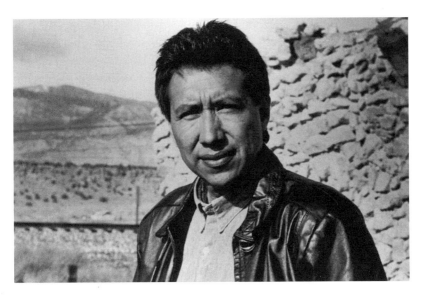

FIGURE 5 ▶ Conroy Chino, *Surviving Columbus*
Conroy Chino (Acoma) hosted *Surviving Columbus,* an exploration of 450 years of inter-
action with Europeans from the perspective of Pueblo Indians. The program was broadcast
on Columbus Day, 1992, the Quincentenary anniversary of the arrival of Columbus in the
Americas. (Photo by Lee Marmon, Courtesy of NAPT)

the elder to the light of a full moon, followed by stop-action-style effect
shots of lightning and a high-contrast shot of the reflection of light on
water. This sequence of edits comes full circle as Burdeau dissolves a
frontal close-up portrait of the elder's deeply wrinkled face over the light-
reflecting water. In other sequences Burdeau and his editor Dale Kruzic
(also executive producer of the episode) dissolve from historical stills to
contemporary shots of ancient structures and landscape forms; almost all
of these are cut on form. For example, an historical still of a group of three
women, each wearing loose, dark cloaks or blankets, is dissolved into a sil-
houetted image of a lone desert tree, echoing the outlined form of the
three women. Through dissolves Burdeau expresses the Pueblos' desire to
"blend their lives into the surrounding environment" (*The Pueblo Peoples:
First Contact* 1990).

A similar sense of connectedness emerges from Burdeau's intercutting
of humans and objects such as pottery bowls or architectural forms. At

one point Burdeau's videographers dissolve from an early portrait of a Pueblo Indian to an Anasazi pottery bowl. The bowl's image then dissolves over an historical still of three Pueblos. The bowl's circular form exactly encompasses the pyramidal form of the three Indians, formally expressing the close integration between art and life in traditional Pueblo cultures. In several instances, shots of traditional art forms such as murals, rock paintings, painted pottery, and ceremonial drums are used by the videomakers to illustrate narrative content. As Mecalita Wystalucy, an elderly Zuni house chief, explains old myths, the videographers dissolve back to very slow pans of early artwork in an example of illustrative, thematic editing. Burdeau's frequent juxtaposition of portraits of humans and their creations imparts a sense of underlying connectedness.

Burdeau uses dissolves so frequently, especially between imagery of humans and nature, that the technique stylistically defines the visual character of this video. His use of multiple dissolves, expressive lighting, montage editing, and other techniques establishes that Burdeau's style remains filmic even though he has adopted the video medium. The formal elements of Burdeau's mature style, seen in the video *The Pueblo Peoples: First Contact* (1990), are already in place in the films of *The Real People Series* (1976). These include editing on form, variations in editing pace, unusual shots such as landscape flyovers and low-angle shots, frequent zooms and pans of various speeds, extensive use of dissolves, many slow-motion and stop-action shots, point of view camera work, early morning and evening photography, and a close linkage between visual material and narrative content.

Like other directors, Burdeau increases the pace of editing to create visual and narrative action. Toward the end of *Spirit of the Wind* he cuts several very short bronc-riding scenes together to express the action and intensity of rodeos. He follows this sequence with a number of slow-motion, lengthier shots of roping and tieing events that effectively convey the formal beauty of the sport. Skillful variations in editing express the violent grace and danger of events like bronc and bull riding and the studied skill of roping, a contrast which could not have been drawn through a single editing tempo. A casual observation about native film and video is that they are paced more slowly than non-native film. This filmic expression of "Indian time" may be true in many cases, but Burdeau varies editing pace within a film to coincide with narrative content; his films do not feel "slower" than films and videos made by non-natives.

Burdeau's heavy use of dissolves in the later video, *First Contact*, super-
sedes the juxtaposed short cuts that varied the tempo in the earlier films.
However, he still introduces temporal variation through the use of special
effects shots, including very slow pans and landscape flyovers. One pan
over the surface of a painted drum late in the video echoes the earlier
flyover shot, drawing a visual analogy between the drum and the earth and
between native ritual activities and natural processes. The constant mo-
tion of the camera expresses the Pueblo principle that "everything is con-
nected to a movement, to a life giving force" stated by the narrator, Chino.
Formal camera motions echo movement in nature: the flow of water or
flight of a bird.

Burdeau also uses camera motion in combination with point of view
shots in order to draw the viewer into the historical narrative. In some
passages Burdeau's videographer Kirk Loy places the camera close to the
earth and advances it across the terrain through tall grass. This coincides
with a narrative description of Coronado's advance upon the Pueblos;
viewers are placed in the shoes and eyes of Coronado's soldiers. As the
grass topples with our forward motion, we become the advancing Span-
iards. This sequence is followed by a close-up shot of a native hand sprin-
kling a sacred cornmeal line on the earth as a warning to stop advanc-
ing. The director then cuts back to the point of view shot, achieved by the
relentless advance of the camera through grass and shrubs. Since Coro-
nado's gruesome exploits make him the villain in this narrative, Burdeau's
choice of a point of view shot at this juncture in the story may be an invi-
tation for white viewers to assume responsibility for the invasion of the
Pueblo homeland or to identify with the invaders. Because this was a pi-
lot for a series to be broadcast nationally, the videomakers could safely as-
sume that the majority audience for the episode would be non-Indian. Al-
ternatively, the shots may increase sympathy for and identification with
the victims of the soldiers' attacks. In either case, like point of view shots
in horror movies through the eyes of the stalker, Loy's camera work im-
parts a sense of imminent danger and inevitable violence.

Burdeau's editing, multiple-angle and point of view shots, and palette of
special effects demonstrate his familiarity with the techniques of contem-
porary filmmaking and videography. The very sophistication of Burdeau's
editing and dissolve techniques strikes some non-native viewers as too
"slick": rather more like a varied repertoire of experimental "film school"
techniques than representing a uniquely indigenous aesthetic (Visual

Communication Seminar 1993). Does this impressive array of modern techniques, many of which are also used by non-natives, detract from or support Burdeau's early stated goal of making films from a distinctly Indian point of view? This question can only be answered by considering formal aspects of native media in tandem with content. Searching for an Indian aesthetic based solely upon formal criteria ignores the link between aesthetic and other cultural systems which join to form a worldview. For instance, Burdeau's technical vocabulary allows him to express a sense of connectedness between humans and nature, between humans and their built world, and to weave an individual, personal focus into his narratives. Though similar technical means may be employed by non-native filmmakers, the particular combination of technique and content that Burdeau achieves in his work results in a uniquely native perspective. In film and video, which developed on an international scale, many formal elements transcend cultural boundaries. However, the application of those formal principles to particular ideas and content varies widely between cultures.

Just as Burdeau has aggressively experimented with the latest media techniques in order to express an Indian point of view, he feels the advent of even newer technologies has enormous potential to create new kinds of Indian communities that transcend former boundaries.

What strikes me most importantly right now, at this particular point in time, this conference, this decade [is that] we as Indian people have a real opportunity because of the technology that is out there to utilize it for our own purposes: to create for ourselves a system by which we can once again effectively communicate, not only in our own individual communities, but also in our regional and national communities, and to the world at large. There are a lot of issues that face Indian people today: economic viability and sovereign rights, our artistic expression, and so many [issues] in the area of education. And we need to be able to communicate not only within our own communities but with each other, to provide some sort of unity in our ability and our efforts to try and improve our quality of life, not only for ourselves but for future generations.

The communication technology is going through tremendous change in this next decade with the advent of all kinds of new communication processes: the interactive capability of computers; the ability of one to talk to one clear on the other side of the continent—at the same time to share in creating something together even though they're not in the same place. It's going to be an incredible, empowering capability. . . .

Technology in the world at large tends to just go in its own direction. It doesn't seem

to have a specific plan as to how it's been utilized. I think we as Indian people have
something to offer. . . . We can use it for our own use, but I think we have as part of our
history a cultural perspective that I think can provide some responsibility in the use of
new technology.

. . . I think we have an exciting potential in that, not only can this serve our basic
needs in terms of education, political expression and our entertainment needs, but also
that it can provide an economic base for us. It allows for this decentralized system to
be in place. What I mean by that is that we can have producers throughout all of our
tribal communities who will be impacting one specific program about the history or
culture of a particular area or tribe. In other words, I could have a producer working
out of Seattle or Spokane, have a writer who lives in the Southwest, and researchers
who live on the East Coast all working together through this interactive communica-
tion system, developing a program for our children about our history and culture. This
means that you could live at home, that you could be on your own reservation or you
could be in the city if you so desire. But you have the choice; we have the choice now,
as Indian people, to . . . have an opportunity to impact not only our own communica-
tion needs but the communication needs we [have in common]. (Burdeau 1991b)

Burdeau's view of the potential of media technologies to unite creative
people and communities separated by distance is distinctly pan-Indian.
Will this pan-Indian aesthetic that is enabled by technology be an indige-
nous aesthetic? Burdeau often refers to regional and national affiliations in
addition to local communities. This is reflected in his recent effort to "try
and develop an overall concept, an agenda, a plan as to how we can em-
power ourselves as native people to use communication technology"
(Burdeau 1991b). Burdeau's national outlook may derive from his child-
hood and youth. Though a member of the Blackfoot tribe, he was raised
in Oklahoma as an "urban Indian," relatively unexposed to his own tribal
background (Burdeau 1991b). As a film- and videomaker his scope has
spanned many Indian cultures, from the Northwestern Plateau tribes in
The Real People Series to Southwestern Pueblo tribes in First Contact.

Burdeau closely attends to craftsmanship, a characteristic seen in other
Indian aesthetic forms. In many of his works he integrates human and
natural activity. He prefers an individual, personal focus over an abstract
approach to issues facing contemporary Native Americans. Though his
technique is progressive, he finds the source of his subject matter in the
impact of the past upon the present. Burdeau employs an expressive,
filmic style that incorporates a number of effects. His open attitude toward

new techniques and technologies might be considered non-Indian by those critics who feel cultural authenticity is determined by modes of material production or that the "local" contains the seeds of indigenous aesthetics. However, Burdeau feels that new technologies hold out the potential of increased communication and economic self-determination for indigenous people, a potential that can help produce a sense of community solidarity at the local, regional, national, and international levels.

VICTOR MASAYESVA, JR.

Like George Burdeau, Victor Masayesva, Jr., brings a high level of craftsmanship and personal vision to his videomaking. Masayesva's attention to the natural environment in which the Hopi live results from a strong connection between the people and the land. And, also like Burdeau, Masayesva often turns to history and living cultural traditions as a source of subject matter and inspiration.

But there are clear differences between the two videographers' ideas and styles. As other scholars have noted, Masayesva's stylistic approach is probably related to his work as a still photographer (Sands and Sekaquaptewa Lewis 1990, 392; Silberman 1992), while Burdeau's style is essentially filmic. With his background in film, Burdeau adeptly manipulates the flow of imagery through editing and special effects. Masayesva's strength lies in his "strong visuals" (Bigcrane 1991). He excels in composition: "Continuous action is not his style. Rather, he focuses on individual moments—faces, subdued movement, long shots of the mesa-top villages, elements of nature—each image connecting an idea before it fades into another connected or contrasting moment" (Sands and Sekaquaptewa Lewis 1990, 392). Masayesva's studied use of lengthy shots and close attention to particular details of his environment create a meditative mood in his early videos *Hopiit* (1980) and *Itam Hakim, Hopiit* (1984).

Itam Hakim, Hopiit is Masayesva's longest video. In it he presents the story of the Hopi people through the words of Ross Macaya, a Hopi elder born in 1887. The video is dedicated to Macaya, who died in 1984. The title of the video translates as "We, Someone, the Hopi." According to the prologue, *Itam* was made in recognition of the Hopi Tricentennial, 1680–1980. The title, dedication, and commemorative intention of the work indicate its importance as an expression of Hopi identity for the videomaker. This points to another difference between Burdeau and Masa-

yesva: the intensely local focus of Masayesva's work. While Burdeau has
targeted a national audience with his most recent video, Masayesva's scope
and intent have been encompassed within the Hopi experience.

Itam Hakim, Hopiit consists of a short autobiographical sequence fol-
lowed by songs, myths, oral history, and a lengthy passage documenting a
ceremonial dance. Masayesva chooses to present the Hopi emergence
myth in its entirety. The visual material that illustrates the myth is used
somewhat literally; verbal references to fire, nature, the ocean, deer, and so
on are accompanied by illustrative visual sequences. Most of the video's
first half is technically straightforward with the exception of Masayesva's
frequent use of rack focus shots and his use of much lengthier visual se-
quences than are typically found in documentaries. Midway through the
video Masayesva employs the effect of posterization (similar to polariza-
tion in black and white photography) for a shot of Spanish riders coming
through the desert. This sequence helps introduce the section of the video
that documents the Spanish era that led up to the 1680 Pueblo revolt. Per-
haps this use of posterization symbolizes the shock of change for the Hopi
brought on by the conflict with the conquistadors. Overall, the strength of
Masayesva's visual style rests on his close observation of nature and his feel
for the patterns that he finds everywhere in the Hopi environment. His
close-ups of Macaya's hands working with beautiful wooden weaving tools
and of women working the blue corn that is the traditional staple of the
Hopi diet richly express the simplicity and dignity of Hopi life.

It would seem, then, that Masayesva's videos represent a Hopi world-
view, but one point of contention in the critical response to Masayesva's
work is whether his videos truly represent a unique Hopi way of seeing or
are essentially traditional documentaries. The noted Pueblo writer Leslie
Marmon Silko writes that *Itam Hakim, Hopiit* and another video, *Ritual
Clowns* (1988), "reveal that the subtle but persuasive power of communal
consciousness, perfected over thousands of years at Hopi, is undimin-
ished. In Victor Masayesva's hands, video is made to serve Hopi con-
sciousness and to see with Hopi eyes" (1990, 73). As Silko uses it, the con-
cept "seeing with Hopi eyes" seems to correspond to that of worldview.
According to Silko, Masayesva's strength lies in his expression of Hopi
consciousness. She seems less concerned with the issue of distinct patterns
of visual perception and creation than with the body of cultural beliefs
transmitted through whole narratives.

In a longer article Sands and Sekaquaptewa Lewis (1990) write that

Masayesva's videos reveal a native way of seeing not found in documentaries by non-Indians. The writers root their analysis in the earlier work of Worth and Adair, claiming: "In his [Masayesva's] work he projects 'innate systems of organization and of categorizing . . .'" (Sands and Sekaquaptewa Lewis 1990, 387). Masayesva's style arises from both subject matter and an approach to filming directly influenced by his immersion in Hopi culture. According to Sands and Sekaquaptewa Lewis, anthropologists present, preserve, or document the facts but native filmmaking practices differ in "theme, composition and structure from those films produced by non-Indians" (1990, 390). Following Worth and Adair, they explain that the differences derive not simply from what the native filmmaker sees through the lens but from what the filmmaker feels ought to be seen.

Adair and Worth call the weaving film, [*A Navajo Weaver* by Susie Benally], and other films made during the Navajo project, "bio-documentary," and distinguish this form of film from conventional data and process oriented non-Native documentary as: "made by a person to show how he feels about himself and his world. It is a subjective way of showing what the objective world that a person sees is 'really' like. . . . In addition, because of the specific way that this kind of film is made, it often captures feelings and reveals values, attitudes, and concerns that lie beyond the conscious control of the maker." (Sands and Sekaquaptewa Lewis 1990, 390)

According to Sands and Sekaquaptewa Lewis, Masayesva's work fits within this "bio-documentary genre" (1990, 390).

Though their explanation of the genre does not point to clearly recognizable conventional characteristics as in Wright's analysis of the Western film genre (1975, 48–49), the authors present some tentative characteristics of biodocumentaries based on their analysis of Masayesva's videos, especially the video *Hopiit*. *Hopiit* incorporates an informal storytelling sequence rather than a formal narrative structure; it presents overlapping temporal cycles in contrast to a linear narrative; and it is an "interpretive" documentary (Sands and Sekaquaptewa Lewis 1990, 392), which suggests values that are passed on, as opposed to "a documentary in the usual sense of focusing on factual information or instruction" (Sands and Sekaquaptewa Lewis 1990, 393).

It is an evocative aesthetic representation of the cycles of the Hopi year that allows the viewers to sense and feel the connections between culture-specific symbols, elements

of daily life, the cycles of the natural world, and the ritual enactments that sustain the relationships of all beings and phenomena. (Sands and Sekaquaptewa Lewis 1990, 393)

In an early article (1965) Sol Worth described biodocumentary film-making as "subjective filmmaking." Worth used the term to describe movies made by his students. He noted their preference for ambiguity of content and spontaneity in film process and style. The students' approach corresponded to the communications device of "hinting" or indirect communication.

However, the question of a distinct biodocumentary genre becomes complex when applied to experienced native producers and directors. In these cases one searches for identifiable and consistent formal traits that would support the existence of a clearly distinguishable genre. The temporal difference in narrative structure discussed by Sands and Sekaquaptewa Lewis seems to be a more concrete contrast with mainstream documentary, but this discussion is based on one video: *Hopiit*. The authors note that this cyclical, nonlinear temporal structure varies within Masayesva's body of work: "Unlike his first film, *Itam Hakim, Hopiit* demonstrates a complex concept of narrative structure in which the content of the storytelling is of critical importance to the sense of the film" (Sands and Sekaquaptewa Lewis 1990, 393). If such variability of narrative structure appears within one director's work, has a narrative structure arisen that clearly establishes a distinct native genre? On its own, this analysis of Masayesva's personal style in *Hopiit* is insufficient to posit the existence of a distinct native genre, but does point to the personal nature of much native videography.

A critical point of view opposed to Sands and Sekaquaptewa Lewis's is that Masayesva's videos portray the Hopi in terms not far removed from the standard non-Indian documentary, which depicts native life in a romanticized historical mode. Masayesva's stated goals of preserving traditional rituals, especially of preserving the sacred and keeping it out of the public, non-Indian arena, may fail to reflect that there is a modern world apart from a romanticized daily life. This view defines romanticism negatively, as the rejection of the contemporary world, and, therefore, as an aesthetic stance incapable of fully responding to modern life. This orientation to the past and implied rejection of contemporary life echoes European Romantics' longing for an idyllic, mythic, legendary past in the face of the increasingly impersonal, secular, industrial, and urban life that de-

veloped in Europe and the United States during the nineteenth century. Many other videos by both native and white directors have documented Native Americans' mythical, spiritual attachment to nature and the past.[2] Therefore, there appears to be a basis for extending the label "romanticism" beyond Masayesva's work to other native productions.

However, Roy Bigcrane (1991), a native videomaker in Montana, stated that assuming native feelings toward the land spring from romanticism is an ethnocentric position that fails to consider natives' own long-term relationship with the earth. There is a power drawn from the long-term relationship to the same environment expressed in native imagery of the land. Bigcrane and many other native videographers prefer "visionary" to romanticist as an aesthetic idea.[3] However, even the term "visionary," with its connotation of the artist/filmmaker as a "seer" whose inspiration often derives from a special closeness to nature, is consistent with a romanticist interpretation of indigenous media. The problem, then, is one of understanding what "romantic" might mean within the context of native ethno-aesthetics, within native views of the relationship between art and life. In a paradoxical collapsing of different aesthetic and ethical systems, natives take the very characteristics that non-natives associate with romanticism—reverent shots of the land, homage to tradition, themes of spirituality and family—as some of the essential ingredients of a native way of seeing. This is what the transference of a Western critical perspective leaves out: the possibility of a different aesthetic, and ethical, system. The danger is that Western critical vocabularies can be reductionistic, just as our images have been in the past. Negative values associated with the Western understanding of romanticism may seem out of place or inaccurate when the term is applied to non-Western cultures. However, it is also possible that Native Americans have been influenced by Western views of the land and of Indians: that Native Americans have, in part, incorporated the larger society's view of them into their own self-image. Unfortunately, a full understanding of the role of romanticism in Native American self-representation extends beyond the bounds of this study because it involves deeply historical cultural dynamics.

Similar problems of interpretation arise when a construct like "traditional documentary," which is used to refer to the Western documentary tradition, is applied in non-Western contexts. This application of a label doesn't take into account traditional Indian forms of cultural and historical documentation. Indians artistically documented their own

lives through winter counts on hides, pictographs and petroglyphs on cliff
walls or boulders, and ledger drawings. The appropriation of documenta-
tion was part of the process of colonization. A simple transfer of critical
constructs from one cultural context to another may have an effect simi-
lar to the appropriation of documentation itself. What does the construct
"traditional documentary" mean when applied to a culture that has its
own documentary tradition?

Supposedly, "traditional documentary" refers to a "talking heads" for-
mat which consists of a great deal of on-screen narration and interview se-
quences and a linear narrative structure. *Itam Hakim, Hopiit* contains few
"talking heads" sequences; there is no on-screen narration or interview se-
quences in the video. Instead, the video takes the form of the elder Ross
Macaya's monologue, which recounts the mythical and historical past
of the Hopi in story and song, accompanied by striking visuals of Hopi
land and life. The arrangement of the tales is chronological to the extent
that stories of the Spanish invasion and Pueblo revolt follow rather than
precede Macaya's account of the Hopi "emergence" myth. However, Ma-
sayesva carefully *avoids* imposing any overarching explanatory framework
beyond this simple ordering of materials. In fact, in the final sequence of
the video, titled "Prophecy," the videomaker artificially fast-forwards the
preceding lengthy ceremonial dance scene until the dancers speed across
the screen like people possessed, then cuts to shots of very slow-moving
figures working in a field. This experimental formal contrast, which is
highly open to interpretation but appears to satirize traditional dances, re-
veals the extent to which this video is not a traditional documentary.

Originally Masayesva wanted to make *Itam Hakim, Hopiit* only in
Hopi—for the tribe only—as a way of passing on tribal knowledge inter-
nally. His decision to release the video with English translation seems to be
a tacit acknowledgment of the importance of the larger non-Indian audi-
ence; *Itam* marks an expansion of Masayesva's intended audience. Subse-
quent videos such as the recent *Siskyavi* (1991) address issues that revolve
around the contrast between the two cultures more directly, but in the first
two films the emphasis is on Hopi tradition, not the problems inherent in
maintaining that tradition in the contemporary world.

For Masayesva, the close tie between the videographer and his or her
community overrides any specific formal or narrative characteristics in
creating an Indian perspective. Though he spoke about the possibility of
an Indian aesthetic at the Two Rivers Film and Video Festival, Masayesva

seemed to be using the term "aesthetic" broadly, corresponding to the idea of perspective or point of view. Even if he was using aesthetic in the narrower sense of specific formal or stylistic characteristics, this more limited definition would not account for the uniqueness of native filmmakers in Masayesva's opinion. His understanding of the unique outlook of native film- and videomakers derives from particular aspects of the relationship between the videographer and his or her community.

> I insist on stories about Native Americans, by Native Americans. I do recognize America . . . as well, but there's another point. There's a point of different value and different viewpoint.
>
> But, we've had enough of that. Right now, we need to start with stories from Native Americans. There is such a thing as the sacred hoop which includes all the different races. And there is ceremony that [includes] everybody, not just skin color. But, we have a responsibility to ourselves first. We need to take care of ourselves first. . . .
>
> That's where we're at as Indian filmmakers. We want to start participating and developing an Indian aesthetic. And there is such a thing as an Indian aesthetic, *and it begins in the sacred*. (Masayesva 1991, my emphasis)

Masayesva shifts the context of the discussion of native aesthetics from formal elements of expression to a spiritual context. Judging from the stylistic differences between just two directors, Masayesva and Burdeau, there is no one set of formal characteristics that comprises an Indian "way of seeing." The problem with searching for such a key to unlock the secrets of another group's outlook is that it tends to lead to a minimization of the variation within the group. In the case of Burdeau and Masayesva there are significant variations in personal style rooted in the individual experiences of each director that might be easily glossed over in the search for a characteristic Indian way of seeing. Similarly, the narrative structure of Indian documentaries ranges from straightforward chronological histories of tribes to highly associative accounts of myths and personal biographies. There is not enough formal consistency in visual style or narrative structures to clearly define a single indigenous documentary genre based on formal considerations alone.

Burdeau and Masayesva liberally incorporate modern special effects into their work, from the combined use of strobes and slow motion, to posterization, rack focus, and unusual camera angles. Both directors are sophisticated editors, cutting on form as well as thematically. And many indigenous directors make use of recent improvements in video technol-

ogy such as the betacam. Thus, the assumption that a contemporary na- tive way of seeing may rest on a naivete rooted in an unfamiliarity with mainstream media practices is no longer warranted.

If individual formal variation and the adoption of mainstream techniques seem to be working against the establishment of a unique genre of indigenous documentary, are there other factors that indicate cohesive genres may be emerging? Genre refers to the recurrence of formal, substantive, or symbolic elements of communication in a patterned way. While there is significant formal variation within indigenous video, distinguishing the overall body of work by culture area points to the emergence of regional genres. The strongest example of this seems to be the emergence of linear historical narratives in Plains culture area documentaries. Whether Masayesva's somewhat different narrative approach will act as the basis for a distinct Southwestern genre remains to be seen as more native documentarians begin to produce in this region.

However, a number of recurrent substantive issues have emerged in indigenous video. When Masayesva points to the "sacred" as the basis of a Native American aesthetic, he is singling out content as a source of aesthetic unity; many videos are about native religion and spirituality, often expressed as reverence for the land. The notion of an aesthetic based in the sacred points to the normative character of the emerging indigenous video genre. Genres are normative: they respond to normative expectations within a culture about how communicative instances or products *ought* to appear or occur.

Genres are also tied to systems of production, distribution, and reception. Native American film and video documentary has emerged within specific economic, historical, and institutional contexts that influence these systems. For instance, tribal councils and tribal colleges have had and will continue to have a growing role in indigenous video production. As videomakers create products which fulfill these institutional needs, clearly definable documentary subgenres are likely to emerge. The interest of culture committees, tribal councils, and tribal colleges in historical and cultural documentation explains the orientation toward the past and tradition found in many native productions.

Genres embody a culture's ethos; generic conventions both reflect and influence social life. As native film and videos gain wider exposure, more community members will affect their style and content. Without studying the reception of indigenous videos, it's impossible to say whether current

productions reflect contemporary native cultures, as opposed to representing the views of a minority. However, the influence of videos is likely to increase as videomakers grow more skilled in their craft and the videos themselves are more widely distributed.

Thus, though there is not a single genre of indigenous video based upon formal characteristics alone, there may be several subgenres developing in response to particular cultural contexts and institutional needs. Certain formal characteristics such as narrative and visual style; substantive issues such as the role of religion and nature in native culture; institutional contexts such as tribal colleges and culture committees; and normative expectations based in Native American cultures will continue to define indigenous media.

NATURE IMAGERY

Since Indians have access to mainstream technology and techniques, it is not unreasonable to assume that they have also been influenced by the larger society's imagery. I have discussed the issue of romanticism in this chapter, especially with regard to Indians' imagery of nature. There are two poles of thought on this issue. One regards Indian nature imagery as an outgrowth of the special relationship Native Americans have with the land. The other holds that pan-tribal similarities in Indian imagery of the land may reflect an assimilation of the larger society's own romanticist imagery of Indians. These two perspectives may reflect the views of members of different audiences. The first perspective seems consistent with an Indian point of view, while the second perspective seems consistent with a skeptical, non-Indian point of view. This issue acquires heightened importance in light of the pervasiveness of nature imagery throughout several indigenous documentary forms. The thematic element of Indians' particular relationship to the land seems to be the single unifying factor underlying indigenous directors' motivations.

A close symbolic attachment of Indians to the land is not surprising since control of land has been the single most determinant economic and political issue for Indians throughout the last century and a half. Land has led to the most violent confrontations between whites and Native Americans during this time period and continues as a site of conflict and negotiation. In addition, group identities, especially before the advent of electronic media, were linked, as they still are, to shared but special access to

physical locations, a main reason for the continued emphasis on place in Native American documentaries. To argue that Indian nature imagery derives in part from the aesthetic vocabulary of Western romanticism risks slighting Indians' own special feelings for the land. The link to romanticism locates Indian nature imagery in an aesthetic realm discredited by the apologists of modernism and postmodernism. Few aesthetic stances in the realm of current high art seem more dated than the reverent attitudes toward the picturesque and the sublime that dominated nineteenth-century discussions of landscape. However, in this rejection of romanticism by many twentieth-century critics and theorists may lie the seeds of the appeal of Indian nature imagery for the larger public. Because it is the expression of a non-European culture, Indian nature imagery becomes an allowable form of romanticism for the larger non-Indian public. That is to say, many people never accepted high art's rejection of romantic nature imagery; romantic imagery of nature remains widely popular even though it may be currently out of favor with high-art aestheticians. Whether beautiful images of the land receive critical validation or not, they remain an effective and viable form of visual communication. For people who continue to respond to nature imagery—and most probably do—debating whether Indian nature imagery is romanticist may seem to be more of a gratuitous play with labels than a substantive issue. There is a power drawn from a long-term relationship to the same environment as expressed in Indian imagery of the land. And, as Meyrowitz writes: "Access to a group's territory was once the primary means of incorporation into the group" (1985, 57). It is not surprising, then, that this continued attachment to the land has been expressed on a consistent basis in indigenous media.

Conflict over land is rooted in different understandings of the relationship between nature and culture. For many whites, nature and culture are divided; they are perceived separately and often in opposition to each other. Whites' fascination with the manipulation of nature through technology remains a source of frustration for many Indians. For some, the word "technology" itself has assumed a cold, hard, threatening connotation. For many natives, nature and culture are continuous; any event or action in one affects the other. Thus, while legal contests over land remain the site of intercultural conflict, different understandings of nature are actually cultural, even moral, in essence.

As Lucas, Deloria, Masayesva, and others have explained, when one re-

alizes that the organized religions of the West were complicitous, and in many cases active, agents in the exploitation of Indians and their land, the moral import of conflicting views of nature becomes clearer. In *Itam Hakim, Hopiit* Masayesva demonstrates that Pueblo peoples experienced the undermining of their traditional belief systems by Catholicism as a separation from nature. The Hopi rejected Christianity because it acted as a wedge driven between the Hopi people and their homeland. Given this complicity of Western institutionalized religions in conquering Indian land and people, the return to traditional religions and dance forms documented through indigenous media seems inevitable. Conflicts over land, then, are rooted in different views of nature that in turn arise from conflicting religious perspectives, each of which carries the weight of moral conviction.

For some Indians and whites, native art, religion, and philosophy seem to offer a way out of the division between nature and culture. Indians consistently express a view of culture as intimately tied to nature missing in Western thought and belief. Many indigenous videos contain a sense of urgency. Some Indians feel that they have been given a slight window of opportunity at the end of the twentieth century to express their philosophy of balance and connectedness between nature and culture. However, they feel this window will not be open for long (Lucas 1991a; *Hopi Prayer for Peace* 1986). The urgency of the desire to express to the world at large alternate ways of living within nature arises from this feeling of limited opportunity.

In the films and videos, images of nature are subjects in their own right but are also used to construct frameworks for viewing other issues. For example, aerial landscape flyover shots appear frequently in recent historical documentaries: Burdeau's *The Pueblo Peoples: First Contact*, Bigcrane and Smith's *The Place of Falling Waters* (1990), and Bearclaw's *Warrior Chiefs in a New Age* (1991). Though the subject matter of these videos is mostly historical, the flyover shots appear in key opening and transitional passages. These shots express the transcendent meaning that nature holds for Indians. The imagery can be interpreted as transcendent in two ways. In the context of unfolding historical narratives, aerial views of land traditionally inhabited by Indians connote a timeless relationship to an area. The shots imply a continuity of physical relationship with the land that "transcends" any specific historical period. Significantly, all of these aerial shots are of natural landscapes unmarked by roads, towns, phone lines, satellite

dishes, and so forth, which would have temporally fixed the images in the late twentieth century. Framing the historical narrative with shots that express a sense of timeless association with the land subtly communicates a sense of survival in spite of the vicissitudes of fortune that constitute history.

However, aerial shots can be interpreted as transcendent in the strictly theological sense: as the visual equivalent of a god's-eye view. In this interpretation, the videographer invests the landscape with a spiritual significance consistent with religious beliefs about nature. The god's-eye view connotes a spiritual significance that transcends the materiality of the earth. Images of the whole earth shot from space similarly connote oneness and spirituality. In the context of indigenous videos aerial shots act as visual metaphors for religious beliefs and as expressions of Indians' lengthy relationship with the land. Both of these interpretations of aerial shots differ with those of Derek Bousé, who analyzed aerial perspectives in his dissertation on wilderness documentaries (1991). In wilderness documentaries, Bousé feels aerial shots are used to portray the wilderness as an "inventory of natural resources," especially in Forest Service films. He writes that aerial shots tend to distance viewers emotionally from the forest, and prevent us from "entering" the image and moving around in it. Bousé (1991) adds that aerial shots make wilderness look as if it can "absorb development projects into its immensity." Therefore, aerial views may be inconsistent with Indians' expression of reverence for the land. However, Bousé does write that the meaning of particular images and framing techniques is constructed through context—through juxtaposition with other images. Further comparisons of contextual aspects of mainstream wilderness documentaries and indigenous documentaries might help explain these divergent interpretations of aerial landscape imagery.

Long shots, wide-angle shots, and expansive pans of landscape vistas were also prevalent in the native documentaries' openings and closings. As with the aerial views, in these establishing landscape shots the directors largely eschewed signs of modern life, preferring instead the contemplative quality of pure nature imagery. In the body of the films and videos, imagery of contemporary settings appeared, but, as in *Winds of Change: A Matter of Choice* (1990), images of modernity were often accompanied by commentary about the dislocation of Indians from traditional communal life. By contrast, architectural structures such as the Navajo hogans seen in

Seasons of the Navajo (1984), a film by non-natives, symbolize the tradi-
tional continuity between culture and nature. Interview settings in the
bodies of native and native-themed videos, as in *Red Road: Toward the
Techno-Tribal* (1984), were frequently outdoors, which reinforced the ties
between humans and nature.

Much of Burdeau's and Masayesva's technical experimentation, as well
as that seen in other directors' work, involves images of nature. Indians' vi-
sions of nature are not strictly realistic. The manipulation of nature im-
agery results in a kind of visual poetry consistent with the goals of many
Indian painters. One Indian artist, Blackbear Bosin, comments that "An-
glo kids want to duplicate" what they see in nature, while "Indians don't."

Rather than try to create something as the Great Spirit created it, they want to do some-
thing entirely human. They want to create the essence of it. Their whole tradition
teaches them this—language and figures of speech and even jokes. Indians are very
poetic people by virtue of the most fundamental elements of their life. So they paint
the symbols around them: the pulse and the essence. (Bosin in Highwater 1976, 159)

Bosin warns against putting "too much realism" in a painting because it
may ruin the painting's "vision" (in Highwater 1976, 159). This emphasis
on visions which capture the "pulse and essence" of nature rather than
simply reproducing the natural world helps explain the attitude of free
technical experimentation that many native directors bring to images of
nature.

Certain images from nature—mountains, lightning, light on water,
stones, animals, the full moon, sunsets and sunrises, rivers, windswept
desert landscapes, and lofty clouds—appear with such regularity in native
documentaries that they seem to comprise a symbolic vocabulary of na-
ture imagery. Lightning over the mountains signifies foreboding; a desert
sunrise signifies new beginnings; a high mountain stream symbolizes
purification. The degree to which particular interpretations of nature
scenes are unique to Indian culture as opposed to borrowing from West-
ern romanticist conventions remains open to question. In either case,
though, the affiliation of man and nature emerges as central to the iconog-
raphy and style of indigenous media. Video images of nature draw upon
emotional associations that take us beyond the outward appearance of the
natural world to its essential characteristics. In these images, directors also
seek to represent the "pulse and the essence" of nature.

Though Native American Public Telecommunications (NAPT) and the Public Broadcasting System (PBS) have targeted Indian directors and programs that speak to a national audience for funding, the strongest expressions of collective identity will continue to come from directors immersed in a specific area. Local ties to nature and religious traditions are strong identity components that can be sacrificed easily through an overemphasis on pan-tribal subject matter. Some subjects, such as the effects of forced education documented in *In the White Man's Image* (1992), naturally lend themselves to pan-tribal treatment. But the successful expression of most other subjects will depend upon the director's familiarity with the nature, thought, and customs of a particular area.

With respect to Indian desires for cultural and political self-determination, land has been the most troublesome point of conflict in Indian/white relations throughout the last century and a half. Group identities are linked to physical locations, a main reason for the continued emphasis on place in Native American documentaries. Natives' feelings for nature predate the era of treaties; the relationship of Native Americans to nature cannot be defined simply as a relationship to property. Whites often perceive conflicts over land in legal terms, whereas Indians perceive them in philosophical terms. Conflicts over land, then, are rooted in different views of nature that carry the weight of moral conviction. These conflicts are likely to intensify as resources are depleted. Respect for nature and attachment to the land will likely continue as central themes in indigenous video.

The feelings of continuity with the earth expressed through indigenous art and media have their basis in native spirituality or religion. Images of nature are subjects in their own right, but they also frame other issues. For example, aerial landscape flyover shots may be used to frame discussions of history. Video images of nature often employ special effects that take us beyond the outward appearance of the natural world to its essential characteristics; these images attempt to capture the "pulse and essence" of nature in a kind of visual poetry.

In representing nature Indian film- and videomakers have found their clearest, most unified voice. A special urgency underlies Indians' representations of nature in the present period of environmental destruction. Though some non-Indian critics may label images of the "pulse and essence" of nature as overly romantic, Indian nature imagery and other forms of aesthetic expression convey a philosophy of continuity between

VISUAL ARTS DOCUMENTARIES

T HIS CHAPTER examines a selection of films and videos that represent close to twenty years of documentation of Native American visual arts and artists by both natives and non-natives. A number of issues have emerged in recent writing about Native American visual art and artists that helped frame the analysis of the documentaries. One is the different understanding of art as a social activity and artists as social actors in native cultures versus contemporary Western culture. Over the last five hundred years the role of artists in Western cultures has shifted from an understanding of artists as "mere craftsmen" to the level of the inspired artist or even genius. By way of contrast, many Native American artists, even those working within contemporary styles, often view art as a form of work closely integrated into the flow of everyday life (Eaton 1989). What are the underlying assumptions and actual statements about the relationship among art, artists, and life in visual arts documentaries?

A second issue is the breakdown of visual patterns that indicate tribal identity as native artists innovate and explore ideas from Western art; this development relates to the problematic status of Indianness for artists between two worlds. Traditional art forms, with their conventional stylistic elements, provided highly visual markers of identity in times of cultural contact and change. For example, McClaughlin demonstrates how stylistic variations in beadwork functioned as a system of boundary marking that indexed a complex series of social realignments among nineteenth-century Plains Indian tribes. Stylistic aspects of artifacts symbolized and supported social boundaries between groups (1987, 55). Many of these stylistic properties and other references to traditional aesthetic expression were carried over into Native American painting as it developed during the first half of the twentieth century.

Since the establishment of the Institute of American Indian Arts (IAIA) in Santa Fe in 1962, the youngest generations of Indian artists, many of

whom were trained at the Institute, have developed innovative styles and an openness toward subject matter not seen in the work of earlier generations of Indian artists (Strickland 1985, 39). This does not mean that recent Indian painters have rejected their Indian identity, but that the way some artists express identity differs from the highly conventionalized styles and subject matter of their ancestors.

Marketplace influences further complicate the discussion of native art and identity. Early in the development of Indian art markets conventional aspects of artistic activity—related to both style and subject matter—were read as the traditional visual language of a group. Clearly identifiable visual patterns were a marker of belonging and authenticity. As the market for Indian art and artifacts developed during the early twentieth century, the assumption that Indian art should be "traditional" or "authentic" by readily reflecting the conventional styles or subject matter of a given tribe became embedded in market economics. This development and the related definition of much Indian art as craft within the Western aesthetic system—following from its categorization by media such as pottery, textiles, and wood carving—have, in many cases, limited the type of art that Indians can successfully market. Native American artists are pressured in the craft marketplace to produce several identical pieces of less monetary value rather than unique one-of-a-kind pieces that may sell for more in the fine-art marketplace (Eaton 1989). But some contemporary Indian artists value innovation in art and hope to make unique pieces rather than produce for a craft market. The question of Indianness can become problematic from both an economic and conceptual perspective as Indian artists seek to balance their heritage and community identity with their artistic and economic goals.

Visual arts documentaries, then, have been created in an era of active discussion about the relationship between Indian art and identity. These issues—assumptions about the relationship between art and life in native cultures, aesthetic tradition and innovation in relation to artists' understanding of Indianness, and social aspects of artistic production including marketplace forces—serve as touchstones for this discussion of visual arts documentaries. Though conceptual frameworks for presenting native art and artists must be addressed, I have downplayed stylistic analysis of the films and videos themselves in order to focus on larger questions of Indian art and identity.

As a background to the documentation of their own art by Native Americans, I first consider several examples of films by non-natives. *Oscar Howe: American Indian Artist* (1973), directed by Sanford Gray, explores the art and career of this pioneer native abstractionist. The film conveys Howe's general philosophy, artistic goals, and methods in addition to offering sketchy biographical material and a lengthy sequence devoted to his paintings. Like the *American Indian Artists* series produced three years later, the filmmakers concentrate on a single artist. We are exposed to Howe's own explanation of his complex art theory, but his work is not placed in the context of other Native American art of the period. As is often the case with accounts that focus on a single artist, the director intimates that Howe was especially motivated or endowed with artistic ability almost from birth. Early in the film we see a dramatization of a story told by Howe about his childhood when his father, angry over his son's constant drawing, took away his drawing tools, forcing Howe to draw in the earth.

In the film, Howe describes his motivation to record Sioux culture and the source of his inspiration. He roots his contemporary working method of "painting the truth" in traditional hide painting ceremonies which employed a technique of "imaginary dots" to develop the composition. Howe discusses the symbolism of lines, shapes, and colors in Sioux culture and the alignment of art with nature. We learn little about the source of Howe's academic art theory—he was one of the few of the early generation of painters to obtain an M.F.A.—or of his relation to other artists, art history, and his audience, but the film conveys his unique theory and artistic motivation.

A contrasting orientation of non-native filmmakers is evident in the series *American Indian Arts at the Phoenix Heard Museum* (1975), directed by Dick Peterson. This series was produced at KAET-TV, Phoenix, by Jack Peterson, and filmed by Tony Schmitz and Don Cirillo, who all worked on the *American Indian Artists* series that appeared a year later. Surprisingly, for two series of films created by similar personnel within a short span of time, these two series vary widely in approach. In *American Indian Arts at the Heard* the filmmakers take an academic approach. The narrated text is

weighed down by specialized terms and questions of dates, origins, and attribution, making the script sound like passages read from a textbook.

The survey format of the series approaches the artwork according to medium. Like many traditional surveys, the films strongly emphasize technique and the succession of important artists or styles within a given medium, but attend less to the social or cultural function of art. The film perpetuates one traditional Western art historical approach recognized through its survey organization; it is the counterpart to the approach taken in *Oscar Howe: American Indian Artist* (1973), which highlights the achievements of one individual. Some episodes of the Heard Museum series, such as the one about painting, focus on a succession of individuals and styles that is consistent with an art historical approach to "high art." Others, such as the episode on pottery, analyze techniques that were developed and applied by specific tribes, which is consistent with archaeological approaches often applied to "crafts" or material culture.

In contrast to the largely descriptive, academic approach of the Heard Museum series, Peterson, Schmitz, and Cirillo take a poetic turn in their *American Indian Artists* series of films. Here, they single out well-known figures in American Indian art for individual profiles and evocatively photograph the artists' working environments and art to convey a sense of each artist's character.

The artists featured in this first series are Allan Houser, Fritz Scholder, Medicine Flower and Lonewolf, Helen Hardin, Charles Loloma, and R. C. Gorman. Like the earlier film about Howe, these individual portraits focus on the current work and ideas of the artists and limit biographical details to information offered by the artists themselves. For instance, we learn that Houser's father, who was on the "warpath with Geronimo," influenced his work through his ability to "put a song or story over" (see Fig. 6). Houser explains that telling stories in his own art is the "basis of what I'm all about." A small amount of biographical material emerges through the discussion of art and ideas. Generally, there is an attempt to encapsulate the artist's relationship to his or her culture or peers in poetic form rather than through detailed explanation. From James McGrath's poetry in the Houser episode: "My Apacheness is the mountain, the bird, the stone, the drum that I am: all of them together . . . I am what I do."

Many of these films open with a striking graphic image. In the Medicine Flower and Lonewolf episode the opening frames depict their exquisite pottery displayed in an outdoor setting of old Pueblo ruins, evoking the

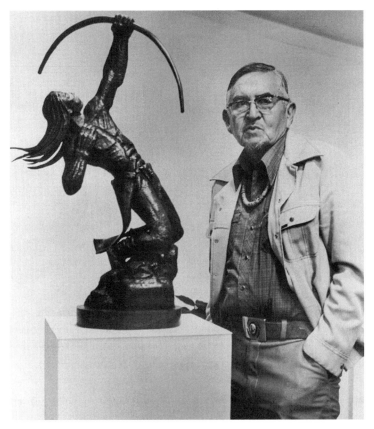

FIGURE 6 ▶ Allan Houser, *American Indian Artists* Series

The late Allan Houser, a noted Chiricahua-Apache sculptor, stands beside one of his bronzes, "Sacred Arrow." His working processes in stone and bronze were featured in the third program of the first *American Indian Artists* series. (Courtesy of NAPT)

timelessness of the pottery art form. Similarly, the episode featuring the painter Helen Hardin opens with a shot of dawn over a Southwestern landscape and cuts to visuals of ancient structures, cliffs, and petroglyphs. The Loloma episode also opens with a landscape filled with warm morning light and shots of petroglyphs. The text reinforces this evocation of the past: "I touch the face and heart of myself when I touch the stone." Elizabeth Weatherford, a scholar and bibliographer of native media, notes that "sometimes the opening sequences lend a romantic atmosphere which is

FIGURE 7 ► Fritz Scholder, *American Indian Artists* Series

Though the influential native painter, Fritz Scholder, distanced himself from the label "Indian artist," many of his paintings concerned the contemporary experience of American Indians. Here, Scholder stands before "Television Indian," a painting created during the filming of a program in the *American Indian Artists* series. (Courtesy of NAPT)

at odds with the straight-forward documentary style of the body of the programs" (Weatherford and Seubert 1981, 14). The romantic style of some of the openings does seem oddly inflated. However, romanticism in text and imagery is a characteristic that runs throughout the series, even in the body of the programs. Perhaps the romantic treatment is in many cases justified, but the artists themselves tend to speak more matter-of-factly about their lives and work.

Less outwardly romantic in approach is the episode about Fritz Scholder, a painter who was at the heart of the debate between traditional and contemporary native artists (see Fig. 7). This film conveys Scholder's status as a symbol of mainstream success with a major reputation in leading art cities: a painter who has been validated by the larger art world of galleries and museums. In this episode, as in other forums such as gallery catalogs and interviews, Scholder distances himself from the label "Indian artist." Scholder says in the film that he is not interested in "making statements"

as much as exploring "new visual experiences." The year before this film
was made Scholder stated, "I'm not directly involved in the whole way that
Indians are thinking currently [1975]. It's, for one thing, very nationalistic,
and, for another, very ingrown" (Scholder in Highwater 1976, 181). But his
paintings are taken as visual statements by Indian artists and the Indian
community at large. Some viewers take Scholder's art as a disparagement,
rather than a celebration, of Indian culture, while others feel his expres-
sionistic style freed Indian art from the formulaic expression of Indian-
ness found in traditional art. The traditional Indian emphasis on pains-
taking control and clarity of detail does seem lost in the expressionistic
style of Scholder, who has stated that he is more influenced by the British
painter Francis Bacon than by traditional Indian art styles.

Those who have found Scholder's influence liberating include artists
such as T. C. Cannon and Jaune Quick-to-See Smith. Cannon, who stud-
ied at IAIA and the San Francisco Art Institute, has taken a Scholderesque
approach to the place of Indianness in art: "First of all, let me say that an
Indian painting is any painting that's done by an Indian. Today, however,
I don't think there is such a thing as an Indian painting. . . . I believe there
is such a thing as Indian sensibility. But I don't believe it necessarily has to
show in a person's painting" (Cannon in Highwater 1976, 177).

It is clear from this early series of films that many contemporary Indian
artists valued innovation in traditional patterns and styles and hoped to
make unique pieces rather than to produce for a craft market. Even those
who were traditionalists had moved away from an understanding of art as
craft objects which can easily be reproduced and marketed as crafts—to-
ward a unique, one-of-a-kind understanding of art objects. For instance,
the Hopi jeweler Loloma designs custom jewelry for clients based upon his
intuition of their "inner feeling" (see Fig. 8). His gemstone designs func-
tion as visual metaphors of the "gems within people": as expressions of the
client's inner self. Loloma has consciously developed a style and sought an
audience for custom jewelry through his travels to cultural centers of Eu-
rope and the United States. His motive has been to "experience what fine
is" in order to do "work that is fine." While the filmmakers, and Loloma,
root his work in the Hopi land and people, his consciousness of the need
to appeal to the wider art marketplace is clearly evident.

This straddling of two worlds is also evident in videos from the sec-
ond *American Indian Artists* series (1984), which features the artists Jaune

FIGURE 8 ▶ Charles Loloma, *American Indian Artists* Series
Charles Loloma, and his relationship to his jewelry, the Hopi community, and collectors, are
the subjects of the sixth and final program from the first *American Indian Artists* series.
(Courtesy of NAPT)

Quick-to-See Smith, Dan Namingha, and Larry Golsh. The series was pro-
duced by Native American Public Telecommunications (NAPT), but the
episodes on Smith and Golsh were produced by Jack Peterson, directed by
Tony Schmitz, and filmed by Don Cirillo, the same crew behind the first
series. However, the narration in the Smith piece is by noted native author
N. Scott Momaday, and the writer is Joy Harjo (Creek).

From the film we learn that Smith's exposure to Western art practices,
including the gallery system, and ideas such as those which emphasize for-
mal training, have led to her increased valuation of formal innovation and
originality in her own work. Smith's abstract art still relates to her Indian
experience. In the film, she describes her *Prairie Series* of paintings, in
which a Bauhaus grid (a design principle developed at the Bauhaus School
in Germany during the 1920s) becomes an abstract image of a travois (an
Indian sledge designed to be dragged by a horse). Triangular tipi-like de-

signs also reveal the play between geometric forms and Indian cultural references. Smith states that the *Prairie Series* is "bound together by my formalist training and caring about things in the Indian world." Later, shots of her studio's interior include shelves filled with books about Klee, Gottlieb, Hesse, Schwitters, and so on, which reinforce this reference to an international formalist tradition.

At the same time Smith feels it is important that her imagery is not "arbitrarily abstract." Thus, in addition to the travois and tipi references, Indian-like figures and strong, bright colors lend a sense of Indianness to the pieces. Perhaps more important are the openness of her composition and the frequent references to landscape forms. Smith's art is shaped by her relationship to the land and to animals. Her home and studio are located in a remote rural location; the adobe-style structures seem to emerge from the surrounding open land (see Fig. 9). Shots of the artist at work are intercut with images of her riding or holding animals—she states at one point her conviction that animals have souls—to impart her strong sense of connectedness to her environment.

The issue of Indianness in art is an underlying concern in the film. At one point Smith is shown in conversation with two other Native American artists. One of them, an unidentified woman artist (Emmie Lou Whitehorse), comments on the expectation of people that Native Americans' art "look Indian." The trio agrees that it's important to be an artist first, that the "brotherly feeling of being an Indian shouldn't limit the art." Though the film reveals values common to Indians such as the spiritual value of the land and animals, it emphasizes artistic vision. Smith states that art has always been important for her: "the obsession was always there . . . but now art gives me great harmony in my life—it is my life." Smith's art and attitudes toward art, then, are definitely a product of two cultures. For her, art is a nonutilitarian activity in its own right. Formal concerns are central to her work, and she seems to derive as much inspiration from European and American modernists as from traditional Indian themes. As revealed in a gallery scene in the film, the audience for her art is the non-Indian art world. And the viewpoint of the film itself emphasizes the solitary, creative, poetic aspects of art making.

What, then, is the collective aspect of this portrait of an artist? The social basis for her group identification seems to derive from educational and professional association as much as a tribal or generational basis. The

FIGURE 9 ▶ Jaune Quick-to-See Smith, *American Indian Artists* Series
Jaune Quick-to-See Smith draws upon the formal innovations of contemporary abstraction and elements of native land and cultures in her paintings. She has remained important as an artist, curator, and promoter of native artists since appearing in this documentary from the second *American Indian Artists* series in 1984. (Courtesy of NAPT)

film itself gives few clues to the social function of Smith's art, focusing instead on the private nature of the artistic process for her, which is consistent with humanist or romanticist aesthetic conceptions that emphasize the autonomous artist. However, Smith's affinity for the land and animals acquires a spiritual cast and points to a common source of collective identification in the Native American community.

The question of *formal* change, so prominent in the films about Smith and Scholder, has social and economic consequences for individual artists. One of the important questions raised here is the degree to which a highly individualistic view, which is a consequence of an emphasis on formal innovation in art, is being absorbed by artists whose cultures' traditional aesthetic outlooks may have been quite different.

Another episode in the second *American Indian Artists* series, *Dan Namingha*, raises similar questions. *Namingha* is unique because it is the only film in the series largely produced, directed, and written by Native Americans. The producer is Frank Blythe, director of NAPT. Larry Littlebird participated in the writing. This film about a Hopi artist opens similarly to films from the first *American Indian Artists* series, with landscape shots of places the artist finds special: in this case, Chaco Canyon in New Mexico, which Namingha feels conveys a sense of mysticism and magic. He explains, "I visualize things that were probably here at one time" and find a "sense of design among the ruins." Architectural and mesa-like landscape forms, along with the warm reds, oranges, and earth colors of the Southwest, permeate Namingha's art (see Fig. 10).

Namingha states, "I live in two worlds." One is represented in native land, Hopi ceremony, and ties to family; the other is the outside world of the successful, modernist gallery artist. In the video, Namingha emphasizes creativity, variety, and experimentation above other aesthetic values: "As an artist, one creates for himself," not the public. Like Smith, he values spontaneity and an emphasis upon personal creativity over adherence to any socially defined guidelines for artistic style. But Namingha also claims in the video that his family has "molded me into who I am," and feels that he has balanced traditional ideas with a modern approach.

Is Namingha, then, like Oscar Howe, a modernist obviously influenced in part by Western art theory in his art, but a conservative in his view of society? If so, this arrangement prefigures adjustments recently made by the entire Hopi culture as documented in *Winds of Change: A Matter of Choice* (1990). In this video we see a culture in the process of transition, striving to maintain an essential core while continually integrating aspects of modern life, from individual housing unit arrangements to Western-style schools, that threaten to divorce the culture from its core. Perhaps this is one reason why native producers and writers chose to document Namingha's art themselves; he represents the elusive synthesis of two ways of life that whole cultures are currently trying to achieve.

FIGURE 10 ► Dan Namingha, *American Indian Artists* Series
Dan Namingha's abstract paintings incorporate geometrical designs, saturated colors, and mesa-like landscape forms to express the sense of place he experiences in the native Southwest. Here, he works on a painting in a scene from the native-produced *American Indian Artists* documentary that profiled him. (Courtesy of NAPT)

NATIVE AMERICAN–PRODUCED VISUAL ARTS DOCUMENTARIES

Visions (1984), produced by Indian News Media of the Blood Reserve in Alberta, Canada, reveals a diversity of opinions about the role of Indian artists, though the videomakers emphasize the role of "tradition and culture" in the visual arts. Their introduction reads: "Indian artists in the 1980s are making a strong impression on art circles around the world. Traditions and culture play an important part in the inspirations and expression of their works." As with the *American Indian Artists* series, the videomakers open with landscape shots and images of a buffalo herd and skull, which are visual references to Northern Plains culture. The opening state-

ment of the first artist interviewed, John Webber (Blackfeet), contrasts with the individualist and modernist positions of some Southwest-based Indian artists: "Indian art to me is just ideas, beliefs put on something tangible, that someone can understand and relate to, rather than just makin' their own idea or own picture of something." For Webber the importance of art is its roots in Blackfoot culture; it provides "something to hold onto" in an area where "much of the culture is lost."

Ironically, in the same paragraph he notes that "a lot of Indian artists were influenced by Russell," referring to the realistic, illustrative art of Charlie Russell, the late-nineteenth-century Montana "cowboy artist." In another interview sequence Everett Soop (Blood) disagrees: "We [Indian artists of southern Alberta and Montana] aren't merely copying Charlie Russell. . . . Russell copied the Blackfoot confederacy because he admired them so much, and he thought they were majestic." Glenn Eaglespeaker, also Blood, feels that the realism of the area derives from the "recording of legends" and sees the realistic illustration of legends from the past as the basis of the "Plains style."

Notably, the native videomakers chose to compare and contrast a number of artists rather than focus on one well-known or "great" artist. This may be due to the relative obscurity of Northern Plains artists compared to the highly successful Southwesterners, but also to a cultural tendency among some Indians of not singling out individuals within a group for special exposure. At a conference on Indian art in Helena, Montana (1991), Salish writer, poet, and videomaker Vic Charlo noted that it's a "hard task for Indian people to get themselves out there" in order to promote their work. An Indian woman participant added that "It's even harder if you're an Indian woman; you're not brought up to brag about yourself." In this type of culture, which values blending in with the group, traditional art is a natural path because "traditional art is its own voice." It doesn't have to be explained like contemporary art, which demands that the artists articulate what they are trying to say (Montana Indian Arts Conference 1991).

Of the artists interviewed in *Visions*, Alfred Youngman (Cree), a college teacher of Indian art, and Everett Soop (Blood) are the most contemporary in style, but they have opposite ideas about the role of Indianness in art. Youngman feels that there is a difference between Indian art and arts of other ethnic groups. However, he feels that the most popular forms of Indian art are determined by people and institutions that collect it, and singles out museums in this regard. The primary interest for museums is

ethnography: the collection of war bonnets, vests, moccasins, and so forth as "ethnographical material" more than as fine art. Youngman feels this does not reflect the response of Indians to contemporary reality that concerns him as an artist. Soop also feels that it's important to respond to contemporary issues, which he does through the art of editorial cartooning. However, he rejects the idea of "Indian art," explaining that the desire to distinguish Indian art as special emerges from a fear of cultural homogenization. He states that the background of all art is in nature and that "how people relate to nature reflects on how they relate to their deity." For Soop, art is a product of its time and place, but there is not a core of Indianness that runs through all art produced by members of that ethnicity.

Another native video, *Native American Images* (1985), parallels *Visions* by featuring artists from the Southern Plains region. Like many of the northern artists, the subjects of this video are "untrained" in a formal academic setting. Palladine H. Roye (or Pon se se) said he never cared about art but was approached by his brother's agent and asked to paint. After selling this first painting, his career was launched. Roye traces his artistic influences to his grandparents, for whom traditional arts such as beadwork were "just another part of life," and the shared cultural symbolism of the Southern Plains. Donald Vanne also had little formal training but enjoyed great success in the first formal competition he entered, sponsored by the Museum of the Five Civilized Tribes (Oklahoma). Roye and Vanne's work fall well within the Southern Plains style, especially strong in Oklahoma, that evolved from an earlier flat, outlined traditional style into a highly illustrative mode. Illustrative, nostalgic, popular, and romantic in vision, Oklahoma artists, like their northern counterparts, use art to document tradition. However, they depart from the northerners with their fondness for theatrical, exaggerated motion as seen in the art of painters like Dick West and Rance Hood. These two videos by and about Native Americans seem rare in their concentration on the two-dimensional art of painting. Most videos about the visual arts by Native Americans have focused on traditional expressive forms that often predate Western contact.

TRADITIONAL VISUAL ARTS VIDEOS

Eyes of the Spirit (1984), written and produced by Corey Flintoff (later to join National Public Radio), and directed, photographed, and edited by Alexie Isaac (Yup'ik), exemplifies coproduced documentaries that draw

on the talents of natives and non-natives and the close cooperation of local civic organizations—in this case the Bethel Native Dancers group. *Eyes of the Spirit* addresses issues of cultural loss and renewal centered around the revival of ceremonial carved masks. Early missionaries looked on the masks with disfavor as superstitious; under outside pressure, masks and even dancing were neglected. Masks were still carved, but as wall decorations and works of art for collectors. They no longer followed the form of a man's face and with this "loss of original purpose . . . lived on as models, toys or stylized representations" (*Eyes of the Spirit* 1984). As they evolved into a new art form, a kind of sculpture, "the masks lost their eyes." In the older art form holes were cut for the eyes, which symbolized the mask's spirit.

Mask making was an aesthetic and spiritual locus for the Yup'iks; theirs were the most complex and imaginative masks made by Eskimos. Ralph Coe describes this link between spirituality and identity in the maskmakers' art.

The concept of soul was the only thing that was somehow stable and permanent—an ice floe, a polar bear, a piece of driftwood, a whale, a rock, everything animate or inanimate, had a soul or *inua*. Any mask with an inner face or carved with a fragmentary part of another face—an additional mouth or partial nose for example—represented not an individual animal but the collective *inua* of the whole species: a reincarnative force. . . . The plural of *inua* is *inuit*, meaning people, which is the name by which the Eskimos referred to themselves as a group. (Coe 1977, 110)

Masks represent humans, animals, stories, and things of the unseen world seen in dreams and visions. The videomakers stress the importance of the "mind's eye" as a source of inspiration and as a guide to the actual carving process, since no formal plan is used. Masks magically transform the physical into the mythic and spiritual.

Eyes of the Spirit documents the technical process of making a mask, traditionally passed directly from master carver to apprentice. The videographers explain the traditional Eskimo learning process based on careful observation, "the Eskimo way of watching," and its difference from Western educational methods.

At the end of the video, viewers see excerpts from the actual performance in which the masks were used. In this way the videographers document the need for a "return of the maskmaker's art to a community purpose," including the relationship between masks and traditional spiri-

tuality, ways of learning, and stories. Socially, masks function as mnemonic aids that trigger narratives about animals, sources of livelihood such as sealing, family relations, shamanism, and the first contact with whites. For those who saw the performance, the effect of seeing the masks after so many years of neglect was "electrifying."

Another locally based organization, the Muskogee Creek Nation Communication Center (MCNCC) in Oklahoma, has produced videos about traditional Creek culture since the early 1980s. Titles include: *Folklore of the Muscogee People*; *Stickball: Little Brother of War*; *The Strength of Life*; *1,000 Years of Muscogee Art*; and *Turtle Shells*. One of these videos, *The Strength of Life* (1984), tells the story of an individual artist, Knokovtee Scott (Creek-Cherokee), and a traditional art form, Creek shellworking. Though he was trained at IAIA, where Indian art was catapulted into the modern art world, Scott is primarily a traditionalist, who looks deep into the past for his inspiration. His formal training fueled an interest in Cherokee jewelry making and ancient designs, which Scott learned from books written about the Southeastern ceremonial complex culture. Of shellwork, Scott says, "If something good lives, it never dies," and adds that shellwork has been done for the last two thousand years. Scott strives to capture the strength, vitality, and power of the old work.

Although its subject is one artist, this video is similar to *Eyes of the Spirit* in its coverage of historical subject matter, technical processes, the social function of the "gorget" art form, and educational processes. This video emphasizes the historical role of shell jewelry in the Creek tribe and in Southeastern Mound Cultures. Technical passages highlight Scott's use of contemporary machine tools, while *Eyes of the Spirit* dwells on the traditional curved carving knife. The Yup'ik video documents the Eskimo way of seeing as an educational form; *The Strength of Life* shows Scott in a classroom, teaching young children basic shapes and designs based on a curriculum of Indian art. The video details the collective social function of gorgets in the historical section, through contemporary footage of the Green Corn Dance, and in gallery scenes where Scott mingles with the opening night crowd. This coverage of historical, educational, and other social factors such as ritual performance contexts reinforces the community purpose of traditional art forms.

Part of the reason for these videomakers' emphasis on the collective function of traditional art may be the problematic notion of Indianness in contemporary art. This problem can be formulated by asking whether In-

dianness is simply a result of the ethnicity of the artist or whether it is a
function of both the art object and the artist's ethnicity. Contemporary
artists have tended toward the former position while traditionalists have
emphasized the latter. For instance, in the video profile, Knokovtee Scott
defines Indian art: "Indian art is that art done of an Indian subject matter
by an Indian artist. . . . Indian subject matter should pertain to that par-
ticular artist's tribal background." By contrast, Indian modernists often
distance themselves from the role of "Indian artist."

Two hour-long documentaries by non-native outsiders, *Seasons of a
Navajo* (1984) and *Hopi: Songs of the Fourth World* (1983), fully demon-
strate the integration of traditional art practices into the total life of the
community. *Seasons of a Navajo* documents the cycle of seasons and ac-
tivities in the lives of one Navajo family, the Neboyias (see Fig. 11). The
video details the close integration of Navajo weaving with the land as part
of a rich portrait of a pastoral lifestyle in the Canyon de Chelly area of
northeastern Arizona. Many shots of Dorothy Neboyia and her family
carding, spinning, weaving, and dyeing wool, boiling flowers for natural
dyes, and hanging wool to dry in the trees near her hogan demonstrate that
the weaving process begins long before the weaver sits at the loom. These
activities are carefully woven into a holistic portrayal of the Neboyias' an-
nual life cycle rather than isolated into demonstration sequences. The
video is less concerned with explaining techniques than documenting a
way of life. The most striking result of this approach is that weaving is not
artificially singled out as an activity; rather, it truly emerges as an integral
part of everyday life. Dorothy weaves throughout the year. She's seen at the
loom outdoors on a bright summer day and weaving indoors by firelight
and gas lamp during the heart of winter. The video's breadth evokes a
sense of connectedness less apparent in profiles of individual artists or
techniques.

A connectedness of art, ritual, nature, and daily life, rooted in ancient
spiritual traditions, is also the keynote of *Hopi: Songs of the Fourth World*
(1983), directed by Pat Ferrero. In this film about the people of the oldest
continuously inhabited settlements on the North American continent,
Ferrero presents a culture largely intact nearly five hundred years after
contact with Europeans. The filmmaker emphasizes the continuity of
Hopi philosophy and ways of life, in contrast to the recent film *Winds of
Change: A Matter of Choice* (1990), which places greater emphasis on so-
cial changes in Hopi land. Without ignoring the changes wrought through

FIGURE 11 ▶ Chauncey and Dorothy Neboyia, *Seasons of a Navajo*
Seasons of a Navajo is a portrait of the life cycle of a traditional Navajo family in the
Canyon de Chelly area. Here, Chauncey and Dorothy Neboyia prepare dried corn in front
of their traditional *hogan* (log dwelling). (Courtesy of NAPT)

cultural contact, Ferrero gives us a visual and verbal essay about a culture
that collectively values tradition and spirituality.

For the Hopi, the visual arts express, record, or participate in a primar-
ily spiritual understanding of life. The filmmaker heavily relies on other
visual traditions: paintings of traditional weddings and other ceremonies
by Hopi artist Fred Kabotie; wonderful historic stills, especially portraits;
and short interview sequences with various visual artists. In one particu-
larly powerful sequence, Kabotie's *kachina* paintings are paired with the
intense music of ceremonies in which *kachina* dancers appear. Hopis be-
lieve that death, the last breath—or spirit—of a person, becomes a cloud,
a *kachina* spirit. Wherever there is breath or moisture, there is the spirit

life of a *kachina*, an idea which has inspired Kabotie: "As I painted the *kachina* dances, I would hum that particular *kachina* music because you're just involved with all that and you're bound with it and you can't help singing very softly as you paint." Kabotie started painting while away at school in Santa Fe. He thought of his people and "heard the *kachina* music among the trees. . . . It's the music that inspires you to start painting."

Many Native American artists, both traditional and contemporary, find artistic inspiration in visions and emphasize the role of spirituality in their art. A video by the contemporary Indian artist Susan Stewart raises questions about the role of visions and rituals in contemporary Native American art. Stewart's video documents a "personal ceremony," her contact with the Mapuche Indians of Patagonia, Argentina, and her painting process and philosophy. It prompts us to consider whether the ritual functions of art can be successfully combined with contemporary art forms.

The Crow Mapuche Connection: The Art of Susan Stewart (1991) begins with a solitary drumbeat, opening shots of clouds and mountain landscapes, and birdlike sounds. Estonian director/editor Arvo Iho then intercuts between shots of a circular drum, a circular ring around the sun, and a ceremonial ring of sand. These visual references to nature and the classic Native American symbol of the circle or medicine wheel introduce the major theme of the video: land and ceremony as a source of connection for all indigenous peoples of the Americas.

Stewart's vision surfaced through a dream: "Over two years ago I had a dream, I was taken above a medicine wheel in the Bighorn Mountains. . . . An old woman said to me: 'This is your connection; this is how you are connected to the earth.' She took me even higher and the earth was a ball and it was rotating and I could see points of light and they were all connected . . . these are the sacred spots all over the earth." This vision led Stewart to visit the Mapuche Indians twice and participate in ceremonies with them.

As she tells the story in voice-over narration, Stewart places different colors of powder, symbolizing the directions, in each quadrant of the ceremonial circle, along with symbols of the indigenous peoples from each region. Placing symbols of all the Indian cultures within the same circle expresses connection: "I was seeing the Indians of the south and they were like brothers and sisters to me. . . . We did not need any words to know who we were. . . . There was so much familiarity; it was like a dream."

Using a slide transfer technique, Stewart and Iho document her experience as the first Indian from the north to participate in Mapuche ceremonies. In the final sequence of the video Stewart paints a large canvas with a circular form, a combined reference to the Mapuche drum and the earth. She effectively combines traditional symbolism with contemporary art-making processes including performance, painting, and the video itself.

Susan Stewart's video expresses the commonly held native values of land stewardship and spirituality. This video's theme of a special attachment of indigenous peoples to the land pervades documentaries about contemporary and traditional artists and Native American media in general. The expression of reverence for nature unites various regions, tribes, and artistic approaches. In the video, Stewart often mentions a special feeling for the land as the motivational force behind her painting and performance art. A number of the visual arts documentaries opened with landscape sequences that root the art and artist in a specific location. Many of the artists speak of the influence of place in their artistic expression.

For Stewart, technology plays a positive role in contemporary art. The video camera, with its immediacy and accessibility, is an important tool for exposing contemporary art to a wider audience. She recognizes that it's more difficult for contemporary artists to be validated within their community; newer art forms such as installations may not even be recognized by some community members as art (Montana Indian Arts Conference 1991). Contemporary arts speak in a different language, and these innovative forms threaten change in cultures that value continuity. Stewart's solution is a merging of contemporary and traditional forms and issues in video.

However, from the contemporary artist's perspective, cultural preservation can have a stifling effect. When preservation is the overriding motive, "culture becomes mummified," and people run the danger of living in the past instead of the present (Charlo 1991). Artists like Stewart try to blend contemporary and traditional influences within the visual arts in order to address a larger audience, but many Native Americans find the strongest expression of their collective identity in the traditional performance arts, especially on the powwow circuit. Some contemporary visual artists are concerned that the powwow and visual art worlds do not cross over—that the songs, dances, and art of the powwow circuit are not integrated into the mainstream art world (Montana Indian Arts Conference 1991).

Traditional visual artists feel differently about this. The rapid growth in the powwow scene has created a marketplace for their art; most traditional art is now made for use in powwows (Montana Indian Arts Conference 1991). Powwows are highly symbolic celebrations of collectively held values, and potential commercial bonanzas for traditional artists. However, many traditional artists creating for the powwow trade may not view themselves as artists, but as craftspeople, and devalue their own work when compared with artists producing for galleries (Horse Capture 1991).

DIFFERENCES BETWEEN TRADITIONAL AND CONTEMPORARY ART

Films and videos documenting contemporary and traditional Native American visual art point out differences in the expression of Indianness by native artists. Native American art is changing rapidly. Some artists might describe this transition as progress, others as loss.

Traditional artists view art as a way to hold onto culture, an activity that prevents even greater cultural losses. In painting, the emphasis of their art is illustration or documentation, but rarely are their paintings exact replicas of life; instead they paint myths, legends, and history from the imagination and memory. These paintings of myth and history may become documentary material in their own right for film- and videomakers, as in Ferrero's use of Kabotie's paintings.

Many traditional arts are land based. The potter collects clay in a nearby field, and the weaver shears sheep and prepares the wool as a prelude to weaving. Through this dependence upon locally available material that must be carefully prepared, art blends into daily life rather than standing out as a separate activity. This material connectedness is echoed in the social and spiritual functions of traditional art forms, which often incorporate symbols, patterns, and myths central to the whole culture. The art form acts as a bridge between material aspects of life and collectively held values.

In contrast to videos documenting traditional arts, videos and films about contemporary artists tend to focus upon the individual artists' creativity and personal artistic philosophies, but do so in the context of balancing Indian and Western influences. Documentaries about individual Indian artists are often created by non-Indians. Though there are exceptions, Native Americans tend to document a particular technique or a

group of artists rather than an individual artist. Native-produced videos usually emphasize the collective or ritualistic functions of art.

For the traditionalist, art may be recognized as Indian in several ways: the medium of expression (shellwork, quillwork, basketry, etc.); designs that clearly relate to tribal, clan, or other group identity; or subject matter pertaining to Indians (Montana Indian Arts Conference 1991). Though all of these elements may not be present in a given work, the underlying assumption is that there is something in the artwork, not just in the artist, that makes an artwork Indian.

The location of Indianness in the ethnicity of the artist rather than in the artwork frees artists from formulaic expressions of Indianness, but risks excluding those audience members who do not understand new visual languages that result from formal innovation. Artistic progress, understood as technical and stylistic development and rooted in the transition to an economic market that values uniqueness, has its price: the problematic relationship of contemporary art to a Native American audience. Artistic progress affects audience understanding or misunderstanding, the latter of which may lead to social exclusion. For example, cultural assumptions (progress, innovation, technological and formal development) acquired by some Indian artists through contact with the non-Indian art world lead to specialization and individualization (in technical ability and in individualized forms of expression) which, in turn, lead to social exclusion.

The relationship between native progress in art and social exclusion must be addressed in the context of competitive social relations. Native artistic progress is partially driven by a desire to succeed in the competitive non-Indian art world. Competition is the exercise of power by one person over another. Progress in competitive societies ultimately depends upon subjugation, which is consistent with a view that progress in art inherently leads to social exclusion. For many traditional Native American cultures, the endurance of the social structure depends on consistency with the past and cooperative decision making rather than subjugation. Very different criteria for artistic evaluation arise in the two types of societies. The traditional society allows for individual styles and artistic development but legitimates art through recognition of a communicative code that has endured across time. Perseverance takes precedence over progress and innovation. The goal of the artist in a competitive society is differentiation through innovation; artwork is legitimized through its creativity or

novelty, which has led to increasingly rapid changes in style. The highly in- dividualized and socially isolated nature of some contemporary art, a product of art world competition and progress, has, in some cases, led to interpretive confusion.

From the documentaries discussed here and related documentaries there emerges a portrait of two very different sets of assumptions about the role of art and artists. Documentaries about traditional arts emphasize the *integration* of art into daily life and collective ritual. In some cases, this integration may be so complete that art is indistinguishable from work or religion. Though individual style is recognized, formal and thematic consistency with the past is most highly valued. Indianness in traditional art is clearly located in the artwork itself and receives its strongest expression in participatory events such as powwows.

Documentaries about contemporary artists emphasize the creative, personal, and relatively *autonomous* aspects of art making. Many contemporary Indian artists are trying to synthesize an Indian worldview with participation in the highly competitive, non-Indian art world. Mainstream values such as formal innovation shape contemporary native artists' work. Since formal innovation eventually leads to the loss of common artistic languages, contemporary artists tend to locate Indianness in the artist's ethnicity rather than in the artwork itself.

I have focused on the different social functions of traditional and contemporary art in this chapter. But there are undercurrents common to much Native American artistic expression. A large percentage of the visual arts documentaries that I viewed open with landscape sequences that root the art and artist in a specific location. Many of the artists, traditional and contemporary alike, speak of the influence of place on their artistic expression. This, perhaps, is one of the greatest advantages of film and video documentaries about art over written expositions of art and culture. Film and video give us a sense of context that can be achieved only through a visual familiarity with the artist's native environment. This body of documentaries fosters an appreciation for the importance of place in all Native American artistic expression.

PERFORMANCE CONTEXTS
AND COLLECTIVE IDENTITY

HIS CHAPTER considers the role of the performing arts in processes of collective affiliation, which is somewhat different than the role of the visual arts. Because film and video incorporate a visual language of motion and the component of sound, they are ideally suited to recording performing arts. More than the still image or written word, they clearly express the complex interrelationships between individuals in performative contexts. A distinct value of indigenous videos may be the way they allow a comparison of how various performance contexts situate the participants, encouraging or discouraging their engagement in collective aesthetic processes.

Performance contexts shape understandings of Indianness differently for varying audiences. Though context is an important aspect of the experience of visual arts, theorists in ethnomusicology and folklore have more actively explored the participatory aspect of contexts and the way that participation evokes collective responses. Additionally, the linking of traditional music and cultural identity in ethnomusicological theory has such a long tradition that Bohlman (1988) has proposed that this linkage is the most persistent theoretical paradigm in the field. The linkage is reflected in some of ethnomusicology's earliest terminology. Bohlman writes: "With the concept of *Volkslied* Herder at once juxtaposed *Lied,* representing traditional music, and *Volk,* representing cultural identity" (Bohlman 1988, 32). The concept of *Volkslied* formed a new paradigm which encompassed a relationship among the roles of the group, music, and language.

Also significant for Herder was the role of the group, which distinguished both a social structure and a tradition within which the folk song was a distinct entity. Immanent in *Volkslied* were concepts of origins, music, language, and culture itself, thus ascribing to folk music the ability to encapsulate and specify cultural identity. (Bohlman 1988, 33)

Many researchers in the field continue to explicitly link music and cultural identification (Blacking 1983; McCarthy 1990; Oliven 1988; Osula 1984; Pacini 1989; Waterman 1982, 1990). In this chapter, I continue in this tradition of linking music and cultural identification by considering musical and dance performance, recorded on film and video, as a process of identity construction.

In an article titled "Performance and the Cultural Construction of Reality," Schieffelin (1985) proposed that there are limitations to "meaning-centered" approaches to ritual performance. The "meaning-centered" approach, which Schieffelin associates with the prominent anthropologist Clifford Geertz, focuses on symbols as sense making: as coded communication. This definition by Schieffelin is consistent with Geertz's own description of his work as based in a "semiotic conception of culture" and concerned with "webs of significance" (Geertz 1988, 535). For meaning-centered symbolic anthropologists, "analysis is sorting out the structures of signification" in order to excavate "superimposed conceptual structures" (Geertz 1988, 536). Schieffelin writes that this leads to an approach to ritual analysis that is akin to textual analysis, which uncovers "permutations of meaning in the symbolic materials themselves" (Schieffelin 1985, 708).

For Schieffelin, the danger of this textual approach is its overemphasis on content and the discursive elements of ritual, and a deemphasizing of performance.[1] He proposes that we must attend to the form of the performance as much as the content because the form shapes the content. Performative elements restrict and prescribe ways of speaking and interacting in ritual contexts. With the issue framed in this manner, the central question is: what are these performative elements? Schieffelin suggests two possibilities: the arrangement of performative space and the media used (song, dance, costume, etc.) (Schieffelin 1985, 209).

In both ritual and musical performance contexts, performance space and media encompass a relationship to other aesthetic forms: speech, dress, architecture, the graphic arts, dance, and so forth. This relational approach to aesthetic experience allows for the discovery of homologies of aesthetic form that may reflect or constitute broader social structures (Hebdige 1979; Kaeppler 1978). Feld (1988) has proposed that these homologic relationships be understood as the iconicity of style, which refers to the "groove" that occurs when the parts and levels of an aesthetic whole draw attention to each other. Understanding the relationship between

music and these other expressive forms leads to a fuller understanding of music in performance contexts: "Any ethnomusicological study of music should begin by examining music in relationship to other art forms, because nothing exists in itself" (Seeger 1987, 25). A basic starting point for understanding song, for instance, is in its relationship to other types of speech genres (Seeger 1987, 25). Coplan's (1988) research into the *Sifela* song forms of the Basotho shows that a relationship between genres, or "intertextuality," may have historical resonances important in understanding the role of music in identity construction.

> [A]s South Africa's regional dominance grew and Lesotho's economic and political dependence increased, the association of chiefly praise poetry with the heroic period of the autonomous Sotho state maintained the prestige of *likotho* [praise poetry] and its role in the expressive formation of Sotho personal and social identity. The permeability of genre boundaries in performance not only makes the poetic resources and resonance of historical culture available to *sifela* [the emergent song genre], but affects such theoretically "fixed" or normative forms as chiefly praises as well. (Coplan 1988, 342)

One can ask whether there has been a similar interplay between traditional and emergent Native American performance genres which relates to historical aspects of the Native American experience. In this conception traditional performance practices do not function as a fixed form but are molded through interaction with other genres. Two types of relationships may emerge: the relationship among various aesthetic forms in each performance context and the relationship among various genres of music, dance, and song.

The group identification of participants through performance partly occurs through the recognition of style or genre. This recognition entails the ability to juxtapose differing styles, enabling the participant to identify with one style and not another. Identification may have its basis in ethnic, class, gender, political, regional, or other social distinctions, but these distinctions are *recognized* through the juxtaposition of styles. Feld, for instance, holds that in Kaluli culture gender differences are marked only in genre or style, through stylistic divisions of performance. Elements of performance context are important because they signal participants to accept or reject the appropriateness of a certain genre of aesthetic communication in that context. Much of this predisposition toward the appropriateness of genres is lodged in prior understanding of who has the power or the right to perform in and control the performance (these are not neces-

sarily the same persons). Genres of aesthetic expression are ways in which social differentiation is enacted, a point argued at length by Bourdieu (1984) with reference to Western culture.

Stylistic or genre characteristics also shape cultural identification through socially defined conceptions of the self. The experience of self in relatively egalitarian social structures differs from that in relatively hierarchical social structures. In the West, certain stylistic characteristics, whether of music, performance, or both, reinforce the experience of self as hierarchically situated within society. Becker (1986) explains that principles of harmony and instrumentation in classical music reveal a hierarchical structuring of musical elements. In previous research, I found that this hierarchical structuring was echoed in the context of classical music performance (Leuthold 1991). The organization of musical performance and social organization resonate with each other; in turn they define and limit the social construction of the self and, therefore, the process of collective identification.

Expectations about participants' skills shape the relationship between self and society. Understandings of skill and competence affect who can perform, how performance is learned, how skill is stratified, and which skills are seen as necessary for the production and reception of music and dance (Kingsbury 1988). If talent is seen as rare, possessed by only a few members of a society, this leads to a different level or type of participation in performance contexts. Where talent is a rare commodity, there may be more distance between performers and participants. But if musical or dance ability is seen as a skill to be generally developed and acquired, then participation in performance events increases. This second attitude toward skill correlates with egalitarian social structures or events, while the sense of talent as rare correlates with a relatively hierarchical social structure.

Underlying the relationship between performance contexts and cultural identification are some basic questions: Who can or does participate and on what basis? In what kind of space does the performance occur? What is the nature of the media and the music? How do each of these characteristics compel the audience to identify with values expressed in the performance they are experiencing?

In previous research on Irish music in four different performance contexts, I attempted to identify these elements that compel audiences to identify with a group ethos through aesthetic practices (Leuthold 1991).

For some audiences, Irishness as a focus for cultural identification is not limited to ethnicity. People assume that an Irish spirit—a touch of the Irish—may abide in the non-Irish. Irishness, then, acts as one of a complex set of identity components, especially for musicians and audiences who have adopted Irishness, in contrast to ethnic Irish, who may place more weight on Irishness as a central component of their identity.

Similar adaptations of Indian identity have occurred for non-Indian groups. For instance, African Americans in Louisiana have developed an elaborate festival tradition of "Black Indians," adapting some of the legends and dress of Plains Indians to a Mardis Gras ritual context. The actual form of the costumes that have been developed and the patterns of dance and ritual interaction are more closely related to African than Native American performance traditions. The identification of African Americans with Native Americans probably relates to a shared sense of oppression by the dominant culture, as seen in this excerpt of song lyrics by the Neville Brothers, a black group from Louisiana:

> That's my blood down there—
> on the reservations
> That's my blood down there—
> all the Indian nations
> That's my blood down there—
> the first Americans
> (Neville Brothers, "My Blood" 1989)

The role of aesthetic experience in forming collective identity is not defined by ethnicity alone; it includes broader rhetorical goals. However, even in various hybrid forms of aesthetic experience, there seems to remain a strong identification with the culture of origin. For instance, much contemporary "Celtic rock" has more in common with the larger pop culture that nurtures rock music than with traditional Celtic customs. And New Orleans's Black Indians exhibit more commonality with the customs of Africa and black culture of the Southern United States than with traditional Native American cultures.

What, then, is the function of "traditional" performance? Traditional performance contexts, which often allow for long conversation and the communal activity of music making and dance, counteract the loss of these activities in the "modern, technological world," where they often get

"hazardously ploughed over" (Winter 1990, 18). Through singing and storytelling, legends are transferred from generation to generation. Often these legends reflect the close integration of biography and place in a culture's construction of group identity. Place names and legendary heroes in songs and myths are a form of poetic evocation shared by many indigenous cultures. Feld explains that songs "project affect onto the environment" so that place becomes a source of evocative, highly resonant imagery (Feld 1991). Many Indian tribes share this powerful sense of place, ascribing a sacredness to the environment through performative and visual arts that is alien to Westerners' interactions with their environments.

In performance contexts, dance is usually inseparable from music and song. Often dance involves an intricate set of skills which each dancer has to master to belong to the group. The Ghost Dance movement that emerged in the late nineteenth century as a response to outside pressures threatening Indian cultures demonstrates the special place of dance in many tribal cultures and was an early attempt at achieving intertribal unity (Morris and Wander 1990, 161). Later, the dance and the movement it symbolized were outlawed, reflecting the severe constriction of Native American life well into the twentieth century. Indians began to revitalize tribal cultures beginning in the 1950s. By the early 1970s protest at Wounded Knee, "the most important consequence of the protestors' efforts to revitalize Native American cultures by revitalizing the ethos of the Ghost Dance movement [was] that the effort produced a rhetoric that functionally parallel[ed] the rhetoric of the Ghost Dance movement" (Morris and Wander 1990, 161). Morris and Wander are clearly focused on the rhetoric of the new protestors rather than the performance contexts of a dance. However, their comparison of the original movement and the contemporary protest demonstrates the importance of both participatory performance and control or lack of control of media.

Because the Ghost Dance movement was embedded in a spiritual context and necessarily relied heavily on face-to-face communication, its members were able to control access to, participation in, and the meaning of their activities. The protestors at Wounded Knee had little control over access to, participation in, or the meaning of their activities. Access and participation, after the first hour, were almost wholly controlled by military forces that had encircled the village. The "meaning" of the protestors' activities was almost entirely controlled by members of the dominant society's mass media. (Morris and Wander 1990, 182)

Perhaps, through indigenous videos which represent music, dances, and other performance activities, videomakers strive to achieve both goals: the sense of participatory communication rooted in spiritual contexts and controlling both the spiritual and political meaning of any event by controlling the medium used to report it.

My observations of contemporary powwows, in Philadelphia, on the Flathead Indian Reservation, and in New York state, indicate that the community dance remains an important form of collective experience for contemporary Native Americans. Morris and Wander write that the Ghost Dance and the story of the Ghost Dance movement functioned as a "master trope" for the protestors at Wounded Knee: "As a story and as a living memory, the Ghost Dance movement provided both a new and a traditionally sanctioned 'I' specific enough to affirm what was 'good' in the old 'I' of tribal membership and yet general enough to transcend specific cultural differences" (Morris and Wander 1990, 183). Even in the less political context of the annual powwow, the experience of specific tribes and the general experience of Native Americans are communicated through art, costume, dance, song, and food to create collective identity.

Dance continues to be an aesthetic and spiritual practice that coalesces Indian identity through participation structures. More generally, powwow groups, with their emphasis on traditional and modern costumes, singing, and dancing, are found in urban as well as reservation settings. Along with sports associations, Native American churches, and Indian community centers, they invite community participation. Dance and ceremony, with their mixed religious and aesthetic functions, demonstrate the situational or contextual nature of group identification.

The unique combination of performative elements in each performance instance shows how processes of identification vary according to context. Each of these contextual elements arises from very real social divisions of labor and expression within a given culture. In explaining the social code, "the Law," underlying Australian Aboriginal social relations and expressive behavior, Michaels writes:

The way this system assures social reproduction involves rigorous divisions in the labours of knowledge and expression. . . . This Law, in its characteristic story forms is differentially distributed across the population. Age, gender, kinship category and "country" determine who might access which aspects of the knowledge, which parts of songs, what designs or dance steps. (1987, 30)

INDIGENOUS AESTHETICS

My attention to performance contexts and constraints, then, is motivated
by the understanding that these reveal underlying social structures or be-
lief systems. Additionally, indigenous videos record those "special sites"
where values integral to social order are expressed and reinforced.

As we can see, the observation and analysis of performance arts and
rituals often focus on the participatory and contextual aspects of a perfor-
mance event. In this chapter I ask how performative elements overlap to
create an aesthetic whole and whether performance practices prescribe
ways of acting that reveal native social relationships. For instance, the
answer to the question of who has the power and right to perform may
demonstrate how performance constraints enact social differentiation.
Similarly, attitudes toward performance skill may correlate with types of
social structure. The practices associated with traditional performance, in-
cluding long conversation, communal activity, games, and the telling of
legends and stories, often indicate the centrally held values that comprise
the collective *ethos* of a group. Thus, several factors will guide my analysis
of performance arts documentaries: performance space and media, atti-
tudes toward skills, types of participation and constraints on performance,
and the relationship of performance arts to Native American worldviews
and social structures.

COMMUNITY DANCE: POWWOW

In Native American cultures, community dance ceremonies are the most
visible traditional form of performance and ritual. These ceremonies in-
clude the potlatches of Northwest Coast and Alaskan Indians, the cere-
monial dances of the Southwestern tribes, and the powwows of the Plains.
Most of the videos available for this research documented powwows; these
ceremonial dance events are the focus of this section of the chapter. The
next section of the chapter examines the role of song and music in ex-
pressing native collective identities as documented through film and
video.

Powwow scenes are frequently used as transitional devices and symbols
of Indian identity in videos like *The Place of Falling Waters* (1990) and
Warrior Chiefs in a New Age (1991) that primarily document other subject
matter. Powwows are growing as expressions of pan-Indianism, a charac-
teristic less evident in the dance ceremonies of other cultural areas. Thus,
analyzing videos about powwows may provide insight into the develop-

ment of pan-Indian collective identity in relation to traditional tribal and clan identity.

Five videos that specifically document powwows were analyzed: *Dancing Feathers* (1983), *A Tradition Lives: The Powwow* (1984), *Powwow Fever* (1984), *I'd Rather Be Powwowing* (1983), and *Keep Your Heart Strong* (1986). All of these are documentaries except *Dancing Feathers,* which is a dramatic episode from the *Spirit Bay* series (1982–1986). This series of thirteen half-hour episodes was produced by an independent company for the Canadian Broadcasting Corporation and has been broadcast in the United States, Canada, and Europe. The videos drew on the talents of both professional and nonprofessional Indian actors, advisors, and production personnel, intentionally providing a training ground for Native American talent (Weatherford and Seubert 1988, 78). Set in the fictional community of Spirit Bay and filmed on the Rocky Bay Reserve in Ontario, the series' plots revolve around the life experiences of the community's children.

Dancing Feathers tells the story of a young girl, Tafia, who excitedly, yet reluctantly, anticipates dancing at her first powwow. Early in the episode she practices her dance on a dock near her house and remembers a bit of advice, "When the bird is ready, it will fly," but thinks to herself, "I don't think I'm ready to fly yet." Other important characters are Tafia's aunt, Lily, who is taking her to the powwow in Toronto, her grandmother, her best friend, and the laughable uncle, Cheemo, played by Gary Farmer, who later acted in *Powwow Highway.*

On route to the city Tafia asks Lily whether she danced in powwows as a girl. Her aunt replies that the church didn't like powwows so they stopped them. Lily adds, "Believe it or not, when I was young, I didn't want to be an Indian; I just wanted to forget."

Tafia asks, "So you didn't want to dance?"

Lily, "Not then."

Later in the ride Tafia announces, "I don't think I want to dance," though she fears Lily will be angry with her decision. By the end of the episode, through familial support, Tafia has recovered her confidence and, when no other "jingle dress" dancers show up, even dances a solo demonstration.

After the girls and Lily arrive in Toronto, a young white kid steals one of Lily's paintings from the back of her pickup truck. The girls chase the thief and finally recover the painting after he drops it, but not until after becoming lost in the center of Toronto. They are befriended by a punk teen

at a taco stand, a type of person they have never seen before, and he helps catch the kid that ripped off the painting. At the police station he demonstrates his punk dance to the girls, and Tafia shows him her powwow steps. Young viewers learn that normalcy in haircuts or dance steps is simply a matter of perspective and that differences can be appreciated rather than feared.

The theme of this show directed at children is self-confidence and readiness. Important criteria of participation in powwows are mental readiness and preparation through practice. It's in the dance that children are encouraged to discover their own uniqueness: to "tell their own stories." Though the singers and drummers in this video are all male, the dancers range widely in age and are of both sexes. The only constraint on dance participation, then, is a proper state of mind, usually described as readiness or preparation. As a result of her preparation, by the end of the story Tafia loses her self-consciousness in the experience of the dance: "I could feel the drum beat moving in my feet and in my heart."

A Tradition Lives: The Powwow (1984), hosted by Johnny Arlee (Salish), also emphasizes the importance of preparation for participation in powwows. The video documents the attention given to each feather in a bustle, which is individually measured and prepared, or each beaded bag carried by a dancer, which takes one to three months to prepare. Many of the materials used to make powwow outfits—the shells, hides, furs, feathers, and so on—are handed down by elders and acquire special importance. Often, dancers make their own outfits, or someone in their family makes it for them. The cost of materials may run into thousands of dollars; a roche, which is worn in the hair, can alone cost three to four hundred dollars. If detailed attention is not given to the outfit and part of an outfit falls during a performance, it results in humiliation for the performer. Criteria of authenticity for an outfit are that it is appropriate to the type of dance, whether traditional or fancy, that it is Indian-made, and that it reflects the style of the dancer's tribe. The uniqueness of the individual should show in the outfit. Powwow aficionados can quickly recognize on videotape the different tribal outfit styles, along with songs and individual dancers. They also comment on particular color combinations, face-painting styles, and other elements of powwow outfits.

Just as powwow outfits are evaluated by the dual criteria of authenticity and uniqueness, so is the dance. Most importantly, the dancer must synchronize his or her movement with the singing; a serious flaw is to over-

step a song. Authenticity is located in accurate performance, the proper steps of each dance style. Less tangible qualities such as "fullness" or "good rhythm" separate the average dancer from the "super Indian" (Bigcrane 1991), but all dancers develop their own style through body movements. It's in the motion of live performance that the "outfit becomes a living thing" (*A Tradition Lives* 1984). Movement, synchronized to the beat of the drum, is the essence of powwow dance. The performance acts as the point of focus for the long, careful months of preparation: a concentrated moment into which the dancer pours his or her life.

I'd Rather Be Powwowing, produced by George P. Horse Capture and directed by Larry Littlebird, explores the place of powwows in the life of one contemporary Native American, Al Chandler, a member of the Gros Ventre tribe from the Fort Belknap Reservation in Montana. At the beginning of the film Chandler leaves his rural suburban house in a suit and tie, gets in his late-model van, and drives into work, where he is a copy machine technician, or "senior technical representative," for the Xerox Corporation, a job he has held for many years. This early sequence and shots of the inside of a copy machine Chandler is repairing contrast strongly with images of the powwow he soon attends. Unlike many productions, *I'd Rather Be Powwowing* places powwows in the context of modern life, with its emphasis on employment, education, salary, and a rigid temporal system. Leaving the world of work for the world of the powwow evokes a different sense of time. The linear, clockwork time governing the world of work impels us to move faster and faster. As John Collier wrote, after living in this system we may look back and notice "we hardly had time to live at all," in contrast to the Indians' different sense of time that creates a "sense of inner spaciousness" (Collier 1972, 13–15). One appeal of powwows is that they establish a different rhythm, a rhythm governed by the drum and the land.

As Chandler loads his powwow outfits into the back of his van and his tipi poles on top, Indian singing appears on the soundtrack, signifying a transition to a different world. This transition continues as Chandler tells his son about his childhood experiences riding up and down the eastern Montana hills that mark the way to the Rocky Boy Reserve, where the powwow is to be held. Many powwows are far from the communities where participants live, but the travel through wide-open country is accompanied by a change of mindset.

I put it in my mind that I'm going to forget everything: the noisy city, going to work, all of this long driving I do. I think of the good things that are going to happen. I pray that we have a good time and I think of getting dressed, meeting our friends, and dancing. When you're at an Indian dance you can hear the drum beating and the bells ringing, the movement of people all in harmony. It's a spiritual feeling which you can't really know about unless you do it. When we get there, we can chant and cook and people are friendly. (Chandler 1983)

For Chandler the powwow represents "one of the few things we have left that we can do" that produces the sense of "togetherness" with family and friends Indians felt before being absorbed into the Western economic system. The powwow ceremony calls to mind the past. Even small details are noticed when they depart from past habits. Chandler comments that we "can't make everything the same as in the past" as he sews parts of his powwow outfit together with thread instead of sinew.

We learn through Chandler's visits with elders and other families, his buying of Indian goods in tipis, and his preparation for and participation in the ceremonies themselves that powwows integrate Indian culture. For some participants the powwow is a religious event where they experience a sense of connection: "As you're dancing you feel yourself stand taller and show everything you've got because the creator has given you what you have. And, as you look around, you can see other dancers and they're all feeling that same feeling" (Chandler 1983). Chandler repeatedly describes his feelings as worshipful: "The creator's telling you that this is the right way." After the powwow, participants "say thanks inside for all the good things the creator has given you . . . this is why I'd rather be powwowing" (Chandler 1983). Powwows are a ritual of transformation from the mundane to the spiritual. Though they integrate Indian culture and belief, they also provide a release from the demands and expectations of the larger culture. They function to separate participants from one social world just as they are integrated into another.

The hour-long video *Keep Your Heart Strong* (1986), directed by Deb Wallwork, addresses several of the themes that emerged in the other documentaries. In an unusual technique, the director presents all of her interview material in voice-over commentary rather than through on-screen interviews. The visuals document the powwow itself, the large annual powwow that occurs in Bismarck, North Dakota, toward the end of sum-

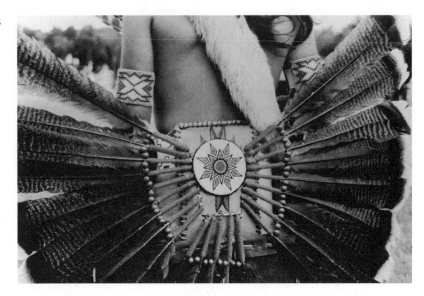

FIGURE 12 ▶ Detail of Dancer, *Keep Your Heart Strong*
The circle is found everywhere in contemporary powwows: in visual expression, the structure of dances, and the form of the drum itself. It symbolizes the circular motion of the eagle as well as the unity and animation of the spirit. (Courtesy of NAPT)

mer and culminates the powwow season in the north. Over six hundred dancers attend from throughout the Northern Plains states and central Canada. Such a large event truly represents the "coming together of the group" (*Keep Your Heart Strong* 1986). This documentary, like the other powwow videos, provides a visual feast for the viewer. The color, motion, and sound of the events provide a natural subject for the combined visual/sound media of film and video. Wallwork's decision to forgo on-camera interviews accentuates the visual excitement of the event.

Like *I'd Rather Be Powwowing*, this video emphasizes a worldview of integration, harmony, and balance symbolized in the ceremony. One participant describes the structure of the ritual as "circles upon circles upon circles" (*Keep Your Heart Strong* 1986; see Fig. 12). All activities, including dancing and singing, are part of the circle. Eagle feathers that help make up the outfits are religious symbols evoking the circling motion of the bird in flight. The eagle "carries prayers to the great spirit" and symbolizes the connection of the dancer to the spiritual. The drum is a circular sacred

symbol that must be blessed before the powwow. Healing, life-giving powers are attributed to the rhythm of the drum, which represents "that which animates, that which moves." The interrelationship of dancers with each other and with the life-giving spiritual and natural world is the "overriding theme" of the celebration.

Powwow participants emphasize that the events are "modern expressions of Indian life," not static reenactments of the past. In the songs and costumes, the ceremony participants constantly adopt new and different styles. At the same time, preservation remains a strong motive; powwow performers both "increase and preserve the repertoire of songs." As a result, the repertoire is quite varied. Singers can perform for many nights and not repeat themselves. One departure from the past is the division of participants into audience and performers. An unidentified commentator states that in the past everybody was a dancer; vicarious experience is a distinctly modern idea.

Another modern invention is the introduction of prizes for the best dancer in each division, such as "men's fancy dancing" or "women's traditional." When asked, Roy Bigcrane said he thought the introduction of competition into the event came about through whites' influence. However, the existence of competition within tribes probably varies based upon each tribe's unique cultural traditions. At large powwows the competition for prizes is keen, pitting the best dancers on the powwow circuit against each other. Some categories of dance, including the honor dances and intertribals, remain noncompetitive, which encourages people of all ages and skill levels to participate. The noncompetitive aspect of the festival is reinforced in its organization. Children are elected as officers, which symbolizes "the highest ideals of the culture—compassion and generosity," and expresses an "all-encompassing outlook" (*Keep Your Heart Strong* 1986). Native Americans take pride that the powwow as an institution is built upon the values of love and caring.

Another value reinforced in this video is the importance of preparation. The quillwork, beadwork, and other elements of the outfits take all winter to prepare, demonstrating an attitude of respect toward the materials and the powwow. One commentator describes the outfits as a "high form" of "kinetic art" that emphasizes the motion of the dance (*Keep Your Heart Strong* 1986).

Powwows clearly emerge as the most important contemporary expression of Indian identity for Plains tribes in this sample of films and videos.

This message was reinforced through conversations with Roy Bigcrane and other natives at Salish Kootenai College (SKC), who eagerly anticipate the arrival of powwow season each year and are saddened by its passing. During the off-season, native families order videotapes of powwows they attended during the summer. Of the videos available at SKC, powwow videos are among the most popular (Bigcrane 1991). A sequence in the documentary *Winds of Change: A Matter of Choice* (1990) depicts a successful Indian family from the suburbs of Milwaukee viewing a powwow video at home in their living room.

Winds of Change explains that through powwows Indian identity transcends tribal differences. This is especially important in urban environments where members of many tribes live. Urban Indians experience cultural isolation and prejudice. In this context of isolation, powwows express Indianness because they clearly show an identity at variance with or in contrast to the larger culture. Native Americans interviewed said that an increase in exposure to the larger non-Indian world leads to a greater appreciation of belonging to Indian groups and communities (*Winds of Change: A Matter of Choice* 1990). As with *I'd Rather Be Powwowing*, powwows in this video symbolize cultural integration for Native Americans but also separateness from many of the values imposed by the non-Indian world. Since powwows are powerful symbols of resistance to assimilation, the integration of powwows into the mainstream art world, a goal expressed by some whites and Indians at the Montana Indian Arts Conference, is unlikely. Powwows' separateness is a powerful source of their appeal.

Powwows may also facilitate healing within a tribe. *The Spirit of Crazy Horse* (1990) documents the struggle for Native American rights that occurred on the Pine Ridge Reservation in South Dakota during the 1970s. After the violent confrontation at Wounded Knee in 1973 which gained national attention, animosity permeated the community for a three-year period. Over sixty people lost their lives in a tribal civil war between supporters of the American Indian Movement (AIM) and supporters of the "goon squad" of Indian vigilantes organized by tribal chairman Dick Wilson. Unfortunately, much of this division occurred along racial lines, with mixed-bloods and full-bloods violently opposing each other. These racial divisions were perpetuated by depressed economic conditions in an area where the BIA is the largest employer and the mixed-blood, "hang around the fort Indians get more than their share." One full-blood com-

ments, "One day they're Indians, the next they're white" (*The Spirit of* *Crazy Horse* 1990). As on many reservations, the internal divisions, economic conditions, and overall breakdown of culture resulted in high levels of alcoholism, child neglect, and beatings.

During the early 1970s a climate of interest in traditional spirituality, documented in the film *Crow Dog's Paradise* (1976–1978), drew city Indians who had "recently discovered their face" back to the reservation. Henry Crow Dog, who died in 1985, provided the spiritual foundation for the political movement. Now, years after his death, the summer powwow in Pine Ridge has emerged as a healing force in the tribe, bringing mixed-bloods and full-bloods together in a unified expression of their Lakota heritage (Milo Yellow Hair, *The Spirit of Crazy Horse* 1990). The hatred generated by the violent events of the 1970s has been partially overcome through participation in powwows and other traditional ceremonies.

There are other views of the political and economic implications of powwows. In his influential book *Custer Died for Your Sins: An Indian Manifesto* (1969), Vine Deloria credits intrusive white academics with the heavy focus on community dances in Indian country. Describing how, after World War II, hundreds of anthropologists descended upon Indian reservations and "bemoaned the fact that whenever [they] visited the reservations the Sioux were not out dancing in the manner of their ancestors," Deloria wrote:

Today the summers are taken up with one great orgy of dancing and celebrating as each small community of Indians sponsors a weekend powwow for the people in the surrounding communities. Gone are the little gardens which used to provide fresh vegetables in the summer and canned goods in the winter. Gone are the chickens which provided eggs and Sunday dinner. In the winter the situation becomes critical for families who spent the summer dancing. (Deloria 1969, 87)

In a presentation videotaped at the University of Montana (1988) Deloria makes a similar point when he argues that social conditions need to be addressed first, before tribal medicine men set off to California in order to profit from the recent interest in Indian religion. Deloria repeats his criticism of the emphasis on dance, but this time in the context of politics. Stating that "Joe Reservation" has to take responsibility for tribal governments by not voting crooks back into power, Deloria explains that many of the harmful religious and political practices grow out of "too much nepotism" (Deloria 1988). He adds that social responsibility goes beyond

the current interest in culture and explains, "It's not enough to just have powwows," and that things would improve "if you took the money that's put into dance contests and put the money into training young Indian men and women" (Deloria 1988).

For Deloria, powwows divert Indians from tackling urgent social and political problems, acting as a kind of modern-day opiate of the masses. While he strongly supports the rights of natives to freely practice their religions, he does not see powwows as religious occasions as much as social events. In addition, he places the initial blame for the overemphasis on powwows at the feet of white cultural purists who bemoaned the loss of ceremony that had occurred in Indian cultures by the mid-sixties. Are these criticisms fair? Possibly. Unfortunately, they do not explain the increasing growth of the powwow phenomenon.

Deloria's criticisms do bring up an important issue: the role of prize money in attracting the best dancers to powwows. Like rodeo circuit riders, the best dancers may make a living off of the prize money they can win from powwow competitions throughout the summer. A short video, *Powwow Fever* (1984), produced and directed by Rick Tailfeathers (Blood), demonstrates that rodeo riding, gambling (stick games), and dancing are all rolled into one big event. Some powwows seem to hold more in common with white-sponsored rodeos and carnivals, which could hardly be described as religious, than with traditional religious ceremonies. Though the ceremonial dancing may distinguish powwows from these other social and commercial activities, an overemphasis on prize money undermines the religious aura some participants ascribe to powwows. In a different film an older woman reacts to new, flashier dance styles: "Both Mattie and I do not see anything in the way that you young people dance. That's not Indian dancing, not the dignified Indian dancing that we all know" (*Circle of Song* 1976). Even though Deloria's and the woman's criticisms probably have some validity, the opinions of most powwow participants documented in the videos lean toward an appreciation of the familial and spiritual aspects of powwows rather than the flashy, competitive side of the events.

Prize money may be one of the few ways dancers can support themselves. Rarely is Indian dancing transported from the powwow arena to the commercial stage, even though there is demand for it as entertainment (Montana Indian Arts Conference 1991). Part of the reason lies in the importance of context for powwow dancing; the origins of dancing

are not as entertainment, but in collective ritual participation. All rem-
nants of this original function are shed when the powwow dancer mounts
the stage as a virtuoso performer for non-Indian audiences. One excep-
tion may be performances designed to explain this cultural activity to the
larger culture. The American Indian Dance Theater, under the direction
of Hanay Geiogamah, has traveled the country demonstrating various
kinds of dances and their symbolic import to both Indian and non-Indian
audiences.

An episode of the PBS series *Great Performances* documents these
dances in *Native American Dance: Finding the Circle* (1989), a production
written and staged by Geiogamah and directed by Merrill Brockway. As in-
dicated in the title, the circle is the symbolic thread running throughout
the documentary: from the drum itself, to the gracefully circular motions
of eagle dancers; hoop dancers whose intricately interwoven hoops sym-
bolize connection; dance settings which are often in the round; and the
flourishing, circling motions of male fancy dancers. This production at-
tends to a variety of dance traditions. The symbolism of Southwestern cere-
monial dances like the Zuni Rainbow Dance and mysterious San Carlos
Apache Crown Dance are explained, along with the more familiar Plains
Indian dances seen at powwows.

Finding the Circle documents the athleticism of the competitive fancy
dancers—"he's good, he's fast, he's got style, he's got control of all his
moves"—and the role of prize money in helping these very entertaining
dancers survive. The pervasiveness of powwows as community celebra-
tions is also noted; over four hundred tribes currently hold powwows.
However, the program focuses on the expression of the sacred through
dance. Watching the video, one is struck by the transformative power of
the combined media: song, dress, and dance. The intensive preparation,
revealed in the attention lavished on powwow outfits, is rewarded in the
experience of spiritual renewal or transformation during the dance itself.
Though more choreographed than the free-flowing dance settings of pow-
wows and other tribal ceremonies, Geiogamah's staging doesn't detract
from the show's central message. Rather, it affirms that dance is a source
of generational, spiritual, and communal connection that continues to
unite Native Americans.

Another coproduced video targeting general audiences is Jamake High-
water's *Native Land: Nomads of the Dawn* (1986), which also ran on PBS.
The video documents the early art, history, and myths of indigenous

Meso- and South American cultures. Highwater uses modern dance se-
quences in outdoor settings to express the spirit of early creation myths.
The dance sequences seem to have little actual connection to the cultures
Highwater documents; the artificial motions of modern dancers in remote
outdoor settings augment this incongruity. Highwater's modernist sound-
track and liberal use of special effects also detract from his narrative. These
incongruencies are unfortunate since Highwater is probably the most
prolific interpreter of Native American cultures for general audiences. He
has written many books on traditional and contemporary native visual
arts, performance arts, and literature and several novels incorporating na-
tive themes. Most recently, he has turned to the subject of myth in books
and documentaries like *Native Land* and the general work *Myth and Sexu-
ality* (1990).

However, discussions with Native Americans at SKC and NAPT indi-
cate that Highwater has a credibility problem. Some Indians claim High-
water is not himself Indian, though his adopted name and appearance in-
dicate that he is. (Highwater is a pen name. His given name is Jay Marks
and his "tribal name" is Piitai Sahkomaapii.) In cultures that value root-
edness and connection to both land and families, Highwater's multiple
names and constant travel (his books' forewords are signed at locations
throughout the world) may be suspect. Most importantly, some of the
passages in his books and documentaries reflect the views of "typical an-
thropology" that sometimes conflict with Native Americans' own per-
spectives (Bigcrane 1991). The Bering Land Bridge migration theory that
Highwater presents without qualifications in *Native Land* is debated by
Native Americans. Roy Bigcrane, who also watched *Native Land*, was put
off by Highwater's apparent lack of awareness of native perspectives as
well as the artificiality of the production. However, in fairness to High-
water, many of his books have served as general introductions to Indian
culture and have been praised by Indians and whites alike. Rennard Strick-
land and Edwin Wade, reputable scholars of Indian art, cite *Song from the
Earth: American Indian Painting* (1976) and *The Sweet Grass Lives On: Fifty
Contemporary North American Indian Artists* (1980) as primary reading
about Indian art in one Philbrook Museum catalog (1981).

The questioning of Highwater's identity, credibility, and insight raises
the general question of productions by non-Indians that rip off native
styles and philosophies in order to make a profit, a concern most pro-
nounced in the domains of traditional arts and crafts and New Age phi-

losophy/religion. Similarly, in the world of documentary media, it's often difficult to tell whether a given production is native- or coproduced. The question of authenticity defined by ethnicity spans several areas of cultural expression, from art to literature to electronic media, but it has been highlighted as a legal issue in the art world with the passage of the Indian Arts and Crafts Law, Number 101644, which attempts to define authenticity in arts and crafts by blood quantum. Some Indians, such as former Institute of American Indian Arts (IAIA) director Rick Hill, support the legislation, while others like the artist Jaune Quick-to-See Smith have branded it a "racist law," because it excludes Indians who haven't been bureaucratically documented (Hill 1992).

Though all of this may seem outside the scope of a discussion of videos about Native American dance, the question of authenticity in expressive forms is often raised. Performance arts seem to have an advantage in this regard. It is difficult to "fake it" as a dancer or singer because the performer/participant is so much a part of the expression; the body is the primary medium in performance arts. Perhaps this easy recognition of authenticity, to the extent that physical attributes have been adopted as the main criteria of Indian identity, is reassuring in a climate where authorship in other media is readily questioned. In any case, questions of a dancer's authenticity seem to be more easily answered. Where questions do arise is in the authenticity of materials: the use of thread instead of sinew or turkey feathers instead of eagle feathers (now illegal to buy and sell), and the adoption of styles of dress from the popular media instead of from cultural traditions. Even with these qualifications, ceremonial dances continue to enjoy a status as the most authentic expression of Indian identity.

These films and videos documenting powwows and other dance ceremonies strongly differ from the visual art documentaries I surveyed. There is little emphasis on technique in the powwow documentaries. While different aspects of the event are explained, the actual techniques of preparing outfits, dancing, or singing are not covered in any of the films. Instead, the productions focus on symbolism, social and spiritual aspects, and personal feelings engendered by the powwow. Powwow videos rarely single out an individual artist. Instead, they focus on the community aspects of the occasions, frequently employing the concept of "extended family" to describe the significance of powwows. This focus on community over individual is emphasized by the relative lack of individual on-camera inter-

views and the greater use of anonymous voice-over commentary. Authenticity of expression is more easily determined in performance arts than in the visual arts.

Talent is seen as more generally available in the powwow setting. Instead of talent, preparation is emphasized as the criterion of successful participation in powwows. Constraints on participation are a lack of preparation or, in rare cases, physical drawbacks such as the clumsiness associated with certain stages of childhood (*I'd Rather Be Powwowing* 1983). The attitude that dancing skill is shared rather than hoarded indicates that many Indian cultures are essentially egalitarian. However, this assumption of the availability of skill is being challenged as dance competition and a division between powwow dancers and observers become more entrenched. Continued competition will increasingly stratify levels of talent. Certain kinds of dances open to all participants, like the honor dance and intertribal, counteract this tendency toward specialization.

These films and videos are present-oriented. None attempted to detail the history of the powwow in a manner similar to the historical sequences of some visual arts videos. Though tradition is a central ingredient of powwows, it is a lived tradition, not one needing resurrection or validation through references to the historical past. Formal innovation at powwows takes place within a set code of expression. The emphasis is on "taking the old ways and carrying them forward" (*Keep Your Heart Strong* 1986) rather than developing new artistic languages. Thus, there is less of the tension between contemporary and traditional styles which emerged in the body of visual arts documentaries. Some modernist onlookers may take this as evidence of the static, changeless quality of powwows, but defenders say that there is constant change in powwow songs, dances, and outfits (Bigcrane 1991 and *Keep Your Heart Strong* 1986).

Indianness is not an issue in powwow documentaries; it is assumed that the celebrations are a powerful expression of Indian identity. The visual arts that most strongly convey Indianness tend to be those that are incorporated in community dances or those that depict these dances and rituals. Just as Indianness is assumed, so is separateness from the larger culture accepted and celebrated. Powwows are less a matter of balancing or integrating two worlds than a means of holding onto the old ways in the face of assimilationist and economic pressures. One reason that separateness is maintained is that powwows don't depend on direct white patronage as many of the visual arts do. They are organized and supported by na-

tives. Many Indians' incomes may be generated by jobs in non-Indian so-
ciety, but outwardly powwows appear self-supporting. In one sequence
that demonstrates Native Americans' financial support for powwows, a
chief strolls the powwow grounds silently accepting contributions and
hiding them under a blanket in preparation for the following year's event
(*Keep Your Heart Strong* 1986).

Powwows continue as an antidote to the economic and cultural influ-
ence of the dominant society. Politics, understood in the sense of formal
political activity, did not emerge as an important part of powwows in the
videos. Perhaps the general feeling of body politic or groupness explains
the political arrangement better. As one Indian commented, "You go to a
world where you are part of a majority" (*Keep Your Heart Strong* 1986). Be-
cause they express cultural cohesion and resistance to assimilation, pow-
wows are a popular subject with native documentarians, whose own mo-
tivations are sometimes rooted in a desire for cultural autonomy and
national sovereignty (Westerman 1991).

Powwows join members of different generations and tribes together.
They also can help overcome divisions within a tribe, as in the case of
those between full-bloods and mixed-bloods on the Pine Ridge Reserva-
tion. But the role of powwows in cultural integration is most evident in
their relationship to Indian belief systems or worldviews. This relationship
is expressed as a connection between performance symbolism and reli-
gious feeling. The circle, which symbolizes connection, clearly demon-
strates the integration between powwow practices and native religious
thought.

SONG AND MUSIC

At dawn, on a peak in the mountains of eastern Washington state, an
Indian man stands with his two children and sings a morning song in
a strong, clear voice to the land that stretches out before him. The song
settles upon the misty valleys and evergreen-covered hills below. Soon, a
coyote sings a refrain, returning the Indian's own gift of song in kind. This
exchange of human and natural songs expresses one Native American's
feeling of a cyclical relationship to nature: first offering something to na-
ture in the form of song or prayer, then receiving a rich return.

Another cycle expressed in George Burdeau's aptly named *Circle of Song*
(1976) is the give and take between generations. Native Americans hold

infants close through the melody of song and rhythm of the drum long before the children understand the song's words. Traditional Indian song reaffirms connections to nature and between generations. An intensely personal and openly public medium, song relies on will and memory, rather than outward appearances, for its continued existence. For Cliff Sijohn (Spokane), song and Indianness are synonymous: "For as long as there is an Indian there will be song. For as long as there is song, there will be Indian" (Sijohn 1976).

Sijohn's song ringing out through the open morning air reminds one of the difference between this natural performance and the modern experience of song, neatly segmented into commercially convenient lengths by business people. Some Native Americans may identify more with the prepackaged Nashville sound piped across radios and jukeboxes throughout the West than with traditional song.[2] In many cases, music's local immediacy has been sacrificed for the sake of commerce. Song has been commodified for the sake of easy consumption; participatory elements of music are now left to specialists. These song documentaries remind one of music's former vitality (or continued vitality in some cultural settings) much more than detailed written studies. Like dance, music is well suited to film and video documentation.

The intergenerational aspect of native song pervades both parts of the two-part *Circle of Song* documentary from *The Real People Series* (produced by the Spokane School District under a grant from the U.S. Department of Health, Education, and Welfare and aired by KSPS-TV, Spokane). In Part 2, grandma sings a song for a young child, rocking him in her arms to a gentle lullaby. Sijohn explains that song is "our first orientation into Indian life, [our] Indian heartbeat. . . . Before he learns how to speak he shall already have heard the words of the Indian heart. Before he learns to walk, he will learn the feelings of the Indian heart. This is where his education begins." As children grow older, they experience song in wider social settings where performance practices emphasize group unity (see Fig. 13).

One formal social activity that expresses intergenerational connection is the "naming ceremony." Sijohn explains, "The circle of song surrounds my family. . . . This is a film about the birth of some children, my children. They are about to be reborn and given Indian names." In the Sun Band of the Spokane tribe, older children are formally given an Indian identity by acquiring an Indian name at a transitional age between childhood

FIGURE 13 ► Chauncey Neboyia, *Seasons of a Navajo*
The theme of intergenerational continuity sounded in *Circle of Song* is well developed in some non-native productions such as *Seasons of a Navajo* (1984). As Elizabeth Weatherford, the bibliographer of native film and video, writes in *Native Americans on Film and Video*, "Possibly no image conveys this sense of continuity better than a scene in which Chauncey Neboyia sings, holding close a baby who is thus literally encircled by the rhythm of his people's tradition" (Weatherford and Seubert 1988, 75). (Courtesy of NAPT)

and young adulthood. Song is an integral part of the ceremony, and, for Sijohn, a metaphor of the force that holds families together. The film-makers reinforce the intergenerational linkage of the naming ceremony narratively and visually. In Part 2 Cliff Sijohn talks with an old man—his grandfather, born in 1893—who tells about his experiences: "I was

forty-two years on the drum." The narrative then cuts to the naming ceremony, where Cliff wonders, "Were they [his children] ready to step forward and be reborn with new names?" Through voice-over narration, he says that his grandfather selected the Indian names his children will adopt. In a related scene, Sijohn states, "With my family, we will never forget who we are and that the old warrior's thoughts and feelings in us are as strong as a hundred winds," while the filmmakers cut on form from an historical still image of a chief holding a ceremonial lance to Sijohn holding a lance at the naming ceremony. This film underlines the importance of song for intergenerational continuity and ethnic identity, even when other aspects of life may closely resemble the lifestyles of the larger, mainstream culture.

Another video by white videographers Curt Madison and Leonard Kamerling, *Songs in Minto Life* (1985), made in close cooperation with the Minto Village Council, examines in detail the close relationship among songs, nature, and hunting. This documentary about the inland Alaskan Tamana tribe shows how songs are used to prepare for and celebrate hunts. For instance, an elderly woman sings a song for attracting moose to the hunters. The connection between songs and animals is so close that animals are sometimes thought to talk through people in songs. Like the mental and physical preparation dancers undergo prior to powwows, preparation is an important function of hunting songs. However, not all Minto songs are about nature and animals in preparation for the hunt. There are memorial songs, war songs, songs for medicine men, personal songs, and others (see Fig. 14). In one moving sequence, an older man sings a song of memory for his deceased son. Another reenacted sequence depicts two women composing a song together, an "airplane song," while they wait for the return of a local air taxi. The Minto have songs for every occasion. However, this may change as children, less tied to the traditional ways of life that are the source of the songs, understand less and less of their meaning. For example, the porcupine song, once understood by everyone, is now rarely understood by children.

Part of the reason for this decline of understanding may be the loss of native languages. For obvious reasons, traditional song can only survive in the fullest sense when native languages survive. Thus, song is more at risk of disappearance and less easy to revive than other expressive forms, such as dance and the visual arts, which depend less on the knowledge of language. For the same reasons, narrative song is less likely to cross tribal boundaries. Musical and rhythmic aspects of music may flourish in in-

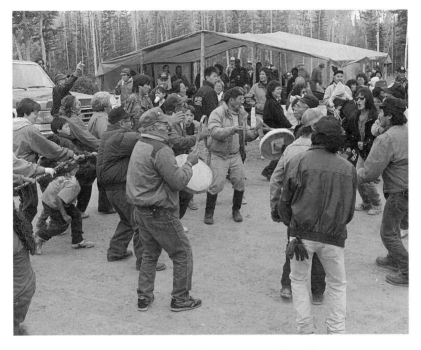

FIGURE 14 ▶ Potlatch Ceremony at Minto, Alaska

The Tamana people of Minto, Alaska, welcome visitors to the first day of a potlatch in late September 1990. A potlatch is an institution of many Northwest Coast tribes for distributing hereditary rights and ceremoniously distributing valuables among the members of the tribe. Along with honorific names and family crests, songs and dances are transmitted according to rules of descent. Potlatches are indicators of the performative and symbolic importance of song and dance for Northwest Coast peoples. The potlatch-maker in this photo is Neal Charlie; every day he was responsible for feeding several hundred guests. (Photo by Curt Madison)

tertribal contexts, but language often highlights the differences between cultures.

A high degree of language retention seems to correlate with a high degree of cultural intactness. In Montana, for instance, many Crows have retained their language; the Blackfeet are struggling to retain theirs; and few Salish speak their mother tongue. This variation may result from the amount and type of contact each tribe has had with outsiders. The Salish live on a reservation with a white majority and are active in the main-

stream economy, while the Crow are geographically and economically more isolated. Some tribes which have a long history of contact, such as the Hopi, may retain as much or more cultural intactness as comparatively isolated tribes. However, the Hopi have consciously guarded themselves and their traditions against cultural assimilation.

In part, this discussion of language is an attempt to explain the relative scarcity of native documentaries about song and music. Perhaps the loss of traditional language complicates the media documentation of song. Language acts as a barrier when trying to interpret songs for a larger non-Indian audience. While many films and videos incorporate song and instrumental music as transitional material, fewer examine music as a subject in its own right. Videos documenting powwows, potlatches, and other ceremonies have song and music sequences but tend to focus more upon dances, outfits, and key cultural symbols than music. A white filmmaker and noted folk musician, John Cohen, has documented the music of several South American communities in films such as *Mountain Music of Peru* (1984). The Canadian Ojibway and Cree Cultural Centre Video produced a video, *The Drum* (1982), which explains the drum as a sacred symbol and its role in the life of the Mohawk tribe. But despite the growing body of ethnomusicological films that have documented musical cultures throughout the world, few producers have singled out Native American song and music for special attention. And the relative scarcity of documentaries about traditional song is surpassed by the scarcity of films and videos about contemporary Indian musical forms.

Native American flutist/composer R. Carlos Nakai has achieved success in scoring recent documentaries. For instance, he scored *Winds of Change: A Matter of Choice* (1990), which was widely distributed through PBS Home Video. Though he may not write the actual score for some documentaries, lower-budget productions like Susan Stewart's *Crow Mapuche Connection* often feature Nakai's recorded music. Nakai's solitary flute, combined with sweeping pans or flyover shots of landscapes, instantly signifies Indianness in recent documentaries.

The other trademark sound of recent documentaries is traditional drumming and singing. Often the source of these soundtracks is more local. For *The Place of Falling Waters* (1990), Bigcrane and codirector Thompson Smith partly relied on old Folkways recordings of traditional Flathead songs produced during Alan Merriam's ethnomusicological study of the

Flatheads in the 1950s. *A Tradition Lives: The Powwow* (1984), which fo-
cused on Northwestern Indian arts and powwows, incorporated music
from the Blackfoot tribe's Kicking Woman Singers. According to Roy
Bigcrane, he and Smith were interested in incorporating the music of an-
other flute player, Kevin Locke, into their score but found copyright re-
strictions and borrowing fees somewhat prohibitive. These same factors
have undoubtedly guided other documentarians' musical selections.

Scores based upon solitary Indian flute music or local drum and singing
groups strongly contrast with earlier documentary scores. *Vision Quest*
(1961), a production by Montana State College (now the University of
Montana), used an all-Indian cast to document the traditional Salish vi-
sion quest that is part of the transition from childhood to adulthood.
However, the score and even the narration of the production are distinctly
Disneyesque; they incorporate the programmatic style of Disney's "wild-
life" movie scores. The musical score detracts from what should have been
a relatively serious treatment of an important tribal practice. Similar prob-
lems of intrusive scores that incorporate music unrelated to the cultures
being documented occurred in films throughout the 1970s, including
Oscar Howe (1973), the *Heard Museum* series (1975), and the first *American
Indian Artists* series (1976).

However, even Indian-produced documentaries do not rely solely on
traditional music. In the Dan Namingha film (1984) from the second
American Indian Artists series, Namingha's own blues-rock guitar play-
ing provides much of the musical backdrop. Canadian singer Buffy
St.-Marie's folk-rock songs and vocals are incorporated into native pro-
ductions and coproductions, including the title song for the *Spirit Bay*
series. Producer/director and singer Rick Tailfeathers provides a country-
western "Indian Cowboy" musical backdrop for his documentary *Pow-
wow Fever*. Similar country-, folk-, or rock-influenced themes are incor-
porated into George Burdeau's *Spirit of the Wind* (1976) and Phil Lucas's
Images of Indians (1980). The feature film *Powwow Highway* (1988), which
was generally popular with Indian audiences, derives some of its appeal
from a contemporary score that includes the music of the rock group U2
and native singer-songwriter Robbie Robertson, formerly of The Band,
who has created contemporary soundtracks for other films. Clearly, then,
there is no single musical expression of Indianness. However, attempts to
create musical scores related to Indian culture seem to have increased

along with native participation in documentary production. A lack of attention to the cultural appropriateness of the musical score usually decreases the credibility of the documentary.

There are relatively few documentaries produced by Native Americans or whites that focus primarily on native song and music. But this small sample shows that song is an important facet of intergenerational continuity and contact. In some cases, youth drum groups have been intentionally formed to counter the effects of cultural destruction. Music and song fulfill several traditional cultural functions, from preparation for the hunt to memorializing the dead and war heroes. In some relatively intact cultural areas, such as the Minto Flats area of interior Alaska, songs remain integral to all aspects of daily life. However, the loss of the knowledge of tribal languages probably poses a greater threat to song than to other expressive forms like dance and visual art. The difficulties inherent in translation may also account for the smaller number of documentaries that explore traditional song and music. No single style of music expresses Indianness, but the incorporation of traditional flute or drum group music into musical scores has increased. Music clearly expresses collective identity; we can hope that more documentarians will soon explore Native American song and music.

INDIGENOUS AESTHETICS OF PLACE

WO MAJOR themes, religion and nature, shape the rela-
tionship between indigenous aesthetic expression and Na-
tive American collective identification. And the feelings for
nature expressed through indigenous art and media have
their basis in native spirituality or religion. Religion is the
conceptual basis for understanding place and space in tradi-
tional native cultures. However, I do not mean native religion in
the sense of organized or institutional religion; rather, religion refers to a
profound sense of one's place in the universe. This is not a New Age con-
ception of Native Americans. Following from this book's premise that
aesthetic assumptions relate to group processes, religion or spirituality
emerges as a central collective process. Political and economic factors are
keys to indigenous aesthetics, as discussed in earlier chapters. But a close
linkage between art and spirituality reflects the particular kinds of values
that natives themselves associate with aesthetic occasions.

This chapter discusses native aesthetic expression in the context of be-
lief, especially in relation to the sacred as the experience of place. Through-
out the chapter I will retrace some of the major themes that have formed
this book: aesthetics in group identification and intergroup relations; art's
relation to ethical concepts; differing conceptions of the artist; along with
the role of cultural continuity and nature in aesthetics. In this chapter I
refer to indigenous peoples (and non-natives) as a whole. Both of these
populations are varied, making for some very broad generalizations; there
are exceptions to each of the general statements that I make. But the
themes of identity, religion, and nature seem so pervasive in indigenous
aesthetics that a discussion of their importance for both native and non-
native populations is needed, even if it must rest on broad statements.

ART, RELIGION, AND INTERCULTURAL INTERACTION

Some Native Americans feel that their cultures attract sympathetic non-
natives because there seems to be no "center" to Euro-American culture:

"They left their center in Europe" (Horse Capture 1991). For these whites, the "Indian way" of reverence for nature—a feeling of connectedness or place—addresses their own sense of spiritual loss. However, some Native Americans may question the superficiality of this interest in indigenous beliefs. Speaking of the representation of natives in popular films, Roger Buffalohead explains that a kind of "aura of sanctity surrounds these films" on the part of natives and non-natives alike: a "reluctance to be critical" that may stem from "our cultural habit of mind of avoiding conflict with our friends" (1991). Of *Dances with Wolves* (1990), he states that the film ultimately fails to transcend Hollywood commercialism. "In *Dances with Wolves* the commercial Indian is the Indian of natural wisdom [and] spirituality. . . . He speaks to the New Age American[s] and their desperate search for spirituality" (Buffalohead 1991). The image of natives in popular culture, then, is that of the "Green Indian," in tune with the wisdom, rhythms, and harmony of the land. Ultimately this image of the wise, spiritual, natural native serves the commercial needs of the non-native culture industry more than it reflects any true understanding of indigenous belief systems. Native beliefs can be reduced to avenues for cross-cultural exploitation.

Particularly disturbing to some commentators is the adoption of the form of religious rituals without an accompanying understanding of their significance. During a taped presentation, Vine Deloria commented on the destructiveness of the "social sweats," an example of non-natives "taking bits and pieces of Indian culture and commercializing it" (1988). This co-optation of aboriginal beliefs and practices relates to the larger question of whether non-natives can ever really comprehend indigenous belief systems.

I really have severe questions whether people brought up in a Western European framework really ever can understand what the tribal religions are about and really have authentic religious experiences in the same way we do. . . . So much of that [Euro-American] tradition is really kind of a mind game. It's a very rational thing; the deity's rational; the creator's rational; behavior is rational. . . . Why are people so tense that they have a hard time being themselves? Even the most devoted are still very tense. (Deloria 1988)

The former seminarian Deloria adds that, for natives, religion is a way of life. In drawing out this contrast he implies that Western rationalization of belief is one source of the disjunction between religion and daily

life, which leads to a state of spiritual and emotional dis-ease he calls
tension.

Ideas about religion, then, reflect a major theme of this book: that the reception of indigenous expressions is relevant for non-natives, but that commercial relationships and Western belief systems often cloud this reception. The poet and anthropologist Wendy Rose refers to Westerners' appropriation of native spiritual traditions as whiteshamanism. According to Rose, non-native poets and visionaries such as Carlos Castaneda and Gary Snyder have drawn an analogy between the contemporary poet/artist and the traditional role of the shaman. In this role, the artist withdraws to solitude to seek visions; he or she serves a dual social role as both an outsider and one who validates experiences for a group; and the artist engages in a public act of "madness" (Rose 1992, 403). (This characterization of the whiteshaman by Rose may sum up a more general contemporary view of the artist in the West.)[1] For Rose, whiteshamans do not use any specific historical or traditional model (except for an ill-defined relationship to native traditions) to support their role; they each invent their own model. This leads to some major problems. Whiteshamans lack significant community acknowledgment and training—they have no real qualifications for their role—and their artwork can quickly descend into invented rituals, relegating the artist to the status of a charlatan. The misinformation resulting from "invented traditions" obscures more "accurate" information.

In a disconcerting way the whole phenomenon of whiteshamanism depends on whites' own system of self-validation. Whiteshamanist art is part of a larger process of cultural imperialism, in which the appropriation of native religions subordinates indigenous cultures conceptually consistent with the general colonialist enterprise of political and economic control (Rose 1992, 404). Euro-Americans try to own ideas in the same way that this group has imposed notions of land ownership; whiteshamanism is intellectual Manifest Destiny. Rose feels that this ownership of native history and ideas relates to the problem of an assumed universality of knowledge resulting from Eurocentrism. In this view, frameworks of knowledge, whether artistic or academic, are Euro-American derived. The European tradition acts as the big picture, the normative expression of intellect, while the thought and experiences of other cultures are seen as appendages, as areas of esoteric specialization. Rose acknowledges that all people are ethnocentric, but, for her, the intrinsic universalism of Eurocentric

thought leads to the denial of one's own ethnicity; "ethnic" is a term reserved for Others. Thus, whiteshamanism reveals fundamental conflicts in aesthetics.

Following from this attitude, indigenous religious expressions are "available" for members of non-native cultures to "use" in inventing their own myths or traditions. But this assumption of availability masks more fundamental problems of integrity and intent. Native artists such as the Hopi videographer Victor Masayesva, Jr., have noted the importance of secrecy in spiritual matters and have stated that there are dangers in making information too available. This seems to be a view shared in his community; the Hopi have prevented photographs of their religious rituals since the 1910s. According to native artists and critics, the right to "use" other cultures stems from those cultures; their traditions are not just available. One must beware of inventing one's own myths or rituals if they involve the appropriation from other cultures of key symbols that have been radically decontextualized. The non-native can never "become Indian," so deep reflection is called for in this intercultural process of religious and aesthetic expression.

Rose's argument powerfully cautions non-natives who seek to incorporate indigenous religious and expressive forms in their own art. However, her argument may rest on a too literal understanding of shamanism as tied to particular cultures. She acknowledges that whites' understanding of the term is more general than what the shamanic role in any particular culture or culture area encompasses (Siberian, Inuit, Plains). In part, the debate over whiteshamanism depends on whether shamanism can have a more general meaning than Rose ascribes to it and, if so, under what conditions. Her argument supports a relativist conception of shamanism. Michael Tucker's (1992) study of the shamanic spirit in twentieth-century art seems to support a much more general interpretation of the shamanic impulse in art than Rose allows. However, Rose's analysis points out intercultural issues central to indigenous aesthetics.

One solution for indigenous peoples, confronted with the stereotypes and misperceptions that arise cross-culturally, is to avoid or subvert the natural, green connotation of the term "native religions" in the same way that artists may try to avoid the label of Indian or ethnic artist. Another solution is for natives to acknowledge the real need—rising out of spiritual barrenness—that fuels the growth of phenomena such as whiteshamanism (Rose 1992, 415).

FIGURE 15 ▶ Joe John, *Return of the Sacred Pole*

In *The Return of the Sacred Pole* Joe John (left), a representative of the Peabody Museum at Harvard University, is seen returning the Sacred Pole in a ceremony on the Omaha Reservation in Macy, Nebraska. (Courtesy of NAPT)

But is the problem with the cross-cultural reception of religious expression merely one of semantics—avoiding the boxes imposed by terms such as green, natural, or shamanic—or does cross-cultural expression involve negotiating very real value differences? For instance, the issue of repatriation goes to the heart of conflicting aesthetic and religious values in cross-cultural contexts. Repatriation is not limited to human remains; it extends to central religious symbols of great significance that were removed from indigenous communities by white collectors during the colonial period. (Collecting is another powerful cross-cultural process often tied up with commercial motives; the desire to own or possess is central to collecting.) A documentary, *Return of the Sacred Pole* (1990; see Fig. 15), recounts the return of a central veneration object to the Omaha people and raises questions about the repatriation of sacred objects and human remains. The tape addresses the controversy surrounding the transfer of the pole to the Peabody Museum at Harvard University in 1888. The pole was returned to

the Omaha people in 1989 and was formally presented to them in an emotional ceremony of thanksgiving at the 185th tribal powwow. Thus, the debate about repatriation extends to objects that have symbolic religious value, though, as Masayesva reveals in *Siskyavi*, the larger society may view these objects as records of an historical past, ethnographic objects, or, more rarely, as aesthetic objects. The repatriation debate does not simply revolve around the question of ownership of objects. It is a debate about who has the power to invest the objects with meaning. Controlling meaning extends beyond legal issues associated with property to the religious values that natives associate with ceremonial objects. The term "religion" itself ultimately refers to the process of investing life with meaning.

Other religious issues, tested in the courts, point to continued misunderstanding between natives and non-natives over spiritual matters. Deloria (1988) speaks of the "lowroad decision," which centered on the right of the U.S. Forest Service to put in a forest road that would have given non-natives access to sacred places. The issue of the invasion of sacred spaces for the sake of natural resource exploitation has affected the Blackfeet tribe, who are attempting to block exploratory drilling for oil on sacred land east of Glacier National Park. Other controversies have centered on the Native American Church, whose members use peyote during some religious ceremonies. The Supreme Court upheld an employer's firing of a church member because of his drug use. Deloria notes that participants in the Native American Church actually have reduced the rate of alcoholism and the influence of drugs among their membership, a fact overlooked by the U.S. Supreme Court. Another controversy erupted over the right of prison inmates to hold ritual sweats in state prisons. For Deloria, all of these cases reflect the status of Native American religions as living religions that incorporate real practices which go against mainstream institutions. He describes the actions by the courts as an attempt to make America into "one functioning machine" (1988).

The continued controversy surrounding native religious practices, despite the Indian Freedom of Religion Act passed in the United States in 1973, recalls the recent past when all native religious ceremonies were illegal. Because religion was outlawed, many native ceremonies were held at night. Recent court cases indicate that open worship still holds dangers for natives involved in tribal religious practices. Seen from an indigenous perspective, the conflict between the courts and native religious practitioners

reflects the failure of the non-native society to recognize the fundamental humanity of indigenous peoples' beliefs. In this climate, many religious practices will continue to be hidden for the sake of self-preservation.

Religion, then, is one site of polarized group relations between natives and non-natives. It can be a source of a romanticized portrait of native peoples, a cause of legal contestation, or a site of contested beliefs. Understanding the aesthetic expression of religious beliefs offers non-natives an avenue into understanding native religious traditions from the perspective of indigenous peoples themselves. But what is the connection between religion and aesthetic expression?

RELATIONSHIP BETWEEN RELIGION AND AESTHETIC EXPRESSION

A strong relationship exists between religious and aesthetic expression in indigenous cultures. In many cases these cultural forms are inseparable and mutually dependent; one could not exist without the other. The indigenous films and videos that I viewed express a much stronger connection between religion and art than between politics or economics and art.[2]

The traditional function of art in native cultures is so closely tied to religion that it is difficult to speak of a social function of art beyond its role in religious expression. In some cases, this close integration of art and religion continues to the present. For instance, if we consider Native Americans' emphasis on preparation, so important for participation in communal dances, are we considering an aesthetic or religious concept? Many Native Americans, including Johnny Arlee, Cliff Sijohn, and Al Chandler, explain preparation in the language of religion. Similarly, the central concepts of oneness and connectedness associated with performative contexts derive their power from religion. In the documentaries, it was the visual artists, often trained in Western art schools, who had adopted the formal and critical vocabulary of contemporary art theory to describe their artistic outlook. However, religious ideas such as preparation, connectedness, and oneness have remained underlying concerns for visual artists as well, from the late Oscar Howe to contemporary artists Frank Lapena and James Luna, who emphasize the interrelationship among art, myth, and ceremony in native visual art (Lapena 1992; Luna 1992). Even in the present, after years of Western artistic influence, religious and aesthetic ex-

pression are not separated in native life. In the work of contemporary native artists such as Susan Stewart, there seems to be a continued interest in the relationship between art and religious ritual and ceremony.

By contrast, there has been a divorce in Western aesthetics between concepts such as beauty and the Good, which had religious connotations for earlier theorists and art. The divorce of spirituality, beauty, and ethics from aesthetics contrasts with the continued interrelationship of these in indigenous aesthetics. Underlying differences in assumptions about aesthetic value reveal larger patterns of difference between indigenous and Western ways of thinking. While Western thought is largely analytic, attempting to separate and reduce experience into its constituent parts for the purpose of mechanistic understanding, native thought is primarily synthetic, involving a search for and appreciation of the connections between categories of experience. Perhaps this high valuation of continuity in thought helps explain the search for historical continuity in native aesthetics. This difference in thinking styles may be the reason for the comparatively small number of indigenous documentaries that focus on art as a separate subject matter and the relative plenitude of films and videos that examine aesthetic expression contextually. Additionally, native directors tend to deemphasize technical explanations of aesthetic processes and to emphasize the larger value or meaning of artistic expression for a community. This attitude of synthesis underlies native desires to live harmoniously in the world rather than alter it. Traditional art is more closely tied to nature than it is to human industry, technology, or "genius." The criteria of aesthetic valuation in native cultures emphasize this connection to the natural world rather than deriving from analytical or critical constructs as in Western aesthetics. Continuity of expression—whether its source is historical, religious, conceptual, generational, tribal, or cosmological—is a central ingredient of indigenous aesthetics.

The native films and videos, comments by artists themselves, and the secondary literature about native aesthetic expression all emphasize that the collective function of art originates in religion. Expressive art is an extension of ceremony, which in contemporary times acts as an antidote to alcoholism, poverty, and the other problems of contemporary life. Perhaps the transformation that takes place in native art or ceremony is a response to negative social pressures. Does entering the state of mind of a dancer or painter release a person from social pain and responsibility?

They [natives] put on their dance costumes, . . . They look like princes! They're trans- formed. They can shut off all that poverty, all of their disasters, because that is their moment. Is it any wonder that is what they want to paint? (Silberman in Highwater 1976, 197)

Arthur Silberman's interpretation of native motives emphasizes the social function of art as an escape mechanism.

However, indigenous art, ritual, and performance can be positively thought of as a form of religious transformation. The power of art to transform everyday reality into a more essential psychic or spiritual reality lies at the heart of indigenous art's significance (Arlee 1976; Sijohn 1976; Chandler 1983). In this context, artistic objects are visionary objects through which artists and performers project psychic intent and spiritual feeling. This interpretation more closely reflects the traditional function of art in native cultures as a repository of "medicine" or spiritual "presence" (Coe 1977, 12). It is this spiritual presence that I refer to when speaking of the profound sense of place expressed in indigenous art. The experience of presence or place has the power to transform one's relationship to the world. This transformational power of some traditional art forms may be quite specific. For instance, the discussion of masks documented in *Eyes of the Spirit* touched on the power of masks to transform humans into animals and the consistency of belief in the transformative power of masks with a worldview which holds that all living things have souls (*inua*). In this worldview the relationship of humans to nature and animals rests on an acceptance of the possibility of transformation.

However, Silberman's statement implying that native art and dance serve an "escapist" or release function raises the issue of what's *not* portrayed in indigenous documentaries about art and culture. The charge that powwows, for instance, are an escape from social realities was never raised in the documentaries themselves. Another central identity ingredient acknowledged but downplayed in the documentaries is the adoption of a cowboy identity by many Native Americans. *Spirit of the Wind* and *Powwow Fever* documented the importance of Indian rodeo in some areas of the country, but none of the videos fully explored the impact of country and western music, pickup trucks, cowboy dress styles, or the identification of natives with media images of cowboys.

The widespread adoption of a Western cowboy identity by natives has

been explained by some theorists as an attempt by Native Americans to fill the cultural void left by the loss of traditional cultural and tribal identities (Trafzer 1985). By contrast, Donald Fixico writes that the adoption of country and western styles has more to do with "practicality" than the loss of cultural identity (1985). From this perspective, pickup trucks and cowboy hats better suit Western environments than other forms of dress and technologies. Even if true, this explanation does not account for the adoption of nonfunctional cultural expressions, such as country and western music, by natives. In either case, the fact that both native and white documentarians overlook the widespread adoption of country and western lifestyle/imagery by Native Americans indicates the directors' desires to emphasize the differences between natives and the larger, mainstream society.

The degree of cultural borrowing by natives from white cultures and its implication for identity formation has not been explored fully by indigenous media people and artists. Perhaps the desire to maintain a separate identity and to retain continuity with the past may be so strong that native directors and artists have overlooked some of the shifting contours of contemporary Native American identity. Is the adoption of country and western dress and music the new pan-tribal identity? Similarly, many native youths have been drawn to rock, reggae, and rap, which have their roots in protest and social commentary. Native identities in the future may be more tied to these expressions rooted in other subcultures than to a sense of a cultural continuity with precontact native traditions.

However, deep feelings for the past cannot be easily dismissed. The connection of native artists and directors with the past gives their work coherence and helps forge a link between art and life. It is easy to contrast this attention to the past with the situation in American culture at large where, in artistic circles, there sometimes seem to be specific efforts to ignore the past. (Modernism is defined, in part, by its detachment from the past.) In native art forms artistic innovation is tied to tradition rather than resulting from a consciously constructed avant-garde. Innovation occurs, but it most often takes place within established artistic codes. Of course, the valuation of innovation is changing in contemporary native art. There seem to be at least two separate art worlds: the contemporary native visual arts (those innovative art forms validated in non-native art worlds) and the art world of performance contexts such as powwows. In integrated art forms there is a clear relationship between aesthetic expression and the

lived experiences or worldview of the members of the culture within which the art is created. In autonomous art there is an emphasis on individual vision or expression. As the gulf between these two extremes has grown wider in the twentieth century, theorists and artists have become aware of an ideological opposition between modern and "primal" art.

Some contemporary non-native artists have tried to reconnect their art and lives to the larger world of politics, nature, history, and myth. The concern for the collective function of art, and its loss, was submerged by the stronger tide of modernism/formalism at midcentury but has swelled recently. Lucy Lippard writes that art must return to "some collective content of general human significance" if it is to have general influence (Lippard 1983, 5). Ironically, many of today's most progressive artists draw from archaic and indigenous art for inspiration, not only in the realm of form, where qualities of much prehistoric art such as simplicity, directness, and monumentality speak to modern interests, but in the realm of content. "Today's vanguard is attracted by the archaic and prehistoric rather than the classical. These artists are rebelling against reductive purism and an art-for-art's sake emphasis on form or image alone with a gradual upsurge of mythical and ritual content related to nature and to the origins of social life" (Lippard 1983, 5). In her book *Overlay* (1983) Lippard wrote that the attraction of prehistoric art and sites is that they are not separated from their social contexts. Thus, indigenous art prefigures the concern of non-native artists for the integration of art into social life.

For both natives and non-natives, then, an attraction of traditional or prehistoric art lies in its relation to the past. Traditional art forms and artistic themes remind natives of their history prior to whites' efforts at assimilation. Constant references to history in indigenous art and media are not simply a romantic longing for the "good old days" prior to white contact. Instead, the retelling of history through traditional narratives and art helps maintain or revive communities. In a very real sense communities are constituted by their sense of the past. The sociologist Robert Bellah's definition of "community of memory" seems particularly suited to the recent efforts of Native American videomakers: "In order not to forget the past, a community is involved in retelling its story, its constitutive narrative, and in so doing, it offers examples of the men and women who have embodied and exemplified the meaning of the community. These stories of collective history and exemplary individuals are an important part of

the tradition that is so central to a community of memory" (Bellah et al. 1985, 153). Native media producers and artists retell the stories that constitute the collective memory of their people. They also document those participatory practices, including rituals, dances, music, rodeo, and other occasions or activities, that express commitment to the community. "People growing up in communities of memory not only hear the stories that tell how the community came to be . . . they participate in the practices—ritual, aesthetic, ethical—that define the community as a way of life. We call these 'practices of commitment' for they define the patterns of loyalty and obligation that keep the community alive" (Bellah et al. 1985, 154).

But how are these practices of commitment integrated into communities in contemporary life? The collective function of aesthetic expression for Native Americans originates in religion, a conclusion supported by Masayesva speaking to his peers: "We want to start participating and developing an Indian aesthetic. And there is such a thing as an Indian aesthetic, and it begins in the sacred" (Masayesva 1991). Lippard similarly concluded that the origin of the collective function of art lies in religion, even though she describes herself as an atheist. However, Lippard writes of a difference between contemporary artists accepting the need for a reintegration of art with collective belief and the *actual* reintegration of art and belief.

While there is definitely a burgeoning belief in believing among artists, few are willing to introduce specific beliefs into their art, and still fewer have realized the potential for the broad collective fusion of belief and its physical products which is in fact an important aspect of ancient art as we envision it. (Lippard 1983, 9)

Thus, though some artists may point to earlier forms that express practices of commitment, it takes a fusion of belief and expression for actual commitment to occur.

There are important distinctions between non-native artists incorporating archaic, ancient, or indigenous forms and natives looking to tradition for inspiration. One is temporal. For natives, the past is not so distant; the forced break with the past that occurred during the middle of the twentieth century was significant but not as extreme as the break of Euro-Americans with their ancient, archaic past. Another distinction is conceptual. Traditional indigenous aesthetic systems rely upon a unity of form

and content, as opposed to the formalist orientation of twentieth-century Western art theory and practice. And thirdly, native aesthetic vocabularies traditionally developed within more contained social contexts than contemporary Western aesthetic theories. Despite the growth of pan-tribal movements, this local emphasis continues. The aesthetic and ritual expressions of Southwestern tribes are still relatively distinct from Northwest Coast, Inuit, or Plains art styles. Just as the artistic styles remain relatively intact in contrast to those styles of the mainstream culture, so the belief systems they express seem relatively more intact.

As separation from the past or between community members occurs, the coherence of artistic languages and belief systems may be threatened in both native and non-native contexts. This is the price of progress: the loss of collective feeling and of a deeply felt sense of place. Artists and those documenting art may rely upon the halo effect of the ritualistic aspects of aesthetic expression without actually conveying any religious content. For instance, sculptors make reference to prehistoric art forms by working on a monumental scale, choosing natural materials such as stone and selecting outdoor work sites. Painters develop "pictographic" styles of brushwork that hearken to early rock paintings or other ideographic forms of written communication. In each case, though, the underlying meaning of the forms has been lost over time. What we are left with is the feel of ritualistic or prehistoric art forms rather than the substance. Even with the nod to the collective art forms of the past, the process and products of many contemporary artists who borrow from the past are essentially personal. A point of comparison is the role of abstraction in prehistoric and contemporary art. Abstraction was originally tied to the development of symbols that had general significance for a culture. The meanings of these symbols were not arbitrary; they were fixed and commonly understood. (And early abstract artists in the West, such as Kandinsky, hoped to develop a system of abstract symbols that had collective meaning.) Now, the meaning of abstract "symbols" is largely individualized. Symbols have lost their power because they no longer express a collectively understood coherent world. The common meanings conveyed by abstract elements in non-Western art forms have been replaced by an individualized abstraction or symbolic vocabulary. This lack of shared beliefs, values, and symbolic languages contributes to the Western fascination with indigenous or ancient images, in which collective belief was expressed.

Another source of the collective function of aesthetic expression for indigenous peoples is nature. For many indigenous peoples, the tie to nature represents consistency with the cosmos, the mystical union of all living things. Native religious thought incorporates a respect for nature. However, for non-natives, this view of nature echoes the nature mysticism of the transcendentalists during the nineteenth century, which implicitly rejected organized religion. Mysticism has often been marginalized in Western institutions because it is a form of religious experience that bypasses the hierarchical structure of churches. Philosophically, it is suspect because it is a direct, intuitive, nonrational experience of the spiritual, in contrast to the dominant trend of rationalism in Western thought. The perception of native views of nature as mystical holds a degree of accuracy. In many traditional native cultures nature is a catalyst for visionary religious experience, a relationship to nature that goes beyond simple concerns for natural preservation. Thus, while some non-natives may be sympathetic to the environmental implications of native views of the land, many may stop short of the visionary, religious understanding of nature found in native cultures. For modern Westerners, though nature may be valued, the explanation and experience of nature as a source of place does not really exemplify a worldview. In traditional native cultures this experience of place (and of space) is *the* worldview.

The perception by indigenous peoples of differences between Anglo-European and their own understandings of nature emerges as a consistent theme from ethnographic, artistic, and media sources alike. Native ideas about nature cannot be defined simply in terms of property, though this is what land debates between natives and non-natives are often reduced to. Treaties involving land led to legal status for natives (even though it may seem to many Native Americans that their only purpose in being made was to be broken), but the indigenous conception of place predates the era of treaties. Ironically, the continuing differences over treaty rights, along with the consistent betrayal of treaties in the past, may be the source of the "greatest feeling of unity" among members of various tribes (Deloria 1969, 50).

Legal battles have proliferated recently with continued attempts by whites to exploit native land. Fishing and hunting rights, oil exploration and drilling, mining and water rights are all confrontational issues that

must be negotiated between natives and non-natives. If the pressure on natural resources continues, and it seems likely to intensify as current resources are depleted, relations to the land will continue as the source of the greatest intercultural conflict between natives and non-natives. But non-natives often perceive this conflict in legal terms, whereas indigenous peoples perceive it in religious or philosophical terms as well as legal terms. As long as this disjunction persists, natives are likely to view non-native pressures on their natural resources as a form of cultural suppression, while Euro-Americans view the problems merely as a set of legal intricacies to be ironed out in the courts. A consistent betrayal of treaties by non-natives motivates indigenous peoples' pan-tribal identification; the hypocritical reversal of promises is something members of all tribes have experienced. Thus, while legal contests over land remain the site of intercultural conflict, different understandings of nature are actually cultural, even moral, in essence.

For many natives, nature and culture are continuous; any event or action in one affects the other. Non-natives bring multiple associations to indigenous expressions of ties to nature. Regarding the reaction of contemporary Anglo-Europeans to the ritualistic, communal art of the prehistoric past, Lippard writes: "We [Anglo-Europeans] tend to confuse our own romanticism about nature with the original purposes of the stones, mounds and ruins" (1983, 12). A similar confusion may arise when Westerners are exposed to contemporary native images of nature. It is very difficult, probably impossible, for outsiders not to project cultural associations onto native imagery of nature. The problems related to non-native understandings of indigenous views of nature resemble the theological problems faced by early explorers and missionaries. Confronted by cultures that were not accounted for in scripture, early immigrants had to explain, or at least rationalize, "foreign" habits and beliefs. Contemporary non-natives are in a similar position. How Westerners adapt to different understandings of the relationship between humans and nature reflects conceptual flexibility and impacts our very ability to survive. Thus, representations of nature assume a central role in intercultural communication.

Though religion is their conceptual underpinning, native peoples' representations of nature form the essence of "indigenous" as expressed through media and art. One aspect of this expression may be simply the sense of spaciousness associated with particular places. Spaciousness is almost always associated with freedom in human experience. And, of

198 course, it was the colonialist policies of Western governments that physically contained the indigenous experience of space. When native aesthetic expression, whether in the visual arts, music and dance, or media arts, celebrates human continuity with the earth, this is also a celebration of freedom and identity.

> Each tribe's total culture is immersed in its specific area. Traditional foods, ceremonies and art come from the indigenous plants and animals as well as the land itself. The anthropomorphism of the land spawns the stories and myths. These things are the stuff of culture which keep identity intact. (Smith 1990, v–vi)

Jaune Quick-to-See Smith's statement makes clear that the local orientation of native cultures is not simply a matter of regional preference. Specific ties to the land unite communities and reflect worldviews. This relationship with nature increases in richness and complexity the longer a people are tied to a certain place.

As the geographer Yi-Fu Tuan has noted, when space has become familiar it is place (1977, 73). But this is not a familiarity that breeds contempt. For instance, the familiar emphasis upon the cardinal directions in many native worldviews locates humans in relation to the cosmos in a profound, mythic way. "Mythic space is commonly arranged around a coordinate system of cardinal points and a central vertical axis. This construct may be called cosmic, for its frame is defined by events in the cosmos" (Tuan 1977, 131). For contemporary non-natives, by contrast, cardinal directions simply reflect the variation in local color found in different regions of the country: the Northeast, Southwest, and so on (Tuan 1977, 99).

Native feelings for nature are an extension of spirituality. Sacred locations, often found in the mountains, are the actual dwelling places of the deities. For example:

> The Pueblo Indian's relationship to his myths and deities arises out of his closeness to them in nature. The home of his gods is nearby; the Hopi gods live in San Francisco peaks, those of the Zuni in Corn Mountain, those of the Acoma in Taylor Mountain and those of the San Ildefonso in the Black Mesa. (Coe 1977, 196)

Our interactions with specific environments are a major basis of the conceptual systems of place that we develop.

It is not too much to assume that evolving relations to nature will be reflected in aesthetic expression. The origins of art may lie in humans' perceptions of their relationship with nature: "Art itself must have begun as

nature—not as imitation of nature, nor as formalized representation of it, but simply as the perception of relationships between humans and the natural world" (Lippard 1983, 41). The unique aesthetic expressions of native peoples have emerged from their particular interactions with the natural world. Oscar Howe describes how this relationship has been transferred from native languages into painting:

> The Indian verbal form is given visual form in Indian art. The language is beautiful and poetic. When the Indian speaks of nature it is like one of the elements speaking of another element. The Indian lived in nature so long he became part of it. He is one of the balancers of nature. . . . The Indian was a very religious man, his altars were the unusual formations in nature: the sun, moon, trees, hills, rocks. I try to paint the Indian's true identity as an intellectual being. (Howe in Highwater 1976, 156)

In one eloquent passage Howe draws connections among native language, art, religion, and views of nature. He finds the source of indigenous identity in the interrelation of these elements. It is clearly the hope of directors like Masayesva that an indigenous aesthetic that combines these elements will also emerge in Native American media. An indigenous aesthetic is already forming with, as Masayesva puts it, its beginning in the sacred, even though indigenous media are less than twenty years old.

Visual and performance arts that express indigenous ideas about religion and nature may be the last surviving source of cultural identity as native peoples increasingly rely upon the "outside world" for economic survival. "Art for Indians is perhaps their last hope to retain their individuality in a country that promotes uniformity" (Hill in Smith 1990, 3). Aesthetic practices are among the most central means of recovering and preserving native ways of seeing and being.

TOWARD A GENERAL AESTHETICS OF PLACE

A profound sense of place, which grows out of the linkage between the spiritual and the natural, is at the center of indigenous aesthetics. The study of indigenous aesthetics opens one up to the possibility of a general aesthetics of place for non-indigenous people. What are the implications of indigenous aesthetics for understanding place attachment in aesthetic experience?

In indigenous aesthetics the source of the sense of place is in the interrelation of several elements: language, art, religion, social life, and views of

nature. Together these comprise the conceptualization and expression of place, the activities within a place, and responses to the physical attributes of specific places. In traditional native culture a sense of place, then, is not generated as much by institutional religious or political systems (an ideological formation of place) as much as through a group's profound experience of place. However, concepts of nation that follow from tribal boundaries, and the current drive for sovereignty by aboriginal groups, may be layered over other experiential bases of place.

This layering risks shifting the conceptualization of place toward a Euro-American model that ultimately undermines a more fundamental experience of place. In the view of the artist and social critic Jimmy Durham, "Americanness" rests on ideology and statism more than a sense of place. He writes that Americans do not have the same sense of place found by Europeans in Europe. According to Durham, America is only a state, not a place, so its ideology must be absolute (1992, 428). For this reason, Euro-Americans never seem to feel "at home." Their patriotism is not based in or on the land (1992, 432). Based on his belief that statism is not the same as sense of place, Durham rejects the notion of tribal sovereignty, which he sees as an extension of colonialist concepts and language. Durham notes that the concept of tribe is drawn from the Roman tribunal and, therefore, is part of a discourse of "enclosure and concealment" (1992, 433).

Durham's attack on the ideological basis of Americanness and the concept of tribe may be controversial among natives and non-natives alike. But his criticism usefully points to an alternative experience of place: in or on the land. This notion is an extension of native worldviews that do not simply revolve around the ownership of objects and property. Durham states his position within a debate about who has the power to invest objects and places with meaning. In singling out the discourse of "enclosure and concealment," Durham critiques the process of how meaning is ascribed to place in ideological contexts. By contrast, indigenous thought incorporates an appreciation of the *connections* between categories of experience. A high valuation of continuity or interconnection is a characteristic of native systems of explanation. Though Durham would probably disagree with a mythic representation of or by natives (because it supports an "Indian-flavored" art useful for commercial purposes and because it makes Indians "less visible" as people) (1992, 436), his argument against

the political language of nation and tribe does return us to a spiritual con- ceptualization of place.

Consistent with indigenous values of continuity and connectedness, a new integration or holism needs to take place in Western culture. A view of art as "personal ceremony" or private visualization, consistent with whiteshamanism, is not enough to create a shared sense of a center in Western culture. Several art forms such as personal altars have emerged as an antidote to the loss of a spiritual center in Western art and as part of an effort to reintegrate art with life. But the personal altar privatizes what was once, and largely remains, a collective expression. The loss of the collective dimension of artworks, as artistic languages have grown increasingly private, is one of the sources of the twentieth-century divide between religion and art. In this sense, I agree with Rose, who critiques the absence of significant community acknowledgment and training found in invented spiritual/aesthetic expressions.

There is a problem of the appearance of collective belief in contemporary art without the presence of it. Recent environmental works echo the structures of archaic earth forms. These ancient works, from the Mississippian mounds to the stone monoliths of Europe to the scarred plains of Peru, seem to be expressions of a collective belief in cosmological power and the potential of religious transformation. Religious art *is* transformative in function and compels collective belief. But what is missing from these new earthworks that echo the appearance of the old? They no longer contain a coded meaning that enables collective belief to occur; rather, they replace the substance of belief with the style of earlier cultures' expressions of belief in an attempt to capture a lost religiosity, a sense of the center. Thus, a sense of place needs to emerge from the conceptualization and expression of place from sources in contemporary Western culture, not from the appropriation of indigenous or archaic forms.

A primary value of the expression of other cultures is that they open up windows onto one's own cultural traditions. Traditionally, members of indigenous cultures often believe that there are rules for art: rules of content, context, form, and personnel. These must be followed and guarded. Art is often seen as sacred, useful, beautiful, and functional, because functionality follows from beauty. The artist is not above or separate from society, not different or eccentric. This brings us to a primary problem of contemporary art in relation to its capacity to express a sense of place. Despite

the developments of postmodernism, much art remains largely autonomous in the industrialized West. The divorce of spirituality, beauty, and ethics from Western aesthetics contrasts with the continued interrelationship of these in indigenous aesthetics. This autonomy is not necessarily a problem in the context of the personal experience of spirituality, but it is definitely a problem in the context of collective belief. Indigenous aesthetic systems, then, create an awareness of the aesthetic dimension in all aspects of our lives.

The emphasis on preparation, so important for participation in communal dances, is a value that can be carried into other areas of life to great benefit. In art, the concept of preparation relates to the valuation of an aesthetic discipline or a long-term relationship to a medium. A key element of the cultural integration that occurs in indigenous aesthetics is that innovation occurs within artistic traditions; thus the meaning of art derives from its relation to the past. It is these values—preparation, a long-term relationship to a medium, and an awareness of history—that provide the groundwork for the vision that leads to the aesthetic experience of place.

Though nature is a catalyst for this vision, indigenous art does not simply re-present the natural world. Rather, to use Bosin's fortuitous phrase once again, native artists capture the "pulse and essence" of nature. If the essence of a culture can be found in its relation to nature; if specific ties to the land unite communities; if a spiritual affinity derives from a view of the land as sacred, then the envisioning of place found in indigenous art can lead to a general aesthetics of place for members of all cultures.

NOTES

INTRODUCTION

1. See David Maybury-Lewis, "The Art of Living," in *Millennium: Tribal Wisdom and the Modern World* (New York: Viking, 1992), pp. 147–174, and Thomas McEvilley, "The Selfhood of the Other: Reflections of a Westerner on the Occasion of an Exhibition of Contemporary Art from Africa," in *Africa Explores: 20th Century African Art*, ed. Susan Vogel (New York: Center for African Art, 1991), p. 270.

2. For critiques of the impact of a mechanistic, technological worldview on Western art see José Argüelles, *The Transformative Vision* (Berkeley, Calif.: Shambhala, 1975), especially the chapter titled "Art as Internal Technology," and Suzi Gablik, "Learning to Dream: The Remythologizing of Consciousness," from *The Reenchantment of Art* (London: Thames and Hudson, 1991), pp. 41–58. A more general discussion of the conflict between the technological and the sacred in the context of Native American culture is Jerry Mander's *In the Absence of the Sacred* (San Francisco: Sierra Club Books, 1991).

3. The same logic of relationship holds true for the other social systems. In my view, political systems are not reducible to religious or economic systems, but the relationship among these systems is important.

4. Griaule quoted in Henry Pernet, *Ritual Masks* (Columbia: University of South Carolina Press, 1992), p. 61.

1. AESTHETICS AND THE EXPRESSION OF IDENTITY

1. Precedence for this view is found in the structuralist aesthetics of Mukarovsky (1978). Mukarovsky explains that art is the only field in which the aesthetic function predominates but not the only one in which it exists. He recognizes aesthetic aspects of other cultural systems; this recognition is based upon an understanding of socially existing aesthetic norms as the basis of aesthetic experience.

2. This common element of aesthetic, religious, and political expression—the power to move people—has been noted by other scholars: "Art and politics and reli-

gion share the capacity to move people, through emotion and to action" (Lippard 1983, 8).

3. The analogy is between the child's dependency on the parent and the individual's dependency on the group for security: "In Bion's (1961) 'dependency group' the individual's sense of weakness and inadequacy reactivates the tendency—so clearly observable in early life—to idealize the leader or parent as omnipotent and to extract from him or her, power and perfection. Members of the group are drawn together by their shared sense of weakness and their demand upon one another—and upon the leader especially—for help against an unfriendly outside world" (Group for the Advancement of Psychiatry 1987, 7).

4. These loci of aesthetic activity vary within societies. "It does not seem that a society maintains an equally intense interest in all the things within its borders. There are certain privileged fields where awareness and performance are higher, where expectations and efforts converge. The class or classes of objects that are localized in these areas of heightened aesthetic consciousness constitute the aesthetic locus of a culture" (Maquet 1979, 31). Maquet writes that the locus of aesthetic experience depends upon the larger social context.

5. Based on this definition, Perris describes the persuasive function of music in European nationalist and totalitarian contexts, religious contexts, opera, Broadway, and in the popular music of the 1960s.

2. REPRESENTATION AND RECEPTION

1. For a history and analysis of Third World filmmaking see Roy Armes, *Third World Filmmaking and the West* (Berkeley: University of California Press, 1987).

2. The use of the term Third World became widespread in the 1950s, but the formation of Third World nations, independent of their former colonizers, began as early as the 1920s.

3. For examples of postcolonialist art and writing see Sunil Gupta (1993) and Lucy Lippard (1990).

4. Russian-born artists Komar and Melamid recently created idealized landscapes based upon public opinion polls conducted in the United States and Russia. See Richard Vine (1994).

5. The most famous recent example of the abuses of a single "strongman" in native cultures was Dick Wilson and his role during the Lakota civil war that took place at Pine

Ridge during the 1970s (Mathiessen 1991). However, other tribes such as the Navajo and Iroquois (Oneida, Seneca) have had leadership controversies in recent years centered around "strongmen."

6. I am indebted to Nelson Graburn (1993) for much of the discussion of "ethnic resurgence" and "traditional art" in this section.

7. This statement is based upon comments by George Horse Capture (1991).

8. This statement is based upon comments by the native artist and writer Vic Charlo (1991).

9. For a provocative analysis, which helped form this discussion, of the manufactured nature of national identity and its relationship to an economics of cultural display, see Brian Wallis (1991).

10. For a discussion of the history and goals of the global indigenous rights movement see Richard Mulgan (1989).

3. IS THERE "ART" IN INDIGENOUS AESTHETICS?

1. By pointing out the encompassing meaning of aesthetics in anthropology, I am not taking the same position as Blocker, who feels that "aesthetic and artistic considerations are generally denied or marginalized" in anthropology (Blocker 1994, 20). Blocker distinguishes between "purely subjectivist" cross-cultural approaches on the part of artists and the "purely objectivist" approaches of anthropologists (1994, 144). This strikes me as an overly limiting view of anthropological work on aesthetics and of artists' varied responses to the art of other cultures. Rather, I am stating that the term "aesthetic" is used differently in anthropology than in philosophy and art; it embraces a wider range of aesthetic activities that may, but do not necessarily, include art. Similar arguments appear in Blocker's earlier article (1991).

2. There are some exceptions to the absence of theory and criticism in indigenous arts. For instance, Robert Farris Thompson (1973) has described in detail the critical framework of the Yoruba. But it is true that abstract theories that consider art to be distinct from other areas of life are rarely found in indigenous cultures. Art or beauty's role in religion is often discussed, as in China, Japan, and India, as well as art's moral dimension, as in West Africa. Thus, the subject of art is raised in religious and ethical discourse but not as a distinct realm of cultural production in the way that Kant and some subsequent aestheticians in the West have considered it. Because of this, indigenous aesthetics must be sought out in the network of dense correspondences that make up particular aesthetic systems, rather than through theories of art.

3. For Gene Blocker this disparity between the lack of an apparent understanding of "art" in "primitive" cultures and the consideration of their expression as art by Westerners is not a problem (1994, 142). He feels that our own response to it as art warrants its being considered as art. However, he feels that this is a weaker sense of the concept "art." Blocker describes the weaker sense of art as a case of "partial compliance," where "our" concept is not the same as "theirs," but there is some similarity. Asking whether, in such a case, we should now take primitive art out of museums and galleries, Blocker answers his own question: "Not at all. We must simply make it clear that we are shifting to a *partial* and therefore *weaker* sense of 'work of art' in which we, the aesthetic audience and consumer, determine the aesthetic context which qualifies the objects as works of art, rather than their makers" (1994, 142).

4. Kandinsky, in *Concerning the Spiritual in Art,* develops a correspondence theory of aesthetic emotion, in which the artist and observer experience the same emotion, with the artwork functioning as the medium. Emotion is the criterion of the authenticity of the artwork; without it the work is a sham, and this inner element determines the form of the work as well. This isomorphic correspondence theory of emotion in art may be questioned today for a number of reasons, but illustrates the affinity between Kandinsky's and Tagore's work from the same period.

5. The relationship of Tagore's aesthetics to Hinduism becomes apparent when he discusses ideas such as "the infinite," religious song and the religiosity of all art in India, the pervasiveness of the life force in all things, and, in "The Sense of Beauty" (1961 [1916], 3), asceticism and the necessity of the artist's control of his passions. Each of these ideas might be discussed by Western thinkers, but the constellation of related ideas presented by Tagore is clearly Hindu in origin.

6. An example of this kind of impersonal principle of unity, distinct from any religious or ethical tradition, is Harold Osborn's idea of organic unity (1984, 216).

7. The interrelationship between modernism and primitivism is discussed at length by Marianna Torgovnick (1990). I am not advocating a purely objectivist account because: (1) given the nature of language and culture, which guarantee that beliefs are always translated into our own conceptual framework, I do not think that this is possible, and (2) an objectivist approach may not be the most desirable within the creative arts, which often emphasize intuitive, emotional, and other nonrational responses. Rather, I advocate an awareness of and empathy with the different understandings of art present in non-Western cultures.

8. I am using the term dialectic purposefully here, because I think style development in the West *can be* viewed as having progressed logically in cycles of thesis, antithesis, and

synthesis. Whether this is the best model to use in understanding style change in West- ern art is open to debate.

9. See Nietzsche's *The Birth of Tragedy* (1967). Similar theses—that styles express overarching worldviews—have been put forth by Panofsky in his various writings.

10. For critiques of the impact of the contemporary mechanistic, technological worldview on Western art see José Argüelles, especially the chapter titled "Art as Internal Technology" (1975, 277–287), and Suzi Gablik, "Learning to Dream: The Remythologizing of Consciousness" (1991).

11. This statement is based upon comments made by several Native American speakers at various forums: George Horse Capture (1991), Roger Buffalohead (1991), and Huleah Tsinhnajinnie (1995). The aspect of the natural-spiritual connection in non-Indians' perception of Indians that seems to bother these individuals most is that the "natural" Indian serves as an ingredient of stereotyping. It reinforces the eighteenth-century *philosophes'* notion of the Noble Savage, which idealized Indians' "natural state" of communal harmony as an alternative to the corruption and complexities of eighteenth-century social institutions.

12. Religion scholars may reject this distinction between spirituality and religion, but, from my experience, it is a distinction that artists often make.

13. Developments have reached a point where "bad painting" emerged as a prominent and critically acclaimed movement by the 1980s. The art of Duchamp and recent conceptual, performance, and other artists influenced by him have attacked standards of taste and beauty, as did the work of Expressionists such as Kokoschka before them.

14. An example is found in the work of Plotinus, the third-century neo-Platonist, who saw beauty in art as a kind of refinement of the beauty, balance, and proportion that occur in nature. In Plotinus's mystical thought beauty in art helped restore balance and unity to life by redirecting us to the One, the ultimate source of life and knowledge.

15. Onyewuenyi begins his article by noting that the link between the Good and the beautiful, found in Africa today, has a precedent in Socrates, who "regarded the beautiful as coincident with the good" (1984, 237).

16. This same close connection between the Good and the beautiful is noted by Richard Anderson in "Yoruba Aesthetics: Goodness and Beauty in West Africa" (1990, 112–139).

1. See Cornell (1988) and Jarvenpa (1985) for extended discussions of the impact of tribal politics on native identities. This historical overview of native collective identity is drawn in part from their research.

2. It should be noted that insight into the spiritual life of Hopis has been obtained through respectful documentation of their artistic, kinship, and agricultural practices and through the visual presentation of traditional narratives, as in Victor Masayesva, Jr.'s videos and the documentary *Songs of the Fourth World*. It is not necessary to violate sacred space in order to gain deep insight into a culture.

3. See my article "Native American Responses to the Western" (1995) for a detailed analysis of native concerns about stereotyping in mainstream media.

5. EXPRESSIVE ANTECEDENTS OF NATIVE AMERICAN DOCUMENTARY

1. Another reason for my selection of the McNickle novel for analysis is personal. I lived on the Flathead Indian Reservation in 1991–1992 while conducting field research on native media and was familiar with the locale of the novel's setting.

2. This approach, conceptualized in recent scholarship as pragmatics, emphasizes contextual and social factors in an ethnographic approach to speech communication. Speech communication ethnographies of Native American oral communication include Keith Basso's observation and analysis of Apache humor, *Portraits of the Whiteman* (1979), Philips's analysis of the effect of participation structures at social events on the Warm Springs Reservation, and other studies from the anthology *Explorations in the Ethnography of Speaking* (Richard Bauman and Joel Sherzer, eds., 1989 [1974]).

3. For a discussion of the role of speech in processes of intercultural representation see Murray (1991).

6. AN INDIGENOUS MEDIA AESTHETIC?

1. Auteurism is an approach to film, rooted in the theories of Bazin, that emphasizes the director's influence on the style of a film. This has the effect of framing filmmaking as an "art" rather than as a mass-mediated form.

2. Many film and video series and individual videos emphasize the mythic dimension of history for Native Americans. Rather than simply recounting historical fact, these

videos represent the past as the wellspring of emotions and ideas that create cohesion in contemporary communities. For example, see several of the episodes of *The Real People Series* (1976) and the *Creek Nation Videos* (1983–1986); *Eyes of the Spirit* (1983) and other productions by KYUK, Bethel, Alaska; the series *Make Prayers to the Raven* (1987); many of the videos distributed by Native Voices in Bozeman, Montana, including *Warrior Chiefs in a New Age* (1991), *Crow Mapuche Connection* (1991), *Transitions* (1991), and *The Place of Falling Waters* (1990); and Masayesva's *Siskyavi: The Place of Chasms* (1991) and *Itam Hakim, Hopiit* (1984).

3. The "New Visionaries" were the names of the awards given out at the Two Rivers Native Film and Video Festival, Minneapolis, 1991.

8. PERFORMANCE CONTEXTS AND COLLECTIVE IDENTITY

1. Schieffelin seems to view performance qualities as more primary than symbolic meanings in ritual performances: "What renders the performance compelling is not primarily the meanings embodied in symbolic materials themselves but the way the symbolic material emerges in the interaction" (Schieffelin 1985, 721). But I am not ready to extend primacy to either the performance context or meaning content in the experience of music. One objection to Schieffelin's ideas might be that the relative importance of context and content may vary between different cultures. However, I do feel that the renewed attention which Schieffelin proposes for formal characteristics of performance is valuable for understanding how musical performance can lead to group identification.

2. Fixico and Trafzer describe this ironic adoption of a country and western cowboy identity by some contemporary Indians in Trafzer (1985).

9. INDIGENOUS AESTHETICS OF PLACE

1. For an extended discussion of the role of the shamanic spirit in contemporary art, music, and culture see Michael Tucker (1992).

2. My sense that religion outweighs political motivations for Indian artists was supported by the comments of James Luna during a panel at the 1992 College Art Association Convention. Luna noted the relative lack of "social commentary" by Indian artists. His own art is filled with "references to spirit manifestations," ceremonial references, and color symbolism derived from traditional religious thought. During the same panel, Frank Lapena noted that the work of many California native artists involves the "illustration of myths," which often have religious connotations.

FILMOGRAPHY

THE FILMOGRAPHY lists documentaries and feature films discussed in the book. The producing agency is listed for videos and films that are native productions or co-productions. Information appears in this order: title, director, producing agency, location (when known), and release date. Native productions and coproductions are listed separately from other documentary films about Native Americans.

NATIVE PRODUCTIONS OR COPRODUCTIONS

Bear Dance, James Ciletti, in cooperation with the Southern Utes and the Ute Mountain Utes of Colorado, 1988.

Creek Nation Videos, Scott Swearingen, Gary Robinson, and Sheila Swearingen, Muscogee Creek Nation Communication Center, Okla., 1983–1986.
 Folklore of the Muscogee People
 Stickball: Little Brother of War
 The Strength of Life
 1,000 Years of Muscogee Art
 Turtle Shells

Changing Visions, Betty White and Frank Tyro, Salish Kootenai College, Pablo, Mont., 1988.

Crow Mapuche Connection, Arvo Iho and Susan Stewart, Native Voices Public Television Workshop, Bozeman, Mont., 1991.

Dan Namingha, Frank Blythe and Larry Littlebird, Native American Public Telecommunications (NAPT), Lincoln, Nebr., 1984.

The Drum, Dennis Austin, Ojibway and Cree Cultural Centre Video, Timmins, Ontario, 1982.

Eyes of the Spirit, Corey Flintoff and Alexie Isaac, KYUK, Bethel, Alaska, 1984.

Finding the Circle (Great Performances series), Merrill Brockway, Hanay Geiogamah, American Indian Dance Theater, WNET-TV, New York, 1989.

Healing the Hurts, Phil Lucas, Phil Lucas Productions, 1991.

Her Giveaway: A Spiritual Journey with AIDS, Mona Hadler, in association with the Minnesota Indian AIDS Task Force, 1988.

212 *The Honor of All,* Phil Lucas for the Alkali Lake Indian Band, B.C., Canada, 1985.

Hopiit, Victor Masayesva, Jr., IS Productions, Hotevilla, Ariz., 1980.

I'd Rather Be Powwowing (Matters of Life or Death series), Larry Littlebird (director), George P. Horse Capture (producer), WNET-TV, New York, 16 mm, 1983.

Images of Indians (five-part series). Phil Lucas and Robert Hagopian, KCTS/9, Seattle, Wash., and United Indians of All Tribes Foundation, 1980.

In the Heart of Big Mountain, Sandra Sunrising Osawa, Upstream Productions, Seattle, Wash., 1988.

In the White Man's Image, Christine Lesiak and Matt Jones, NAPT and Nebraska Educational TV, 1992.

Itam Hakim, Hopiit, Victor Masayesva, Jr., IS Productions, Hotevilla, Ariz., 1984.

Kahnesatake: 270 Years of Resistance, Alanis Obomsawin, National Film Board of Canada, 1993.

Lighting the Seventh Fire, Sandy Johnson Osawa, Upstream Productions, Seattle, Wash., 1994.

Native American Images, Carol Patton Cornsilk, Southwest Texas Public Broadcasting Council, 1985.

The Place of Falling Waters, Roy Bigcrane and Thompson Smith, Salish Kootenai College, Native Voices Public Television Workshop, Bozeman, Mont., 1990.

Powwow Fever, Rick Tailfeathers, Bullhorn Productions, Indian News Media, Blood Reserve, Alberta, Canada, 1984.

The Pueblo Peoples: First Contact, George Burdeau and Larry Walsh, KNME-TV, Albuquerque, N. Mex., and the Institute of American Indian and Alaska Native Culture and Arts Development, 1990.

The Real People Series, George Burdeau, Office of Education (Department of Health, Education, and Welfare), Emergency School Aid Act.

> *Awakening* (1976)
> *Circle of Song* (1976)
> *Circle of Song: Part II* (1976)
> *Legend of the Stick Game* (1976)
> *Mainstream* (1976)
> *Spirit of the Wind* (1976)

Red Road: Toward the Techno-Tribal, Daniel and Juan Salazar, Front Range Educational Media Corp., 1984.

Ritual Clowns, Victor Masayesva, Jr., IS Productions, Hotevilla, Ariz., 1988.

Siskyavi: The Place of Chasms, Victor Masayesva, Jr., IS Productions, Hotevilla, Ariz., 1991.

Songs in Minto Life, Curt Madison, Leonard Kamerling, and Charlotte Yager, in

cooperation with Minto Village Council, Alaska Native Heritage Project, Univer-
sity of Alaska Museum, Fairbanks, Alaska, 1985.

Surviving Columbus, George Burdeau and Larry Walsh, KNME-TV and Public Broadcasting System, 1990.

Tiwa Tales, Chuck and Maggie Banner, Joseph L. and J. Leonard Concha, Eagle Springs Productions, 1990.

A Tradition Lives: The Powwow, Glenn Raymond, in cooperation with the Colville Confederated Tribes and Kalispel Tribe, Glenn Raymond/Darryl Suta Productions, Seattle, Wash., 1984.

Transitions, Darrel Kipp and Joe Fisher, Native Voices Public Television Workshop, Bozeman, Mont., 1991.

Ute Bear Dance Story, Larry Cesspooch, Ute Audio-Visual Department, 1988.

Vine Deloria presentation at University of Montana, classroom videotape, 1988.

Visions, Rick Tailfeathers and Duane Mistaken Chief, Indian News Media, Blood Reserve, Alberta, Canada, 1984.

Warrior Chiefs in a New Age, Dean Bearclaw, Native Voices Public Television Workshop, Bozeman, Mont., 1991.

Winds of Change: A Matter of Choice, Carol Cotter (producer/writer), Frank Blythe, Roger Buffalohead, Phil Lucas (advisors), WHA-TV, Madison, Wisc., Wisconsin Public Television, 1990.

Winds of Change: A Matter of Promises, Carol Cotter (producer/writer), Frank Blythe, Roger Buffalohead, Phil Lucas (advisors), WHA-TV, Madison, Wisc., Wisconsin Public Television, 1990.

OTHER DOCUMENTARY FILMS AND VIDEOS
ABOUT NATIVE AMERICANS

American Indian Artists series (six parts: Hardin, Loloma, Houser, Gorman, Lonewolf, Scholder), Tony Schmitz and Don Cirillo, KAET-TV, Phoenix, Ariz., 1976.

American Indian Arts at the Heard Museum series (three parts: Painting, Pottery, Basketry), Rick Thomson, Tony Schmitz, Don Cirillo, KAET-TV, Phoenix, Ariz., 1975.

Apache Mountain Spirit, Bob Graham, Kate Quillan-Graham, screenplay by Joy Harjo and Harry Greenberg, produced by John and Jennie Crouch, Silver Cloud Video Productions, for the White Mountain Apache Tribe, 1985.

By This Song I Walk: Navajo Song, Denny Carr, Mike Orr, University of Arizona Radio/Film Bureau, 1978.

Chalath Whadlik—Follow the Teachings, Loran Olsen, KWSU-TV, Pullman, Wash., 1989.

214 *Crow Dog's Paradise,* Mark Elliott, Centre Productions, Boulder, Colo., 1976–1978.

Dancing Feathers (Spirit Bay series), Eric Jordan, Paul Stephens, Spirit Bay Productions for Canadian Broadcasting Corporation, 1983.

From the First People, Leonard Kamerling and Sarah Elder, Alaska Native Heritage Project, 1977.

Hopi Coyote Stories with Helen Sekaquaptewa, Denny Carr, Mike Orr, University of Arizona Radio/Film Bureau, 1978.

Hopi Prayer for Peace, Chuck Banner, Maggie Banner, A Masadavo Production, 1986.

Hopi: Songs of the Fourth World, Pat Ferrero, Independent, 1983.

Jaune Quick-to-See Smith, Tony Schmitz, NAPT, Lincoln, Nebr., 1984.

Jaune Quick-to-See Smith: Interview on Sioux Country, South Dakota Public TV, 1979.

Keep Your Heart Strong, Deb Wallwork, Prairie Public TV, North Dakota, 1986.

Lakota Quillwork: Art and Legend, H. Jane Naumann, South Dakota Arts Council, 1985.

Make Prayers to the Raven series, Mark Badger, KUAC-TV, University of Alaska, Fairbanks, 1987.

Mountain Music of Peru, John Cohen, 1984.

Nawatniwa—A Hopi Philosophical Statement with George Nasoftie, Denny Carr, Mike Orr, University of Arizona Radio/Film Bureau, 1978.

Native Land: Nomads of the Dawn, Jamake Highwater, PBS, 1986.

On Spring Ice, Leonard Kamerling and Sarah Elder, 1975.

Oscar Howe: American Indian Artist, Joan and Sanford Gray, University of South Dakota, 1973.

Return of the Sacred Pole, Michael Farrell, University of Nebraska–Lincoln, Nebraska ETV, NAPT, 1990.

Seasons of a Navajo, John Borden, Peace River Films for KAET-TV, Tempe, Ariz., 1984.

The Spirit of Crazy Horse on *Frontline,* James Locker, Milo Yellow Hair (correspondent), WGBH, Boston, PBS Home Video, 1990.

Vision Quest, Jack Stonnell, Montana State College, Missoula, Mont., 1961.

Word and Place: Native Literature from the American Southwest (series), Denny Carr, Mike Orr, University of Arizona Radio/Film Bureau, 1978.

FEATURE FILMS

Dances with Wolves, Kevin Costner, 1990.

Powwow Highway, Jonathan Wacks, 1988.

Plains and Northern Plateau Culture Areas

Vision Quest (1961)

Oscar Howe: American Indian Artist (1973)

The Real People Series:
 Awakening (1976)
 Circle of Song, Parts I and II (1976)
 Legend of the Stick Game (1976)
 Spirit of the Wind (1976)

Crow Dog's Paradise (1976–1978)

Jaune Quick-to-See Smith: Interview on Sioux Country (1979)

Jaune Quick-to-See Smith (1984)

Creek Nation Videos (1983–1986)

I'd Rather Be Powwowing (1983)

A Tradition Lives: The Powwow (1984)

Powwow Fever (1984)

Visions (1984)

Lakota Quillwork: Art and Legend (1985)

The Honor of All (1985)

Native American Images (1985)

Changing Visions (1988)

Vine Deloria presentation at U. of Montana (1988)

The Spirit of Crazy Horse (1990)

The Place of Falling Waters (1990)

Crow Mapuche Connection (1991)

Warrior Chiefs in a New Age (1991)

Transitions (1991)

Lighting the Seventh Fire (1994)

Southwestern Culture Area

American Indian Arts at the Heard Museum (1975)

American Indian Artists series: Hardin, Loloma, Houser, Gorman, Lonewolf, Scholder
 (1976)

By This Song I Walk: Navajo Song (1978)

Hopi Coyote Stories with Helen Sekaquaptewa (1978)
Nawatniwa—A Hopi Philosophical Statement with George Nasoftie (1978)
Hopi: Songs of the Fourth World (1983)
Dan Namingha (1984)
Seasons of a Navajo (1984)
Red Road: Toward the Techno-Tribal (1984)
Itam Hakim, Hopiit (1984)
Apache Mountain Spirit (1985)
Hopi Prayer for Peace (1986)
The Pueblo Peoples: First Contact (1990)
Tiwa Tales (1990)
Siskyavi: The Place of Chasms (1991)

Inuit/Aleut/Athabaskan

Eyes of the Spirit (1984)
Songs in Minto Life (1985)
Make Prayers to the Raven (1987)

Northwest Coast

Chalath Whadlik—Follow the Teachings (1989)

Northeast

Kahnesatake: 270 Years of Resistance (1993)

Intertribal/Other

Finding the Circle (*Great Performances* series) (1989)
Winds of Change: A Matter of Choice (1990)
Winds of Change: A Matter of Promises (1990)
In the White Man's Image (1992)

BIBLIOGRAPHY

Agovi, Kofi E. 1989. "The Political Relevance of Ghanaian Highlife Songs since 1957." *Research in African Literature* 20(2):194–201.

Anderson, Richard. 1990. *Calliope's Sisters*. Englewood Cliffs, N.J.: Prentice Hall.

Argüelles, José. 1975. *The Transformative Vision*. Berkeley, Calif.: Shambhala.

Arlee, Johnny. 1976. *Awakening* (*The Real People Series*). Office of Education (Department of Health, Education, and Welfare) and KSPS-TV, Spokane, Wash. Film.

———. 1991. Classroom presentation to "Images of Indians" class. Salish Kootenai College, Pablo, Mont., Spring. Video.

Armes, Roy. 1987. *Third World Filmmaking and the West*. Berkeley: University of California Press.

Barnouw, Eric. 1983. *Documentary: A History of the Non-Fiction Film*, 2d ed. Oxford, England: Oxford University Press.

Basso, Keith. 1979. *Portraits of the Whiteman*. London: Cambridge University Press.

Bataille, Gretchen, and Charles Silet, eds. 1980. *The Pretend Indians: Images of Native Americans in the Movies*. Ames: Iowa State University Press.

Bauman, Richard, and Joel Sherzer, eds. 1989 [1974]. *Explorations in the Ethnography of Speaking*. Cambridge, England: Cambridge University Press.

Beaver, Tom. 1991. "Producers' Forum 1: Uncovering the Lies." Symposium at Two Rivers Native Film and Video Festival, Minneapolis, Minn., October 10.

Becker, Howard. 1982. *Art Worlds*. Berkeley: University of California Press.

Becker, Judith. 1986. "Is Western Art Music Superior?" *Musical Quarterly* 72(3): 341–359.

Bergesen, Albert. 1987. *The Sacred and the Subversive: Political Witch Hunts as National Rituals*. Storrs, Conn.: Society for the Scientific Study of Religion.

Bellah, Robert, et al. 1985. *Habits of the Heart*. New York: Perennial/Harper and Row.

Bellman, Beryl, and Bennetta Jules-Rosette. 1977. *A Paradigm for Looking: Cross-Cultural Research with Visual Media*. Norwood, N.J.: Ablex Publishing Corp.

Benedict, Ruth. 1989 [1934]. *Patterns of Culture*. Boston: Houghton Mifflin.

Berkhofer, Robert. 1978. *The White Man's Indian: Images of the American Indian from Columbus to the Present*. New York: Vintage.

Bigcrane, Roy. 1990. *The Place of Falling Waters*. Salish Kootenai College and Native Voices Public Television Workshop, Bozeman, Mont. Video.

———. 1991. Series of personal interviews with author. Salish Kootenai College, Pablo, Mont., September–December.

Blacking, John. 1983. "The Concept of Identity and Folk Concepts of Self: A Venda Case Study." In *Identity: Personal and Socio-cultural,* edited by Anita Jacobson-Whiting. Uppsala, Sweden: Acta Universitatis Upsaliensis, Uppsala Studies in Cultural Anthropology 5.

Blocker, H. Gene. 1991. "Is Primitive Art Art?" *Journal of Aesthetic Education* 25(Winter):87–97.

———. 1994. *The Aesthetics of Primitive Art*. Lanham, Md.: University Press of America, Ltd.

Blythe, Frank. 1991. "Producers' Forum 2: Confronting the Challenges." Symposium at Two Rivers Native Film and Video Festival, Minneapolis, Minn., October 10.

Bohlman, Philip V. 1988. "Traditional Music and Cultural Identity: Persistent Paradigm in the History of Ethnomusicology." In *1988 Yearbook for Traditional Music,* edited by Dieter Christensen. Urbana: University of Illinois Press.

Bourdieu, Pierre. 1984. *Distinction*. Boston: Harvard University Press.

Bousé, Derek. 1991. "The Visual Rhetoric of Wilderness in Documentary Film and Video Images." Ph.D. diss., University of Pennsylvania.

Brisebois, Debbie. 1983. "The Inuit Broadcasting Corporation." *Anthropologica* 25(1):107–115.

Buffalohead, Roger. 1991. "Film and Its Effect on Native Communities." Speech at Two Rivers Native Film and Video Festival, Minneapolis, Minn., October 10.

Burdeau, George. 1991a. "Producers' Forum 2: Confronting the Challenges." Symposium at Two Rivers Native Film and Video Festival, Minneapolis, Minn., October 10.

———. 1991b. "Pathways to Understanding: Native Participation in the Film Industry." Speech at Two Rivers Native Film and Video Festival, Minneapolis, Minn., October 11.

Canter, David. 1977. *The Psychology of Place*. New York: St. Martin's Press.

Champagne, Duane. 1989. *American Indian Societies: Strategies and Conditions of Political and Cultural Survival*. Cambridge, Mass.: Cultural Survival, Inc.

Chandler, Al. 1983. *I'd Rather Be Powwowing*. WNET-TV, New York. Video.

Charbonnier, George. 1969. *Entretiens avec Claude Levi-Strauss*. Paris: Union generale d'editions.

Charlo, Vic. 1991. Montana Indian Arts Conference Workshop, Helena, Mont.

Chopyak, James D. 1987. "The Role of Music in Mass Media, Public Education and the 219 Formation of a Malaysian National Culture." *Ethnomusicology* 31(3):431–451.

Churchill, Ward. 1992. *Fantasies of the Master Race: Literature, Cinema and the Colonization of American Indians,* compiled by Annette Jaimes. Monroe, Maine: Common Courage Press.

Clairmont, Corwin. 1992. Comments at "Images of Indians" class. Salish Kootenai College, Pablo, Mont., Spring.

Clifford, James. 1988. *The Predicament of Culture: Twentieth Century Ethnography, Literature and Art.* Cambridge, Mass.: Harvard University Press.

Coe, Ralph. 1977. *Sacred Circles: Two Thousand Years of American Indian Art.* Kansas City: Nelson Gallery Foundation.

Collier, John. 1972. *American Indian Ceremonial Dances.* New York: Bounty Books.

Collier, John, Jr., and Malcolm Collier. 1986. *Visual Anthropology: Photography as a Research Method.* Albuquerque: University of New Mexico Press.

Coplan, David. 1988. "Musical Understanding: The Ethnoaesthetics of Migrant Workers' Poetic Song in Lesotho." *Ethnomusicology* 32(3):337–368.

Cornell, Stephen. 1988. "The Transformations of Tribe: Organization and Self-Concept in Native American Ethnicities." *Ethnic and Racial Studies* 11(1):27–47.

Deleuze, Gilles. 1993. "A Theory of the Other." In *The Deleuze Reader,* edited by Constantin V. Boundas. New York: Columbia University Press.

Deloria, Vine. 1969. *Custer Died for Your Sins: An Indian Manifesto.* Norman: University of Oklahoma Press.

———. 1988. Videotaped classroom presentation. University of Montana, Missoula.

Diawara, Manita. 1992. *African Cinema: Politics and Culture.* Bloomington: Indiana University Press.

Douglas, Mary. 1972. "Pollution." In *Reader in Comparative Religion,* 3d ed., edited by William A. Lessa and Evon Vogt. New York: Harper and Row.

du Preez, Peter. 1980. *The Politics of Identity: Ideology and the Human Image.* New York: St. Martin's Press.

Durham, Jimmie. 1992. "Cowboys and . . . Notes on Art, Literature, and American Indians in the Modern American Mind." In *The State of Native America: Genocide, Colonization, and Resistance,* edited by M. Annette Jaimes. Boston: South End Press.

Durkheim, Emile. 1915. *The Elementary Forms of Religious Life.* London: George Allen & Unwin.

Dyck, Noel. 1985. *Indigenous Peoples and the Nation-State: "Fourth World" Politics in Canada, Australia and Norway.* St. Johns: Memorial University of Newfoundland, Institute for Social and Economic Research.

Dyer, John. 1992. Film class comments. University College, Syracuse University, Syracuse, N.Y., Fall.

Eaton, Linda. 1989. "The Only One Who Knows: A Separate Vision." *American Indian Art Magazine* 14(3):46–53.

Edelman, Murray. 1964. *The Symbolic Uses of Politics.* Urbana: University of Illinois Press.

Elsass, Peter. 1991. "Self-Reflection or Self-Preservation: A Study of the Advocacy Effect." *Visual Anthropology* 4:161–173.

Emerman, Marsha. 1989. "Film, Video and Self-Representation in Northern Ireland." *Cineaste* 17(2):40–41.

Fahey, John. 1974. *The Flathead Indians.* Norman: University of Oklahoma Press.

Faris, James C. 1993. "A Response to Terence Turner." *Anthropology Today* 9(1):12–13.

Feld, Steven. 1976. "Ethnomusicology and Visual Communication." *Ethnomusicology* 20(2):293–325.

———. 1988. "Aesthetics as Iconicity of Style, or 'Lift-Up-Over Sounding': Getting into the Kaluli Groove." In *1988 Yearbook for Traditional Music,* edited by Dieter Christensen. Urbana: University of Illinois Press.

———. 1991. Classroom communication. University of Pennsylvania, Fall.

Fiedler, Leslie. 1968. *The Return of the Vanishing American.* New York: Stein & Day.

Fischer, John L. 1961. "Art Styles as Cultural Cognitive Maps." *American Anthropologist* 63(1):79–93.

Fisher, Jean. 1991. "Dancing with Words and Speaking with Forked Tongues." *Third Text* 14(Spring):26–41.

Fisher, Joe, and Darrel Kipp, directors. 1991. *Transitions.* Produced by Native Voices Public Television Workshop, Bozeman, Mont.

Fixico, Donald L. 1985. "From Indians to Cowboys: The Country and Western Trend." In *American Indian Identity,* edited by Clifford Trafzer. Sacramento, Calif.: Sierra Oaks Publishing.

Fixico, Michelene. 1985. "The Road to Middle Class Indian America." In *American Indian Identity,* edited by Clifford Trafzer. Sacramento, Calif.: Sierra Oaks Publishing.

Forbes, Jack. 1990. "The Manipulation of Race, Caste and Identity: Classifying Afroamericans, Native Americans and Red-Black People." *Journal of Ethnic Studies* 17(4):1–51.

Forrest, John. 1988. *Lord I'm Coming Home: Everyday Aesthetics in Tidewater North Carolina.* Ithaca, N.Y.: Cornell University Press.

Fowler, Alastair. 1989. "Genre." In *International Encyclopedia of Communication.* New York: Oxford University Press.

Francesconi, Robert. 1986. "Free Jazz and Black Nationalism: A Rhetoric of Musical
Style." *Critical Studies in Mass Communications* 3(1):36–49.

Friar, Ralph. 1972. *The Only Good Indian . . . Hollywood Gospel*. New York: Drama Book
Specialists/Pubs.

Gablik, Suzi. 1991. "Learning to Dream: The Remythologizing of Consciousness." In
The Reenchantment of Art. London: Thames and Hudson.

Geertz, Clifford. 1988. "Thick Description: Toward an Interpretive Theory of Culture."
In *High Points in Anthropology,* edited by Paul Bohannan and Mark Glazer. New
York: Alfred A. Knopf.

Giago, Tim, Mary Cook, and Gemma Lockhart. 1991. "They've Gotten It Right This
Time." *Native Peoples* 4(2):6–14.

Ginsburg, Faye. 1991. "Indigenous Media: Faustian Contract or Global Village?" *Cultural Anthropology* 6(1):92–112.

———. 1993. "Aboriginal Media and the Australian Imaginary." *Public Culture* 5(3):
557–578.

Graburn, Nelson. 1993. "Ethnic Arts of the Fourth World." In *Imagery and Creativity:
Ethnoaesthetics and Art Worlds in the Americas,* edited by Dorothea and Norman
Whitten. Tucson: University of Arizona Press.

Grass, Randall F. 1986. "Fela Anikulapo-Kuti, The Art of an Afrobeat Rebel." *TDR: The
Drama Review* 30(1):129–148.

Gross, Larry. 1975. "How True Is Television's Message." In *Getting the Message Across*.
Paris: The UNESCO Press.

Group for the Advancement of Psychiatry (GAP). 1987. *Us and Them: The Psychology
of Ethnonationalism*. New York: Brunner/Mazel Publishers.

Gupta, Sunil, ed. 1993. *Disrupted Borders: An Intervention in Definitions of Boundaries*.
London: Rivers Oram Press.

Haberland, Wolfgang. 1986. "Aesthetics in Native American Art." In *The Arts of the
Native American Indian,* edited by Edwin L. Wade. New York: Hudson Hills
Press.

Harjo, Suzan. 1991. "Negative Portrayals of Native People, from Columbus to the
Hollywood Western." Speech at Two Rivers Native Film and Video Festival, Minneapolis, Minn., October 10.

Hauck, Shirley. 1986. "Extinction and Reconstruction of Aleut Music and Dance."
Ph.D. diss., University of Pittsburgh.

Hebdige, Dick. 1979. *Subculture: The Meaning of Style*. London: Methuen and Co., Ltd.

Heider, Karl. 1976. *Ethnographic Film*. Austin: University of Texas Press.

Henry, Edward O. 1989. "Institutions for the Promotion of Indigenous Music: The
Case for Ireland's Comhaltas Ceoltoiri Eirann." *Ethnomusicology* 33(1):67–95.

222 Hertzberg, Hazel. 1971. *The Search for an American Indian Identity: Modern Pan-Indian Movements.* Syracuse, N.Y.: Syracuse University Press.

Hibben, Frank. 1975. *Kiva Art of the Anasazi at Pottery Mound.* Las Vegas, Nev.: KC Publications.

Hicks, Bob. 1991. "Producers' Forum 1: Uncovering the Lies." Symposium at Two Rivers Native Film and Video Festival, Minneapolis, Minn., October 10.

Highwater, Jamake. 1976. *Song from the Earth: American Indian Painting.* Boston: New York Graphic Society.

———. 1980. *The Sweet Grass Lives On: Fifty Contemporary North American Indian Artists.* New York: Lippincott & Crowell.

Hill, Rick. 1990. "The Rise of Neo-Native Expression." In *Our Land/Ourselves: American Indian Contemporary Artists,* Jaune Quick-to-See Smith, Guest Curator. University Art Gallery, SUNY, Albany, N.Y., February 1–March 17, 1991.

———. 1992. "Everybody Needs an Indian: Native Needs beyond 1992." Panel presentation. College Art Association Conference, Chicago. February.

Hirschfelder, Arlene B. 1982. *American Indian Stereotypes in the World of Children: A Reader and Bibliography.* Metuchen, N.J.: Scarecrow Press.

Hockings, Paul, ed. 1975. *Principles of Visual Anthropology.* The Hague: Mouton.

Holm, Bill. 1986. "The Dancing Headdress Frontlet: Aesthetic Context on the Northwest Coast." In *The Arts of the North American Indian: Native Traditions in Evolution,* edited by Edwin Wade. New York: Hudson Hills Press.

Horse Capture, George. 1991. Workshop at Montana Indian Arts Conference, Helena, Mont., September.

Images of Indians. 1992. Students' class comments. Salish Kootenai College, Pablo, Mont., Spring.

Isaacs, Harold R. 1975. *Idols of the Tribe, Group Identity and Political Change.* New York: Harper Colophon Books.

Jaimes, M. Annette, ed. 1992. *The State of Native America: Genocide, Colonization, and Resistance.* Boston: South End Press.

Jarvenpa, Robert. 1985. "The Political Economy and Political Ethnicity of American Indian Adaptations and Identities." *Ethnic and Racial Studies* 8(1):29–48.

Jones, Dan. 1991. "Producers' Forum 4: Realizing Our Visions." Symposium at Two Rivers Native Film and Video Festival, Minneapolis, Minn., October 11.

Jung, Carl G. 1959. *The Archetypes and the Collective Unconscious.* Princeton, N.J.: Bollingen Series.

Kaemmer, John E. 1989. "Social Power and Musical Change among the Shona." *Ethnomusicology* 33:131–145.

Kaeppler, Adrienne. 1978. "Melody, Drone and Decoration: Underlying Structures and Surface Manifestation in Tongan Art and Society." In *Art in Society,* edited by Michael Greenhalgh and Vincent Megaw. London: Duckworth.

Kandinsky, Wassily. 1972 [1912]. *Concerning the Spiritual in Art.* New York: Wittenborn.

Keil, Charles. 1987. "Participatory Discrepancies and the Power of Music." *Cultural Anthropology* 2(3):275–282.

Kingsbury, Henry. 1988. *Music, Talent, and Performance: A Conservatory Cultural System.* Philadelphia: Temple University Press.

Kohrs Campbell, Karlyn, and Kathleen Hall Jamieson. 1976. "Form and Genre in Rhetorical Criticism: An Introduction." In *Form and Genre: Shaping Rhetorical Action,* edited by K. Kohrs Campbell and K. Hall Jamieson. Falls Church, Va.: Speech Communication Association.

KYUK Bethel Alaska Notes. 20th Anniversary Issue. 1991. September.

Lapena, Frank. 1992. "Everybody Needs an Indian: Native Needs beyond 1992." Panel presentation. College Art Association Conference, Chicago. February.

Leuthold, Steven. 1991. "Cultural Identification and Irish Music in Four Performance Contexts: Rock, Folk, Folk Dance, and Classical." Presented at the Seventeenth Annual Conference on Social Theory, Politics, and the Arts, Jacksonville, Fla. October.

———. 1994. "Social Accountability and the Production of Native American Film and Video." *Wide Angle* 16(1–2):41–59.

———. 1995. "Native American Responses to the Western." *American Indian Culture and Research Journal* 19(1):153–189.

Lincoln, Louise. 1992. "The Social Construction of Plains Art, 1875–1915." In *Visions of the People: A Pictorial History of Plains Indian Life,* edited by Evan Maurer. Minneapolis: Minneapolis Institute of Arts.

Lippard, Lucy. 1983. *Overlay: Contemporary Art and the Art of Prehistory.* New York: Pantheon.

———. 1990. *Mixed Blessings: New Art in a Multicultural America.* New York: Pantheon.

Loizos, Peter. 1993. *Innovation in Ethnographic Film, 1955–85.* Chicago: University of Chicago Press.

Lopach, James, Margaret Hunter Brown, and Richmond Clow. 1990. *Tribal Government Today: Politics on Montana Indian Reservations.* Boulder, Colo.: Westview Press.

Lucas, Phil. 1981. Speech at arts conference, Missoula, Mont. Videotape.

———. 1991a. "Producers' Forum 4: Realizing Our Visions." Symposium at Two Rivers Native Film and Video Festival, Minneapolis, Minn., October 11.

———. 1991b. "Comments on *Healing the Hurts*." Two Rivers Native Film and Video Festival, Minneapolis, Minn., October 12.

Luna, James. 1992. "Everybody Needs an Indian: Native Needs beyond 1992." Panel presentation. College Art Association Conference, Chicago. February.

McCall, Catherine. 1990. *Concepts of Person: An Analysis of Concepts of Person, Self and Human Being*. Brookfield, Vt.: Gowen Publishing Group.

McCarthy, Marie. 1990. "Music Education and the Quest for Cultural Identity in Ireland, 1831–1989." Ph.D. diss., University of Michigan.

McClaughlin, Castle. 1987. "Style as a Social Boundary Marker: A Plains Indian Example." In *Ethnicity and Culture: Proceedings of the 18th Annual Conference of the Archaeology Association of the University of Calgary*, edited by Reginald Anger. Calgary: The Archeology Association of the U. of Calgary.

McEvilley, Thomas. 1991. "The Selfhood of the Other: Reflections of a Westerner on the Occasion of an Exhibition of Contemporary Art from Africa." In *Africa Explores: 20th Century African Art*, edited by Susan Vogel. New York: Center for African Art.

McLuhan, T. C. 1971. *Touch the Earth: A Self-Portrait of Indian Existence*. New York: Simon and Schuster.

McMaster, Gerald, and Lee-Ann Martin. 1992. "Introduction." In *Indigena: Contemporary Native Perspectives in Canadian Art*, edited by Gerald McMaster and Lee-Ann Martin. Ottawa: Canadian Museum of Civilization.

McNickle, D'Arcy. 1978 [1936]. *The Surrounded*. Albuquerque: University of New Mexico Press.

Madden, Katherine. 1989. "'To Be Nobody Else . . .': An Analysis of Inuit Broadcasting Attempts to Produce Culturally Sensitive Video Programming to Help Preserve Inuit Culture, 1983–1985." Ph.D. diss., Pennsylvania State University.

Mander, Jerry. 1991. *In the Absence of the Sacred*. San Francisco: Sierra Club Books.

Maquet, Jacques. 1979. *Introduction to Aesthetic Anthropology*, 2d ed., rev. Malibu, Calif.: Undena Publications.

Masayesva, Victor, Jr. 1991. "Producers' Forum 1: Uncovering the Lies." Symposium at Two Rivers Native Film and Video Festival, Minneapolis, Minn., October 10.

———, and Erin Younger. 1983. *Hopi Photographers, Hopi Images*. Tucson: Sun Tracks and University of Arizona.

Mathiessen, Peter. 1991. *In the Spirit of Crazy Horse*. New York: Viking.

Maultsby, Portia K. 1983. "Soul Music: Its Sociological and Political Significance in American Popular Culture." *Journal of Popular Culture* 17(2):51–60.

Maurer, Evan. 1992. "Visions of the People." In *Visions of the People: A Pictorial History*

of Plains Indian Life, edited by Evan Maurer. Minneapolis: Minneapolis Institute 225
of Arts.

Maybury-Lewis, David. 1992. "The Art of Living." In *Millennium: Tribal Wisdom and the Modern World.* New York: Viking.

Merriam, Alan P. 1964. *The Anthropology of Music.* Chicago: Northwestern University Press.

———. 1967. *Ethnomusicology of the Flathead Indians.* New York: Wenner-Gren Foundation.

Merrill, Elizabeth Bryant. 1987. "Art Styles as Reflections of Sociopolitical Complexity." *Ethnology, An International Journal of Cultural and Social Anthropology* 26(3):221–230.

Meyrowitz, Joshua. 1985. *No Sense of Place: The Impact of Electronic Media on Social Behavior.* New York: Oxford University Press.

Michaels, Eric. n.d. "Teleported Texts." Unpublished manuscript.

———. 1982. "TV Tribes." Ph.D. diss., University of Texas at Austin.

———. 1986. *The Aboriginal Invention of Television in Central Australia 1982–1986.* Canberra: Australian Institute of Aboriginal Studies.

———. 1987. *For a Cultural Future: Francis Jupurrurla Makes TV at Yuendumu.* Melbourne, Australia: Artspace.

———. 1991. "Aboriginal Content: Who's Got It—Who Needs It?" *Visual Anthropology* 4:277–300.

Montana Indian Arts Conference. 1991. Sponsored by Montana Arts Council, Helena, Mont. Author's notes.

Morris, Richard, and Philip Wander. 1990. "Native American Rhetoric: Dancing in the Shadows of the Ghost Dance." *Quarterly Journal of Speech* 76:164–191.

Mukarovsky, Jan. 1978. *Structure, Sign, and Function: Selected Essays by Jan Mukarovsky,* translated and edited by John Burbank and Peter Steiner. New Haven, Conn.: Yale University Press.

Mulgan, Richard. 1989. "Should Indigenous Peoples Have Special Rights?" *Orbis: A Journal of World Affairs* 33(2):375–388.

Murray, David. 1991. *Forked Tongues: Speech, Writing, and Representation in North American Indian Texts.* Bloomington: Indiana University Press.

Nettl, Bruno. 1983. *The Study of Ethnomusicology.* Urbana: University of Illinois Press.

Neumann, Mark. 1992. "The Traveling Eye: Photography, Tourism and Ethnography." *Visual Sociology* 7(2):22–38.

Neville Brothers. 1989. "My Blood," on *Yellow Moon* (sound recording). A&M Records.

226 Nichols, Bill. 1991. *Representing Reality: Issues and Concepts in Documentary.* Bloomington: Indiana University Press.

Nietzsche, Friedrich. 1967. *The Birth of Tragedy.* New York: Vintage Books.

O'Connor, John. 1980. *The Hollywood Indian: Stereotypes of Native Americans in Films.* Trenton: New Jersey State Museum.

Oliven, R. 1988. "Man Woman Relations and the Construction of Brazilian Identity in Popular Music." *Social Science Information* 27(1):119–138.

Onyewuenyi, Innocent C. 1984. "Traditional African Aesthetics: A Philosophical Perspective." *International Philosophy Quarterly* 24(3):237–244.

Osborn, Harold. 1984. "Organic Unity." In *Philosophical Issues in Art,* edited by Patricia H. Werhane. Englewood Cliffs, N.J.: Prentice-Hall.

Osula, Bramwell. 1984. "'Redemption Song': Protest Reggae and the Jamaican Search for Identity." Ph.D. diss., University of Waterloo (Canada).

Pacini, Deborah. 1989. "Social Identity and Class in Bachata, an Emerging Dominican Popular Music." *Latin American Music Review* 10(1):69–91.

Pasztory, Esther. 1989. "Identity and Difference: The Uses and Meanings of Ethnic Styles." *Studies in the History of Art* 27:15–38.

Pernet, Henry. 1992. *Ritual Masks.* Columbia: University of South Carolina Press.

Perris, Arnold. 1985. *Music as Propaganda: Art to Persuade, Art to Control.* Westport, Conn.: Greenwood Press.

Philips, S. 1989. "Warm Springs 'Indian Time': How the Regulation of Participation Affects the Progress of Events." In *Explorations in the Ethnography of Speaking,* edited by Richard Bauman and Joel Sherzer. Cambridge, England: Cambridge University Press.

Pines, Jim, and Paul Willemen, eds. 1989. *Questions of Third Cinema.* London: British Film Institute.

Roberts, John. 1990. "Sinn Fein and Video: Notes on a Political Pedagogy." *Screen* 31(Spring):91–101.

Rodriguez, Sylvia. 1989. "Art, Tourism, and Race Relations in Taos: Toward a Sociology of the Art Colony." *Journal of Anthropological Research* 45(1):77–99.

Rollwagon, Jack R., ed. 1988. *Anthropological Filmmaking.* New York: Harwood Academic Publishers.

Rose, Wendy. 1992. "The Great Pretenders: Further Reflections on White Shamanism." In *The State of Native America: Genocide, Colonization and Resistance,* edited by Annette M. Jaimes. Boston: South End Press.

Ruby, Jay. 1992. "Speaking For, Speaking About, Speaking With or Speaking Alongside: An Anthropological and Documentary Dilemma." *Journal of Film and Video* 44(1–2):42–66.

Rupert, Robert. 1983. "Native Broadcasting in Canada." *Anthropologica* 25(1):53–61. 227

Rushing, Jackson. 1988. "The Impact of Nietzsche and Northwest Coast Indian Art on Barnett Newman's Idea of Redemption in the Abstract Sublime." *Art Journal* 47(3):187–195.

Sands, Kathleen M., and Allison Sekaquaptewa Lewis. 1990. "Seeing with a Native Eye: A Hopi Film on Hopi." *American Indian Quarterly* 14(4):387–396.

Schieffelin, Edward. 1985. "Performance and the Cultural Construction of Reality." *American Ethnologist* 12(4):707–724.

Scholder, Fritz. 1981. *Fritz Scholder/the Retrospective 1960–1981*. Tucson Museum of Art. Foreword, R. Andrew Mass; essay, Dr. Joshua C. Taylor; statement, Fritz Scholder.

Seeger, Anthony. 1987. *Why Suya Sing: A Musical Anthropology of an Amazonian People*. Cambridge, England: Cambridge University Press.

Sekaquaptewa, Emory. 1983. *Hopi: Songs of the Fourth World*. Produced and directed by Pat Ferrero. Film.

Shulevitz, Judith. 1990. "Tribes and Tribulations." *Film Comment* 26(January–February):2, 4.

Sijohn, Cliff. 1976. *Circle of Song (The Real People Series)*. Directed by George Burdeau. Office of Education (Department of Health, Education, and Welfare) and KSPS-TV, Spokane, Wash. Film.

Silberman, Robert. 1992. "Victor Masayesva and the Question of a Native American Aesthetic." Paper presented at the annual meeting of the College Art Association, Chicago, February.

Silko, Leslie Marmon. 1977. *Ceremony*. New York: Penguin Edition, 1986.

———. 1990. "Videomakers and Basketmakers." *Aperture* 119(Summer):72–73.

Smith, Amanda, and Thomas Loe. 1992. "Mythic Descent in Dances with Wolves." *Literature Film Quarterly* 20(3):199–204.

Smith, Jaune Quick-to-See. 1990. *Our Land/Ourselves: American Indian Contemporary Artists*. Jaune Quick-to-See Smith, Guest Curator. University Art Gallery, SUNY, Albany, N.Y., February 1–March 17, 1991.

———. 1992. "Everybody Needs an Indian: Native Needs beyond 1992." Panel presentation. College Art Association Conference, Chicago. February.

Snodgrass-King, Jeanne. 1985. "In the Name of Progress, Is History Being Repeated?" *American Indian Art Magazine* 10(2):26–35.

Sperber, Dan. 1985. "Anthropology and Psychology: Towards an Epidemiology of Representations." *Man* 18:327–345.

Steadman, Raymond. 1982. *Shadows of the Indian: Stereotypes in American Culture*. Norman: University of Oklahoma Press.

228 Strickland, Rennard. 1985. "Where Have All the Blue Deer Gone? Depth and Diversity in Post War Indian Painting." *American Indian Art Magazine* 10(2):36–45.

Tagore, Sir Rabindranath. 1961 [1916]. "What is Art?" and "The Sense of Beauty." In *Rabindranath Tagore, on Art and Aesthetics: A Selection of Lectures, Essays and Letters*. Calcutta: Orient Longmans.

Thompson, Robert Farris. 1973. "Yoruba Artistic Criticism." In *The Traditional Artist in African Society*, edited by Warren D. Azevedo. Bloomington: Indiana University Press.

Todd, Loretta. 1992. "What More Do They Want?" In *Indigena: Contemporary Native Perspectives in Canadian Art*, edited by Gerald McMaster and Lee-Ann Martin. Ottawa: Canadian Museum of Civilization.

Torgovnick, Marianna. 1990. *Gone Primitive: Savage Intellects, Modern Lives*. Chicago: University of Chicago Press.

Towner, Lawrence. 1978. Introduction to *The Surrounded*, by D'Arcy McNickle. Albuquerque: University of New Mexico Press.

Trafzer, Clifford E., ed. 1985. *American Indian Identity*. Sacramento, Calif.: Sierra Oaks Publishing Co.

Troy, Timothy. 1992. "Anthropology and Photography: Approaching a Native American Perspective." *Visual Anthropology* 5:43–61.

Tsinhnajinnie, Huleah. 1995. Presentations during the Matrilineage Symposium, Syracuse University, Syracuse, N.Y., February.

Tuan, Yi-Fu. 1977. *Space and Place: The Perspective of Experience*. Minneapolis: University of Minnesota Press.

Tucker, Michael. 1992. *Dreaming with Open Eyes: The Shamanic Spirit in Twentieth-Century Art and Culture*. San Francisco: Aquarian/Harper.

Turner, Terence. 1992. "Defiant Images: The Kayapo Appropriation of Video." *Anthropology Today* 8(6):5–16.

Turner, Victor. 1988. "Passages, Margins and Poverty: Religious Symbols of Communitas." In *High Points in Anthropology*, edited by Paul Bohannan and Mark Glazer. New York: Alfred A. Knopf.

Vine, Richard. 1994. "Numbers Racket." *Art in America* 82(10):116–119.

Visual Communication Seminar. 1993. Syracuse University. Spring.

Wade, Edwin. 1981. "The Ethnic Art Market and the Dilemma of Innovative Indian Artists." In *Magic Images*, edited by Edwin Wade and Rennard Strickland. Norman: Philbrook Art Center and University of Oklahoma Press.

———, ed. 1986. *The Arts of the North American Indian: Native Traditions in Evolution*. New York: Hudson Hills Press.

Wallis, Brian. 1991. "Selling Nations." *Art in America* 79(September):80–131.

Waterman, Christopher. 1982. "I'm a Leader, Not a Boss: Social Identity and Popular
Music in Ibadan, Nigeria." *Ethnomusicology* 26(1):59–71.

———. 1990. *Juju: A Social History and Ethnography of an African Popular Music.* Chicago: University of Chicago Press.

Weatherford, Elizabeth. 1990. "Native Visions: The Growth of Indigenous Media." *Aperture* 119(Early Summer):58–61.

———. 1992. "Starting Fire with Gunpowder." *Film Comment* 28(3):64–67.

———, and Emilia Seubert. 1981. *Native Americans on Film and Video, Volume I.* New York: Museum of the American Indian/Heye Foundation.

———. 1988. *Native Americans on Film and Video, Volume II.* New York: Museum of the American Indian/Heye Foundation.

Weitz, Morris. 1984 [1956]. "The Role of Theory in Aesthetics." In *Philosophical Issues in Art,* edited by Patricia Werhane. Englewood Cliffs, N.J.: Prentice-Hall.

Westerman, Floyd. 1991. Banquet speech at Two Rivers Native Film and Video Festival, Minneapolis, Minn., October 12.

White, Armand. 1988. "Totem Takes." *Film Comment* 24(April):6–8.

Winter, Dennis. 1990. *Doolin's Micho Russell, a Portrait.* Rosendale, N.Y.: Canal Press.

Woestendiek, John. 1990. "Film at Center of Hopi Riff." *Philadelphia Inquirer,* Oct. 11: 1-A, 14-A.

Worth, Sol. 1965. "Film Communication: A Study of the Reactions to Some Student Films." Offprint from *Screen Education* (July/August):3–19.

———. 1968. "Toward the Development of a Semiotic of Ethnographic Film." *PIEF Newsletter* 3(3).

———, and John Adair. 1972. *Through Navajo Eyes: An Exploration in Film Communication and Anthropology.* Bloomington: Indiana University Press.

Wright, Will. 1975. *Six Guns and Society: A Structural Study of the Western.* Berkeley: University of California Press.

Younger, Erin. 1983. "Changing Images, A Century of Photography on the Hopi Reservation (1880–1980)." In *Hopi Photographers, Hopi Images,* compiled by Victor Masayesva, Jr., and Erin Younger. Tucson: Sun Tracks and University of Arizona Press.

INDEX